"[Ferguson sees] a modern Canada [...] from the established stereotype of the Great White North, populated by Mounties, moose and very nice people. The result is *Why I Hate Canadians*, and the response has been overwhelming."—THE COAST: HALIFAX'S WEEKLY

"[Ferguson] pulls no punches and in one slim volume becomes the Brash Young Writer that this country has needed for a long time...He is one of the most articulate voices of the generation just coming into the influence and power that is its birthright."—HAMILTON SPECTATOR

More praise for Will Ferguson's first book, **Why I Hate Canadians**:

"Ferguson is a skilled writer with terrific insights. *Why I Hate Canadians* is essential reading for a generation weaned on the political irreverence of the CBC's *This Hour Has 22 Minutes.*"—WEEKEND EDITION

"Funny, ironic, informative."—KITCHENER-WATERLOO RECORD

"An aggressively patriotic book ... Ferguson shows his love for Canada the way an older brother shows love for a younger sibling—with a wedgie."—CHARLOTTETOWN GUARDIAN

"[Ferguson] uses a healthy sense of humour and a good dose of history to challenge the notion of what it is to be Canadian."—FASTTRACK: CALGARY'S WEEKLY

"Is this another cynical X rehash of the Spirit of a Nation? No. It is an entirely digestible skewering of the national bedrock ... No doubt we will be hearing more from Uncle Will in the future. We are fortunate to have him back among us."—TORONTO STAR

"Irreverent, incisive and informative . . . I give it a resounding five out of five maple leaves."—KINGSTON WHIG-STANDARD

"Amusing and surprisingly thoughtful, and very much in the Canadian spirit of poking fun at ourselves . . . There are 24 chapters, and each one contains a kernel of truth wrapped up in pointed humour."—WHITEHORSE STAR

"Filled with humour and insight, *Why I Hate Canadians* deserves attention from Canadians of every political ilk."—SEE MAGAZINE

"If Canadians think it's their right to adopt the title of nicest people in the world, they should first read this book."—VOX

"A smooth read . . . Ferguson is both insightful and hilarious." —GEORGIA STRAIGHT

"Grab this book for a fun look at yourself and your country, and be prepared to laugh."—PRINCE GEORGE FREE PRESS

"Hilarious . . . Dipping into one paragraph of this witty social commentary was enough to convince me to buy a copy."—SAINT JOHN TIMES GLOBE

"The book shows a confidence about the survivability of Canada and its culture . . . Some older nationalists will find *Why I Hate Canadians* infuriatingly glib and smart-ass . . . But as a glimpse into how the next generation of nationalists sees Canada, it is both fascinating and encouraging. The country may pass into better hands than we thought."—OTTAWA CITIZEN

"A wickedly funny book."—FREDERICTON DAILY GLEANER

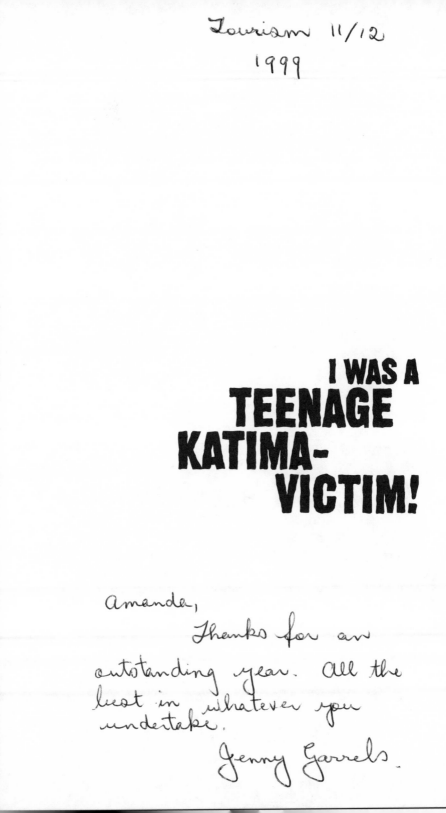

I WAS A
TEENAGE
KATIMA-
VICTIM!

Amanda,
Thanks for an
outstanding year. All the
best in whatever you
undertake.
Jenny Garrels.

A Canadian Odyssey

Will Ferguson

I WAS A TEENAGE KATIMA-VICTIM!

Douglas & McIntyre
Vancouver/Toronto

Douglas & McIntyre Ltd.
1615 Venables Street
Vancouver, British Columbia
V5L 2H1

Canadian Cataloguing in Publication Data
Ferguson, Will.
 I was a teenage Katima-victim
 ISBN 1-55054-652-X
 1. Canada—Description and travel—Humor. 2. Katimavik (Organization)—Humor. 3. Canadian wit and humor (English)* I. Title.
FC173.F46 1998 c818'.5402 c98-910593-8
F1026.4.F47 1998

Cover and text design by Peter Cocking
Cover photograph by Randall Cosco
Typesetting by Rhonda Ganz
Printed and bound in Canada by Transcontinental Printing and Graphics, Inc.
Printed on acid-free paper ∞

The publisher gratefully acknowledges the support of the Canada Council for the Arts and of the British Columbia Ministry of Tourism, Small Business and Culture. The publisher also acknowledges the financial support of the Government of Canada through the Book Publishing Industry Development Program.

Katimavik can be contacted at: Port of Montréal Building, Wing 2, Suite 3020, Cité du Havre, Montréal, Québec H3C 3R5 • Tel: (514) 868-0898 • Fax: (514) 868-0901 e-mail: katimavk@camitel.com

FOR KAY PARLEY OF SASKATOON —a fellow writer, friend, and aunt—who taught me one of life's most important lessons: "Push-brooms only work when you pull them."

Contents

KATIMAVIK (ka·tē´·ma·vik) *n*. An Inuit word meaning common ground or meeting place

Introduction

KATIMAVIK WAS GOING TO save Canada. That was the goal. That was the whole idea. That was the driving force behind it. Quixotic? You bet. Canadian? Absolutely.

Katimavik was a cross-country volunteer corps. Described as "an apprenticeship for life," it brought together young people from every region of Canada. We called ourselves "Katima-victims." We were between the ages of seventeen and twenty-one, we worked on everything from soup kitchens to outdoor conservation trails, and for our efforts we were paid the princely sum of $1 a day.

More than 20,000 participants went through Katimavik and thousands more were involved: group leaders, community sponsors, work supervisors, host families. The scope of the program was staggering: 1,400 different communities across Canada, and more than 200,000 people directly involved or affected. For better or worse, Katimavik helped shape an entire generation.

Katimavik participants were chosen to represent the demographics of the nation as a whole, with the same ratio of French to English, East to West, urban to rural—and with all the tensions and contradictions that entails. This is the story of one such group.

If the first sign of old age is nostalgia, then I am growing old. Or at least, growing up. I am now thirty-three. I have a wife, a child, and a career (of sorts). I travel. I write books. I piss people off. It's not a bad life. But before any of this, before the creature comforts and the notoriety—before this, I was nineteen and caught in mid-motion, filled with panic and joy.

Prior to Katimavik, Canada was little more than an abstract concept to me. My first stirrings, my first sense of belonging to this place—this *thing*—called Canada came in 1972 when I was seven years old, as we listened to the final showdown between Team Canada and the Soviet national team. I didn't understand politics, or even countries, but I understood hockey, and I knew full well that I belonged to Canada in the way one belongs to a peewee club. For me, Canada was a hockey team. And being Canadian meant being a fan. Or a player. It was a point of view that stayed with me for years.

When you grow up in the North, as I did, Canada hardly exists at all. Canada is where the radio signals fall from, somewhere *out there*. Katimavik made it real. It was the first journey I ever made, the first one that counted, and I was obsessed with details. Notebooks were filled with my observations and scribbled asides, everything from letters home to snippets of conversations. In putting this book together, I went through these notes—winnowing them down, cutting and condensing—and I was struck by what a singularly naive person I was, even then. Cynical and naive. Even then.

The names have been changed and the identities altered, and a few incidents have been reworked from other Katimavik groups, but the places and events are real. I wrote the original manuscript in longhand, and I owe a huge debt of gratitude to my mother, Lorna Bell, who typed the entire book—via dictation, no less—and to my sister-in-law, Sherry Ferguson, who later retyped the revised version. I would also like to thank Sheila Ehman, who believed in this book back when I was a dishwasher living in Edmonton spinning tales and elaborate anecdotes about the time I spent in that bizarre, yet oddly Canadian, institution called Katimavik.

Part One
KELOWNA
BRITISH
COLUMBIA

1

"YOU LOOK LOST."

This is where it all begins. This is the statement that launched my stumbling, cross-Canada, government-sponsored endurance test. *You look lost.* Not lost in the philosophical sense. Not lost in the metaphorical sense. Not lost in the generational, Calvin Klein–ad, Gen-X sense. Lost in the "where-the-hell-am-I" sense.

It is midnight, ten days into January, and I am standing in the Kelowna bus depot somewhere in the snowy interior of British Columbia. I am all alone in a depot that is deserted and echo-empty, and I have just spent twelve hours (years? millennia?) on board a Greyhound from Hell as it made its way from the flatlands of central Alberta through the Rocky Mountains and into the Interior. The journey was claustrophobic and mind-numbing and eye-socket aching and all the things that long-distance bus rides always are. My joints have atrophied. My head is filled with sawdust. My tongue has a coat of fur growing on it. I am standing here like a refugee, waiting for someone—*anyone*—to contact me.

I never heard her coming. I never heard her coming because among the many idiosyncrasies that define her is this: she wears crepe-soled shoes, like a nurse. But she is not a nurse. She is Group Leader.

"You look lost."

I turn, startled, and find myself face to face with a forehead—a forehead wrapped in a beaded headband with a "Save the Whales" button pinned slightly off centre, which is appropriate, I suppose, because I'm looking at—

"Joyce. Joyce Seward." She presents her hand. I shake it. And my fate is sealed.

2

THERE WAS ONLY ONE vehicle in the parking lot outside the bus depot: a sleek white van with the minimalist Katimavik logo on the door. I threw my backpack inside as Joyce lurched the van into gear.

I looked over at her. "Am I the first?"

"No, but you're a close second. A participant from Vancouver arrived this morning."

Kelowna was asleep. We drove through the city streets, and the falling snow pincushioned into the headlights. Joyce and I made a few traditional comments about the weather. (For example, we agreed that it was snowing and that, generally, winter is cold.) Then she asked me a question I was hoping to avoid.

"Why did you join?"

To be honest, I didn't know. But even in the grips of Greyhound Fatigue, I realized this was not a good thing to admit to a group leader, especially *my* group leader.

"Well," I began, "a Katimavik recruiter came to my—"

"I hate that word: 'recruiter.' It has such negative energy. It sounds too militaristic."

"Well, then. This, um—" I tried to come up with a word that had better energy. "This *resource person* came to my high school."

Joyce bobbed her head in vigorous approval. Encouraged, I continued.

"He was giving a presentation during chemistry class and I figured that anything is better than chemistry, so I attended. The resource person gave us a talk and showed us some slides of kids—"

Joyce had her hand up, like a flag on a play. "Sorry. We don't call them 'kids' in Katimavik."

"Negative energy?" I guessed.

"That's right. Calling someone a kid denotes a lower status. In Katimavik we prefer to use the word 'participants.' Or just 'parts' for short." Then with a laugh she said, "I know one group leader who prefers to call them 'party-pants.' He feels it creates a more positive atmosphere."

"He sounds like quite the zany fellow."

"Oh, he is," she assured me, my sarcasm lost on her.

"Anyway," I said. "This resource person gave a slide presentation showing groups of *parts* dressed in lumber jackets. They had hard hats and chain saws and great enormous grins. And the recruiter—resourcer—whatever, he told us that in Katimavik parts travel to different areas of Canada doing volunteer work, apparently involving chain saws. They get a dollar a day and a thousand bucks at the end." It still didn't make a lot of sense to me. "Oh, yes, and Katimavik is an Eskimo word. But I can't remember what it means."

An awful silence descended. Joyce turned and gave me a horrified look. "Is that it? Is that all you know about the program?"

I thought for a moment. "And you aren't allowed to smoke drugs or hitchhike or sleep with the other parts. And you live in a group home."

"That's *it*? That's all they told you?"

"Yes. That's pretty much the sum total of my knowledge about, ah . . . Why do you ask?" I was getting nervous. Was there something they weren't telling me?

"What about the learning programs? What about the second-language aspect? What about—what about the *goals* of Katimavik?"

"He didn't mention any of that. He just said it was a great chance to travel across Canada, all expenses paid, and that we'd get a thousand dollars at the end. We *are* going to get a thousand dollars at the end, right?"

Joyce rolled her eyes. "Stupid recruiters."

By now, Kelowna proper had slipped away and we were in the southern suburb of Mission, driving along the lakeshore past houses

fringed with elaborate displays of Christmas lights. If religious faith can be measured in terms of pure wattage, this was one very religious neighbourhood. Rich, too. The garages had multiple doors and the homes were set back from the road, aloof and expensive. It appeared that we, however, were to live in a barn. A *converted* barn, true, but a barn nonetheless. This was where Katimavik had placed us, on land owned by the Kelowna Centennial Museum.

We walked inside and Joyce turned on a single dismal light. "This is the living room," she said, her voice echoing. "The set-up is, well, a bit Spartan . . . "

To say the least. It was a cavernous biopsy of a place. The walls were a ragged patchwork of drywall and amateur adventures in home improvement. A single sad, sway-backed shelf held our provisions: a great big jar of granola and another one filled with powdered milk. There was no furniture, and all I could think as I looked across this barren interior was that Joyce had thought to buy granola before she thought to buy chairs or a table.

"I really wanted it to be ready before the parts arrived," she said. "But I had a hard time just finding a place."

Tea towels. She had also found the time to buy tea towels.

"This barn came up at the last minute. It's a bit rough, but once we get some chairs and a couch and some, ah, cupboards and lamps and, um, pots and pans and some curtains and . . . " Her voice trailed off.

"Can I come back in a few weeks when it's finished?"

The room also contained the following:

1. a gas range for cooking

2. a small wood-burning stove, the kind our forefathers used to shiver around as they dreamed of the day they could afford central heating

3. no apparent thermostats

This led to the unavoidable conclusion that the entire vast room was to be heated by the single wood-burning stove, an obvious impossibility. We could see our breath and we were *inside*.

"Where do we sleep?" I braced myself for the worst, and I got it.

"The bedrooms are on the other side of that wall," she said. "But

we can't get there from here. We have to go outside and reenter through another door. Follow me."

I hoisted my backpack over one shoulder, took a step, and tripped.

"Watch out," said Joyce. "The floor changes levels."

I picked myself up off the floor. Or rather, the *floors*. The main room had five, all at different heights. We had a sunken kitchen, a more sunken porch, an almost sunken living room, a half-sunken hallway, and a raised dining area. It was like living in an optical illusion. A trip from the front door across the room to the back door involved two steps up and three steps down. For my entire tour of duty in Kelowna I tried to discover *why* the main room was so constructed, and all I came up with was "whimsy." It was an Escher drawing. It was a Möbius strip. It was, in a word, Katimavik. Everything conspired to remind me that I had left the real world and had plummeted down the rabbit hole.

We were about to step out the back when Joyce cautioned me. "Be careful with this door. It locks automatically. But sometimes it doesn't."

Just above the door handle was a hole cut in the wood. It was big enough to put an arm through.

"Why is there a hole cut through the door?" I asked (sensibly).

Joyce looked at me as if I was more than a wee bit thick and slowly repeated herself. "The door locks automatically, remember?"

"And?"

She sighed. "The hole is there so we can get back in if we get locked out." To demonstrate this, she stepped outside and closed the door. She then reached in through the hole, unlocked the door, and swung it open.

I had never seen anything so stupid in my life. "How—how—*how* long," I stammered, "do you think it would take the average burglar to crack this ingenious system? I mean—I mean, anybody with half a brain could—"

She smiled benignly at me. "Come on, Will. Look around you. No burglar would ever break in here. What do we possibly have that could be worth stealing?"

"Nothing right now, but once we get some furniture . . . "

"Oh." She flicked her hands at me. Silly boy. "The furniture *we'll* be getting won't be worth stealing. This is the last place a burglar would come. Too many rich houses nearby."

I was trapped in a Fellini film. "So why should we bother locking the door at all?"

"The only reason we lock the door is to stop it from blowing open when we aren't here."

"Oh."

We stepped outside and were circling around to the bedrooms when I stopped in my tracks. "Joyce?"

"Yes?"

"Why didn't they just put the lock on the *outside*? You know, instead of cutting a hole through the door. The last person out could lock it."

"William," she said. "You really shouldn't be so logical all the time. Don't be so rigid and linear in your thinking. Try to see life in a more open way. That's what Katimavik is all about: personal growth and developing a wider sense of things around you."

"But, but—"

She had already turned and was on her way. I followed Joyce back into the barn, through a different door, to where the sleeping area had been set up. Once again, I was struck by the Zen-like use of empty space to underscore the transitory nature of life. Converting this section of the building had amounted to little more than adding an occasional hanging lightbulb. The floor was rustic, which is to say, *cement.* You could still see the original feeding troughs along one side. A large sliding barn door divided this area from the showers and toilets. The bedrooms themselves were partitioned off with unpainted, unfinished plywood walls. One good kick would take them down. The "rooms" were simply squares of floor space, maybe ten feet by twelve. Maybe. Curtains were strung across the entrances in lieu of doors. And such were the sleeping quarters. Clearly, the Geneva Convention was being compromised.

"Home!" said Joyce, beaming.

"Home?" I asked.

"Home," she said firmly.

Twelve hours. On a bus. For this.

Joyce picked a curtain at random and said, "This will be your room. You'll have to share it with the other male parts if they arrive. *When* they arrive."

I lugged my pack inside, the curtain clinging to me like Saran Wrap. As I've said, the room was small. Very small. You would think that with an entire barn to work with, they could have come up with something bigger. At least, I allowed, the floor was all one level. Concrete, to be sure, but at least *level* concrete. Now, where was my bed?

Joyce reappeared on cue with a mess of netting and nylon. "Here's your hammock." She held up a hammer, a screwdriver, and some hooks. And off she scampered, leaving me to my own ingenuity.

My bedroom was too short one way and too long the other, which left me with two options: either a hammock hanging so low I would be facing my knees when I got in, or one strung out taut as a drum. I chose the latter and stretched the hammock the length of the room. By the time I was done, it was so tight I could have plucked it like a lute. Slowly, I climbed on—and immediately crashed to the floor. (The cement floor.) I lay there a long while, and a sense of calm came over me. If I started walking now, I thought, I could be back in Alberta by Wednesday.

Round Two of man vs. hammock went slightly better, and in Round Three I triumphed. By now, however, I had other worries. The temperature was dropping, and my breath was coming out in cumulus-cloud formations—though how much of that was a product of my bus-ride diet of sour-cream potato chips and carbonated beverages is hard to say.

"Joyce!" I called out. "Where's the thermostat? This place is ice-cold."

She fought her way in through the curtain and flashed me a grin.

Damn. "You realize," I said, "that I will freeze in the night."

"We have small heaters for the boys' rooms, but they won't be delivered until tomorrow."

Hmmm. "Joyce, where do *you* sleep?"

"I have a cabin next door. We passed it on the way in."

"I see. And how is this cabin of yours heated?"

"Electricity. Why?"

"You know, Joyce, when I first saw you, I said to myself: 'That is one sexy lady.'"

"William?"

"Yes, Joyce?"

"You can't sleep with me tonight."

Damn.

"Cheer up," she said. "Sarah has two heaters in her room. I'm sure she'll lend you one."

"Who's Sarah?"

"The other part. Remember? She flew in from Vancouver this morning."

Sarah, it turned out, was on the other side of the barn, ensconced in her room, and she refused to show herself. Joyce went in and tried to coax her out, but to no avail. Through the curtain I heard a giggle. That giggle. *Her* giggle. It would haunt me for the next nine months. Even today, there are nights when I wake up in a cold sweat with that—that *giggle* echoing through my brain.

"*Noooo*, Joyce! (Giggle, giggle.) I don't want to. (Giggle, giggle.) I wanna put some make (giggle) up (giggle) on (giggle)."

Joyce's voice was tense. She must have been speaking through clenched teeth. "Don't be silly, Sarah. Go out and say hello."

The curtain billowed open and a heavy-set girl was shoved out. I smiled at her. She had green hair.

"Hiya," she said. She waved at me. We were standing two feet apart.

"Hello."

Sarah, clearly, was someone who had read too many fashion magazines. Her approach was kind of post-modern. Her shoes were glitter, and everything else in between was layered in strata of fashions dead. It was like looking at a clothes closet that had exploded.

"Bye!" She waved and scurried back into her room. (Joyce scampered. Sarah scurried. I lurched.)

"Can I come in?" I said to the curtain.

"Giggle."

Interpreting that as a "yes," I drew the curtain aside and entered into chaos. Inside were more suitcases than I would ever have

imagined could fit. Some bags were open and empty, some half-full, others still unviolated. *Her* room had a dresser, on which she had massed her arsenal of hair spray and make-up. Mounds of clothes lay stacked in towers. I spotted at least a half-dozen pairs of shoes, none of which were the requisite work boots. (She was apparently planning to chain-saw in open-toed pumps.) Sarah had also found the time—and inclination—to plaster the walls with posters of thin, head-banging rock bands with names like Das Vömit-burger and the Highly Annoyed Power Tools. Her hammock still wasn't up.

In a way, I found this reassuring. Here was a person even less prepared than I was. It also allowed me to feel haughty and superior. After all, *I* had an entire pack filled with proper work clothes, newly bought and crisply folded. Why, some of my plaid shirts still had the tags attached, and my spiffy new work boots came complete with reinforced steel toes. Indeed, I couldn't wait to drop something heavy on my toes—maybe a cinder block or an anvil—and then brush it aside with a hearty laugh. Sarah, meanwhile, looked like a refugee from a shopping mall.

"Well, hello there," she—and I choose this verb with care—sputtered. (I once had a friend who could talk by burping; as he forced the air out he would form words. Sarah managed to do the same with giggles.)

"Uh . . . hi yourself." I still hadn't spotted the heaters. "Nice room."

"You're the guy from Alberta, right?"

"Yes." They must be somewhere underneath all those jackets.

"Are you a cowboy?"

"No." I spotted an electric cord and followed it back . . . to a hair dryer.

"That's too bad. I like cowboys." She seemed genuinely disappointed. "So, do you have a girlfriend back home?"

I paused for a second and considered the question and its implications. "I'm not sure."

"I'm single myself," she volunteered. "Totally unattached, that's me."

"That's, um, that's—" Behind her sleeping bag I saw a small electric heater. "Great!"

"It is?" she asked breathlessly.

I high-stepped across her splayed, gaping suitcases and plucked up the heater from whence it was hid. As I was winding up the cord, Sarah politely inquired where I was taking it. I told her.

"No way!" she said. "I had it first!"

"You've got two, for cryin' out loud. Joyce told me to take one." I made my way across the room. She grabbed the heater from me. I grabbed it back.

"No fair! No fair!" she said.

Resisting the urge to shake her by the neck until her head rattled, I asked why she had to have this particular heater.

"It's electric," she said. "The other one uses kerosene. Why don't you take that one instead?"

I took a deep, deep breath and exhaled. "Sure. Where is it?"

Sarah slowly surveyed the calamity that was her room. "I'm not sure."

I found it beneath a tangle of clothes hangers and assorted belts. As I worked the heater free, a thought struck me. "Sarah?"

She looked up from behind a suitcase. "Yes?"

"Why do you prefer the electric heater over the kerosene?"

"Oh, well, we don't have any kerosene. Joyce's gonna get some tomorrow."

Just then, Joyce made the mistake of looking in to see "how things were going."

"Things are swell, Joyce. Except that I have no heat." I held up the kerosene heater like Exhibit A in a murder trial. "No oil. Somebody forgot."

Joyce frowned. "That's right." She scratched her chin, thought a bit. Frowned some more. "The oil won't get here until tomorrow."

I pushed one of Sarah's suitcases to one side and staked my claim. "In that case, I'll sleep right here."

Joyce was quick to put a damper on my cunning plan. "I can't allow that," she said.

I sighed. "Why not?"

"Yeah," Sarah echoed. "Why not?"

"Rule Number Three," said Joyce.

"Okay," I said. "You've got me. What is Rule Number Three and what does it have to do with me not freezing to death in my sleep?"

"Rule Number Three: *'No cohabitation between male and female participants. And no relations between participants and work sponsors.'* "

"Joyce, just by living together we are—technically—cohabiting." (I'm a stickler for semantics.)

"Male and female parts must have separate sleeping quarters. That's all there is to it. Sorry."

"Joyce," I said. "All I want now is to go to sleep and know that I will wake up again. I do not want to become frozen in the night. Do you understand my concern?"

"Yes."

"Good. Now this barn of ours has little insulation—"

"None, actually."

"*No* insulation, a cement floor, no central heating. No heating of any kind except—aha!—for a single heater in Sarah's room."

"Forget it."

So here's what happened: Joyce checked Sarah's kerosene heater and found that the tank still had some oil in it. This, she decided, would be just enough to get me through the night. "Are you sure?" I said. "Trust me," she said. And that was how I awoke in a dark barn in a strange town in the middle of January, colder than I had ever been in my life. Fortunately, I had shivered myself awake and hadn't drifted off into hypothermic dreamland. The heater (of course) had died in the night.

With my teeth chattering like one of those novelty items you see in joke shops, I squirmed out of my sleeping bag and swung my feet onto the floor. The cement stuck to me like dry ice. I hopped about doing my impression of an untalented fire-walker as I turned on the light and searched for my socks, one of which had slithered out of sight during the night. My shivers grew into uncontrollable spasms and my nose was as wet as a puppy's, but not nearly as cute.

You're history, Joyce.

I pulled on a pair of jeans and a sweatshirt; clothes stored in an icebox would have been easier to wear. Rummaging around in my backpack, I came up with a comical toque (comical because all toques are comical), a scarf, and half a pair of mittens. I yanked the toque down over my ears, and I wrapped the scarf around my face in the style of the Invisible Man. I tried to fit both hands into the single mitten; it couldn't be done. Instead, I put the mitten on my right hand and tucked my left hand under my armpit. (I figured that if frostbite knocked off a few fingers on my left hand I would still have my right one with which to write a stern letter to the Katimavik head office.) Hunched over in a quasi-Quasimodo posture, I staggered out of the room, dragging my sleeping bag behind me.

I considered my options. I could *(a)* sneak into Sarah's room and steal her heater, *(b)* go back to the living room, where the wood-burning stove was located, or *(c)* set the barn on fire and warm my hands as it burned. Regrettably, I chose option *(b)*, not *(c)*.

Leaving the sleeping area, I went outside into the night. The snow was blowing and the wind was positively howling. Or should I say *growling*. I stopped and craned my neck. Yes, something was definitely growling. Possibly a wolf. Maybe a wolverine. Probably a dog. I began walking at a brisker pace, one which an uninformed observer might have confused with running. When the dog that had been stalking me finally broke from the cover of darkness, my feet were practically a blur, so brisk was my walk. I may have yelled something as well. Something along the lines of "Help! Help!"

You know how yippy little dogs have those annoying little voices, and how, say, a German shepherd has a nice deep baritone, and how you can generally extrapolate from the timbre of a dog's bark to his size? Well, whatever was behind me had a low bass *whoof* that put his size at somewhere above Saint Bernard and just below T.rex.

I reached the door and the door (of course) was locked. Thrusting my hand into the hole I fumbled with the lock, my fingers numb and leaden. The dog came at me, the door swung open, and I fell onto the floor. Rolling over, I kicked the door shut as I let out a shriek that is still, I believe, echoing somewhere over the mountains of central British Columbia.

With my pulse throbbing in my temples, I stood up. Realizing I was out of danger, I peered out of the hole in the door and cursed the dog, questioning the moral standards of his mother and challenging him to come and get me if he was so damn tough. (I don't suppose that calling a canine a son-of-a-bitch is really much of an insult. Still, I felt better.)

At least I was safe. Now I had to find heat. It was all very primitive and instinctual. Big sabre-tooth. Run. Hide. Find fire.

I stumbled across the various floors to the wood stove and looked inside. There was a thick layer of ash along the bottom. This, I decided, was normal, and I began to look around for matches and wood. I found a box of matches, a large bundle of old *Kelowna Couriers*, and a single, solitary log, as thick around as my thigh. So far, so good. I then attempted to start a fire by holding one match after another against the log. The log refused to burst into flames. (Though I did manage to scorch the bark somewhat.) The log was clearly defective, so I switched to Plan B, which involved stuffing the stove full of crumpled-up newspapers and tossing several matches inside. Hallelujah! Orange flames burst into being and a warm glow spilled forth . . . for about twenty seconds. The papers then curled into a black wasps' nest of ash and the fire died. The log wasn't even smouldering.

I'll admit I'm no boy scout, but eventually the concept of kindling rose in my mind. I needed to reduce the log to splinters. But how? The sharpest object I could find was a butter knife, which, unless I was prepared to whittle the night away, would be of no help. I would have smashed the furniture to bits had Joyce only thought to buy some. Of course, I could have snuck outside to collect kindling, but that would have involved facing the Beast. (And armed only with a butter knife, mind you.) So instead, I turned on all the elements on the gas stove, opened the oven, and curled up on the floor. A gas leak could have easily killed me, but at that point death was no longer a big fear—especially considering that the place I was probably going to end up would at least be warm.

3

JOYCE FOUND ME on the floor the following morning. I coughed and sniffed and blinked as I woke, much like a tramp who has just had his boxcar door opened unexpectedly.

"Will! What on earth are you doing in here?"

"Staying alive. Barely."

The sun wasn't even up yet. *You are one dead group leader, Joyce.*

"What—" I blocked a yawn. "What time is it, anyway?"

"Just after six."

Prepare to die.

"Listen, Will, I have to go to the airport to pick up the rest of the parts. They're arriving on the seven o'clock flight. Some men will be coming around with the furniture, so if you—"

"Joyce?"

"Yes?"

"My heater ran out of oil last night."

"I see. Anyway. A fellow named Christian will be dropping in as well. He's our cook, and if—"

"Joyce?"

"Yes?"

"A dog tried to kill me last night."

"I see. Now, when he—"

"It wasn't a very good night."

"Tell me, this dog. Was he black with a white spot over one eye?"

"Yes, with huge fangs. They were glistening in the moonlight."

"Oh, that's just Spats, the neighbour's dog. He's an old softie. Half-blind, really. Wouldn't hurt a flea."

"What I don't understand, Joyce, is why you lied to me. 'The kerosene will last,' you said. 'Trust me,' you said. I just wanted to get out of chemistry class. That's all I wanted. They were smiling. They had chain saws. And now it's, it's like I—I—I—"

Joyce put a hand on my shoulder and gave me one of those sincerity stares that they teach counsellors and therapists to fake in Counsellor and Therapist School. "You don't sound very happy," she said.

"I'm *not* happy! I'm bloody well pissed-off. Katimavik is a crock.

At least in the army they don't let you freeze to death. At least not on your first shift."

"Now, now. Let's be calm. Don't worry. Learning is a process, and the first step is always difficult. Don't ever be afraid to express your feelings. Keep those lines of communication open. That's what Katimavik is all about." She smiled and squeezed my shoulder. "There. I'm glad we had this little talk."

And she was gone.

The other participants, or "party-pants" or "lucky bastards"—take your pick—had spent the night in Vancouver. Their plane was to have landed the night I arrived, but the same snowstorm that almost killed me rerouted their flight. They stayed at a hotel. A hotel with soft, warm beds. Room service. Heat. No dogs allowed.

The furniture arrived just before they did. Christian, a Québécois-in-exile (the Okanagan Valley around Kelowna is teeming with them), arrived as well and helped unload a mouldy old chesterfield and a bunch of chairs. I held the door open.

As I soon learned, for the first week of orientation, Katimavik assigned cooks to each group to help ease the participants into the self-sufficiency that was yet another of Katimavik's many—and apparently endless—"goals." Christian was our cook. He had a ponytail and a poncho, and he came stocked with his own supply of granola.

Christian filled our shelf with such succulent offerings as lentils, figs, garbanzo beans, unsulphured dried apples, millet, turnips, molasses, nuts, berries, twigs, leaves, and mulch. Okay, so I made the last few up, but you get the idea; one of the goals of Katimavik was to pursue better health and nutrition, apparently by having participants eat the kind of roughage usually served to large rodents.

As Christian organized our foodstuffs, Sarah sauntered in, well-rested and with fluorescent mascara carefully attended to. I, meanwhile, smelled like a goat. I was sprawled out in a boneless, advanced-fatigue state, and I could feel the fungi from my body genetically bonding with that of the chesterfield.

I was still in that position—head lolled back, limbs flopped out, eyes half shut, jaw slack—when Joyce returned with the rest of our merry band. Sarah rushed out to meet them. The door swung open

and in they came: a parade of bewildered souls, weighed down with duffel bags and backpacks. Sarah gave them the grand tour. "This is the main room. Here's the wood stove. We use wood. The dining area is over there. That's Will. That's the stove. Over here . . . "

I felt like a piece of furniture. But then again, I probably looked like a piece of furniture. I hoped I looked like a dining room table, because we still didn't have one.

The parts filed by, tripping and stumbling on the floors. They nodded to me as they passed.

"Hi."

"Hmm."

"Hello there."

"Hi."

I counted five. Three girls, including Sarah, and two boys. Three if you included me, but by that point I would probably have been better classified as either mineral or vegetable. I tore myself away from the chesterfield's tendrils and went outside to meet the people I was about to spend the next nine months with.

The sun was breaking through the evergreens, and the air had that uplifting coolness that comes from melting snow. Patches of snow were transmuting into puddles in the driveway, and water was tapping out Morse code messages from the corners of the barn. At the foot of the hill was Joyce's little cabin and beside that a jumbled pile of firewood, plopped down like some large timberland spoor.

The other parts had gathered around the woodpile; some sat on sawhorses, a few on old orange crates. The two new girls—one tiny and elflike, the other tall and strong-looking—were chatting to each other in French without the courtesy of subtitles. I stood beside them for a while, pretending I understood and nodding like an imbecile, before giving up and moving on.

A dark-haired boy with sniper's eyes came over to me. "François. Montréal."

"Will. I'm from Alberta."

And after that we pretty much ran out of things to say. I moved on to a roundish chap with a thin, ephemeral moustache—the kind that

only teenagers can grow. His name was Duncan, and we dutifully shook hands.

"So," he says. "Where'ya from?"

"Alberta," says I.

"Swell," says he.

"Great," says I. (This introductory ritual was already getting on my nerves.)

Duncan shook my hand a second time, apparently in congratulations for my being from Alberta, and said, "I'm from Parsons Pond myself."

I waited, but he didn't elaborate. I wasn't sure how to approach it. "So, Duncan. Just which province is Parson's Pond *in?*"

"Newfoundland. Near Daniel's Harbour, to be exact." And for a moment I thought he was going to shake my hand again. He didn't. Instead he asked, "Alberta, you say? So, you a cowboy?"

I made my exit just about then. I wandered back to the two French girls, but they were still French, and by the time I returned to Duncan, Sarah had already latched onto him. She was, in her own subtle way, letting Duncan know she was unattached.

"I'm unattached," she said. "Single. Not tied down a bit."

Duncan, meanwhile, was still excited about having survived such an ordeal as being rerouted to Vancouver. "The plane banked once, twice, three times," said Duncan. "Then the pilot figured, too much fog. And let me tell you, I was afraid they'd try to land her anyway."

"I *used* to have a boyfriend," Sarah said coyly. "Lots of boyfriends. But not now. I'm as single as they come."

Duncan continued. It was like watching a tennis match. "There was no way we coulda landed. Way too much fog. Way too much."

"My last boyfriend was really possessive, and I just said, 'Hey, I need my freedom.'"

"So we hadda go all the way to Vancouver. I'm just glad we had enough fuel. There was definitely too much fog to land, I could see it out the window, and I thought to myself—"

"Duncan," I said, cutting in. "That wasn't fog, that was a snowstorm. You were rerouted because of high winds and snow."

"Exactly," said Duncan. "There was too much fog." And they were off again, speaking at cross-purposes.

François of Montréal was in deep with Joyce, discussing work sites, sponsors, group projects. He even knew some of the goals of Katimavik. It was all very serious and sincere and about as much fun as chemistry class. That left the two girls from Québec. I took a deep breath and tried again.

"*Bonjour, coma say va?*" I said, using up my entire French vocabulary in one go.

"Allo," said the little one. With painful, practised English she recited: "My name, it is Marie-Claude. I yam from Ste-Foy. Ste-Foy, she is near to Québec City. 'Ow are you?"

"Oh, I don't know. Not bad. Could be worse," I said with a shrug, though I couldn't really imagine how. "And yourself?"

The girl's eyes became panicked. "I yam sorrie I don't speak the, the, the—"

"My name is Lysiane," said the other girl. "I too am from Ste-Foy. Marie-Claude and I—we are almost the neighbours." Lysiane had a flurry of artfully dishevelled reddish-brown hair and a scarf flipped around her neck with a certain flair. She suggested that the three of us go explore the property. "François, *aussi*," said tiny little Marie-Claude, and they called him over.

Behind the barn was an old pioneer house built with logs and dry caulking and topped with weathered shakes. A path led past it, deeper into the woods along a mountain stream. We followed the path to a small cabin, tucked in beneath pine boughs like a secret hide-out. It was deserted. A wind chime, tangled in on itself, was making faint unintentional music. The door was bolted with a padlock and the windows were fogged with dust. Lysiane, Marie-Claude, and François peered in, perfectly silhouetted as targets for any deranged trapper inside with a rifle. I stood to one side.

Beside the cabin we found a decomposing mattress lying half hidden in the snow. "Dibs!" I yelled, but this only elicited puzzled looks. "Dibs," I said. "It's what we say when we, well, never mind."

"Look!" François pointed to a path that ran directly up the side of the hill behind the cabin. "*Par ici!*" And off he strode, a man on a

mission. The escarpment was loose with scree, and François scrambled up with a sure-footedness that bordered on bravado. He was waiting at the top, scarcely out of breath, as the rest of us crawled up, panting and sweating. Lysiane caught her foot on a root and would have tumbled back down had she not also snagged herself on a branch at the same time. Her elegance and decorum were lost as she flailed about on the edge. Marie-Claude rushed out to rescue her and Lysiane almost dragged her down as well.

"I am clumsy," said Lysiane. François snickered. Marie-Claude laughed, and I—well, I said something stupid like "But you're very pretty."

"Um, thanks," she said, and I felt my face burning as we walked along the escarpment.

Beneath the canopy of evergreen branches, the snow hadn't melted but had merely glazed over. A broken-back fence trailed barbed wire in and out of the snow, and a clearing in the forest allowed a view. There was a church, our barn, the highway, a clutch of homes, and— beyond that—Lake Okanagan, like polished cobalt, framed by the mountains of the Interior.

We were walking down towards the barn when we discovered the Indian graves: cairns of rocks ringed by circles of stone. Spaced throughout the forest we found one, then another of these cairns, some caved inward, others still piled high. Farther along, we came across pictograms painted in ochre and vermilion—and we began speaking in whispers. (What we didn't know at the time was that these pictograms had been painted by the museum staff as part of a school hike.)

We came out of the forest right back where we had started. "*Allons au lac!*" said François, and he and the two girls headed towards the highway.

I stopped them. "What's up?"

"To the lake," said François. "We go."

"You want to come?" asked Lysiane.

"Sure, I just wish you'd speak English. I mean, we are in *British* Columbia." But they had already headed off, and my mutterings went unappreciated.

4

LAKE OKANAGAN FILLS a long narrow valley. The waves roll and break, roll and break, along the pebbled shores, and the mountains hem you in.

We walked out on a pier. Marie-Claude tried to skip stones but couldn't because of the waves. François expressed his disappointment that there wasn't more snow on the mountains. He soon got bored and left. Marie-Claude wandered off not much later, leaving Lysiane and me standing at the end of the pier.

So there I was, alone with a beautiful French girl, overlooking a lake in central B.C. with romantic waves lapping along the shore and an amorous wind ruffling our hair. All I had to do was come up with something witty and memorable.

"That's, um, some lake," I said.

She nodded. What more could she add? It certainly was a lake.

After a long, agonizing pause she turned and said, "You are from Alberta, correct? It is like this? Mountains and the lake?"

Needless to say, I found this to be a *fascinating* inquiry. "Yes!" I said. "Yes, parts of it are like this. I suppose they are. Not—not where I'm from. I'm from Red Deer, that's in the prairie. Sort of. Not really. Lots of farming, though. Wheat and barley and oats and, ah, grain. But it's not so flat as you think. A lot of people think it's flat, but it isn't. Mind you, I'm not actually from Red Deer. I mean, I went to high school there, but I grew up further north. Do you know Wood Buffalo National Park? No? Um, that's near where I grew up. Well, not really. But it's kind of on the same latitude but it's more to the left, well, west—" I knew I was babbling, but I couldn't stop. And to make matters worse, Lysiane was looking at me intently as I spoke, hanging on every single stupid word that was spilling out of my mouth.

Finally, in desperation, I lobbed the conversation back to her. "But how about Québec? Listen to me, I'm talking away about Alberta, but what about Québec? You have mountains and lakes and whatnot?"

She shrugged. "Yes and no. We have the mountain, but not so grand as like Colombie Britannique."

"Kolombee breetaneek?"

"British Columbia."

"Ah."

"Why did you come here?" she asked. "To Katimavik."

"I wanted to get out of chemistry class. And you?"

"I don't know. *Le défi*. The challenge." She swept back her hair and sighed a sad, poetic sigh. "I think it is a terrible thing to be young."

(The Québécois were always doing that to me, making maddening philosophical non sequiturs. I never did get used to it.)

"Terrible?" I said.

"And beautiful."

"Beautiful?"

"Yes, and now it is time for us to go." She walked down the pier, hugging her flowing overcoat to her body, her long scarf fluttering in the wind.

"Hang on," I called out.

"Yes?" She half-turned, her collar held high. She looked like a black-and-white still from an old movie.

"Don't walk too close to the edge," I said.

"Why?"

"Ogopogo."

"Ogopogo?" It was her turn to be puzzled.

"A monster. He lives in Lake Okanagan, kind of like Nessie but meaner. He has a habit of jumping out of the water and snatching people off piers. I read it in a brochure. They built a statue to him downtown. Kind of to appease him, I guess. You know, human sacrifices, that sort of thing. They have bumper stickers, buttons, T-shirts—everything."

"A monster?"

"That's right."

"I don't believe," she said, and with a fling of her scarf, she turned to walk away. Her exit would have been more dramatic if she hadn't tripped and almost fallen flat on her face.

"Sure," I yelled. "That's what the headlines will read when he gets you: *French Girl Dead. Last Words Were 'I Don't Believe in the Ogopogo.'* "

"*Tu est terrible*."

"Hey, you better watch out or I'll learn French and figure out what you're saying."

She laughed—almost literally, *ha*—and said, "It will never 'appen."

But she was only half right. I would eventually learn enough French to understand her, but never enough to make myself understood. Like most things in Katimavik, there was a huge gap between the ideal and the real.

5

TOFU IS NOT FOOD.

You can dress it up, but you can't take it anywhere. You can slice it, you can dice it, you can flambé it or hide it in a stew. You can even try—through the power of suggestion—to convince people that it is edible. But no matter how thin you cut it, it is still, unquestionably, irrevocably, unfortunately, tofu. So when Christian served up the Miracle-Food-That-Will-Feed-the-Masses for lunch, I was underwhelmed to say the least. It is the unfortunate fate of this watery, untextured bean curd to always taste like, well, untextured bean curd. Christian sautéed it with garlic and mushrooms and served it to us on rice, disguised as real food, but it was still—*tofu*.

"This," said Sarah, "is gross."

Sure, it was gross, but it was *organically* gross, not your run-of-the-mill, prepackaged, processed gross. No sir. This was healthy.

Sarah played with her food for a little bit and then asked, "Is there a McDonald's around here?"

"Katimavik has a strict nutritional policy," said Joyce. "No junk food. Now, try the tofu. It's very healthy."

"No way," said Sarah. "It looks disgusting."

François snorted. "We don't come to Katimavik to eat hamburgers." And then, under his breath, "You ate too many hamburgers already, I think."

"And what is that supposed to mean?" said Sarah, huffily.

"What do you think it means?" said François.

"You tell me," said Sarah.

"You are a clever girl, I think maybe you can figure it out by yourself."

And so on.

"People," said Joyce above the din and flying utensils. "I have some announcements." She stood up, cleared her throat, and said, "Bird cages. Volunteers?"

No one had a clue what she was talking about, so she elaborated. The Kelowna museum had a small menagerie of live tropical birds (peacocks, cockatoos, parrots, and the like). As our main sponsor, the museum wanted us to build enclosures for the birds sometime before spring. With our work projects not scheduled to begin for another week, Joyce had decided to have us build the enclosures today. She also decided to hold a general yard cleanup as well, because the melting snow was revealing embarrassing details—whiskey bottles, tanks of toxic waste, dead bodies, McDonald's wrappers, that sort of stuff. Of course, being Katimavik, it wasn't simply a yard cleanup, it was a Self-Motivating Exercise Activity Project. My assignment was hauling garbage to the dump.

And that's when I met Gerhardt. Gerhardt was German. He had a grey beard. He drove a huge, low-slung, American death-mobile. And he had a trailer. His wife, not coincidentally, worked part-time at the museum, which is how Gerhardt got roped into loading garbage on his day off. For all that, he was remarkably upbeat. As he and I flung garbage bag after garbage bag into his trailer, he ruminated on Katimavik. "Great idea," he said. "Young people. Working. Together. It is good." When the trailer was packed solid, we climbed into the car and Gerhardt popped his rust-afflicted Chevy into gear.

I do not know whether ESP exists, but I do know that, if it does, I don't have it. For if I had even the smallest psychic propensity, something would have twigged—some omen, some premonition, some sense of dread, a tingling of the Spidy-sense, *anything*. I was about to get into a car driven by Gerhardt Braun. I was about to put my life on the line, and—nothing. Not even a vague sense of apprehension.

Gerhardt drove like a madman. Worse, he drove like a *German* madman. He stomped his foot on the accelerator and fishtailed out of the driveway, and he didn't lift his foot again until we got to the dump.

Gerhardt drove up, up, up, to the crest of the mountain rim and then—for one awful, roller coaster moment—we were poised at the top, pointed straight down. I clutched the dash and we were gone,

screaming downhill like an eagle on fire, shimmying the entire way. Then up another hill and down again. The next slope was even steeper—at least ninety degrees—and Gerhardt battled for control all the way down. At the bottom was a sharp—and let me say that in italics for emphasis—a *sharp* corner. We took it on two wheels, careening like crooks in a getaway car. Except, of course, that getaway cars aren't normally weighed down with trailer boxes filled with old bedframes and garbage bags. Gerhardt successfully hit every pothole on the way. And each time, an instant later, the trailer would do the same, often bouncing right off the road.

A small noise came from the back of my throat.

"Relax," said Gerhardt.

I would have leaped from the passenger door if I could have gotten my fingers to let go of the dash.

"You know," Gerhardt yelled over the roar of the car and the pounding of my heart, "they don't have speed limits on the autobahn."

"You don't say," I squeaked.

There are no roads in British Columbia, just a series of corners joined together. From skid to swerve, we swung from one to another. The scenery that was blurring past on either side as we approached imminent warp drive might very well have been picturesque, but it was hard to say.

Gerhardt turned onto an access road that was washboard and loose gravel—creating a sort of dry-ground hydroplaning effect—and the garbage dump came up fast on the right. Gerhardt stomped on the brake pedal with the same vengeance he had applied earlier to the gas. We skidded to a long, sliding stop.

He tossed me a mismatched pair of work gloves, size gorilla, and said, "Well, here is how you earn your keep."

I wasn't at all carsick. No sir. And the fumes emanating from the masses of composting waste did not twist my stomach further into knots. Not in the least. And I certainly didn't want to crawl away and die.

"You look pale," said Gerhardt. "Are you all right?"

Town dumps, like Holiday Inns, are the same everywhere: big,

steaming mountains of fetid waste rotting into diseased pools of maggot-infested ickiness. (I'm talking about the dumps now, not Holiday Inns.) Fortunately, it was still cold out and most of the garbage wasn't thawed. Gulls were everywhere, squawking and shitting and pulling at plastic bags filled with disposable diapers.

Join Katimavik! See the nation!

A mound of green straw that some hero had tried to set fire to was smouldering, throwing out bucketfuls of foul smoke.

Experience Canada at its finest!

Gerhardt tossed me a plank and I ferried it along to the nearest heap. When the scrap wood had been unloaded, Gerhardt began swinging down garbage bags filled with plaster dust and ashes. One bag burst as I caught it and I ended up with a mouth full of dust. I choked and wheezed and coughed and suddenly it turned into this war dance, with me cursing and kicking the bag—which only produced more dust—as Gerhardt watched in stunned silence.

When I was done, he asked me again, "Are you all right?"

I looked up at him wildly from beneath my plaster-dusted hair. "I want out."

Gerhardt heaved a metal bedframe over the side and it clattered to the ground. "But we just started."

"Not the dump. *Katimavik*. Life. Canada. I don't know." I took a deep breath and felt the adrenalin subside. "It feels like I'm running in deep snow. It feels like—I don't know what it feels like."

"And getting angry, this will change everything?"

We unloaded the rest of the rubbish. A bottom gave out on one bag and I shoved the debris over with my foot. The rubber boots I was wearing were burning raw rings into my calves.

Gerhardt said, suddenly, "Katimavik is a good thing."

"I'm hauling garbage for a dollar a day, Gerhardt."

"So?"

"So, *I'm hauling garbage for a dollar a day.*"

"Just today. Who knows tomorrow?"

"Sure. Maybe I'll get to clean out some sewer lines."

"Exactly," said Gerhardt, missing the point. (I really have to work on my sarcasm, I thought.)

My eyes still stung from the plaster dust and I rubbed them with my knuckles. "One reason, Gerhardt. Give me one reason I should stay."

"One? Ha! I could give you a hundred."

I waited.

"Well," he said. "You will get to meet other fellow citizens."

"Like Sarah? Or Duncan?"

"Exactly!"

"There's only one problem. I can't stand Sarah *or* Duncan."

Gerhardt levelled his gaze at me and made one of the meanest comments I have ever heard. "And just what makes you think they are so wild about you?"

I flipped through my Filofax of stinging rebuttals, but all I could come up with was stuff like "So?" "Oh, yeah?" and "Who asked you anyway?" so I let it pass.

Gerhardt made a sweeping gesture towards our grand vista. "What do you see, right now?"

A fat gull was flying low, dragging a heavy diaper. It slipped away from him and tumbled down a pile of tin cans and broken glass.

"I see a garbage dump, Gerhardt."

"What? You don't see the mountains? Look at them. They are beautiful."

"They're far away," I said. "Now that pile of rubbish over there—"

"You can choose to look at the rubbish if you want. I choose to look at the mountains."

"The doughnut and the hole, right?"

"No, it is more than that. Have you ever read a man, his name is Kafka?"

"No."

"Well, don't bother. His point is that terrible, horrible, awful things happen to people for no reason whatsoever. You know, life is absurd and all of that."

It sounded reasonable.

"But you see, Kafka missed the point entirely, no? Bad, horrible, awful things do happen to people for no reason, but so do wonderful, good, pure things."

"And Katimavik?"

"I tell you this: any travel is better than no travel. Especially now when you are young. Canada is a big, wonderful country, and you have a chance to see it from the lawn-roots level."

I flicked an eggshell from my pant leg. "That's *grassroots*."

"Come. I will show you what I mean."

It was either be left behind at the dump, miles from the nearest town, or risk life and limb in Gerhardt's Chevy of the Apocalypse. Like a fool, I got back in the car. The trailer, now empty, bounced along behind us like a tin can tied to a wedding car, and Gerhardt was driving faster than ever. I was sure the speedometer needle had spun around at least once while I wasn't looking. And I usually was. We burst onto the highway and veered north, with Gerhardt weaving in and out of traffic wrecklessly [*sic*]. He was oblivious to my terror, and I was terrified by his obliviousness.

"The most important thing in life is patience," he said. He turned and looked me in the eye, which made me feel uncomfortable because it meant he wasn't looking at the road.

"When I came to Canada I had nothing," he said proudly.

"That's great, Gerhardt. Really." I swallowed. We were right on the rail guard, and in the valley below, the fir trees were so far away they looked like saplings.

"And now," said Baron von Richthofen, "I have my own house. A lovely wife. A very beautiful daughter—"

"I'd like to meet her someday." (Even at two thousand feet and facing certain death, my hormones were alive and kicking.)

"I have a good job. A sailboat."

And a death-mobile.

"And my car!" He slapped the seat and dust swirled up. Looking over at me, he nodded in a fatherly way.

Damnyoukeepyoureyesontheroad. "That's great, Gerhardt. Really."

"All this, and why? Because of patience. Patience and persistence. I started slowly. I spoke almost no English at all. In my first days, I learned one word." He held up a finger as a visual reference, which of course involved taking that hand from the steering wheel. "One word

a day! I enrol in school at night. I try very hard. And now, well, I am not doing so bad. In this country, anything is possible *if you have the patience!*"

And then it happened.

We came over a crest in the mountains and down to a valley half-hidden below. The road was now little more than a wagon trail as it wound its way through vineyards and apple orchards. Frost was everywhere. On the grass, the trees, the vines.

Gerhardt stopped the car and we walked out across an orchard. Below us, a mountain lake lay dimmed with vapour, like smoke pooled in a wine glass. Above us, clouds were rolling. Sunlight fell through as the sky opened up like an fan, striking highlights of gold on the water. Shafts of light. Mist and frost and apple orchards.

"My house," said Gerhardt, pointing to a building that overlooked the lake. It had that preoperative look of a place still under construction. Gerhardt opened the door and we went inside.

The house went on forever. We made our way from room to room, past stacks of lumber and plastic drapes and paint cans, as Gerhardt pointed to a future that only he could see. Here would be the dining room, here the kitchen, here the sunroom for breakfast, here the family room complete with bay windows and a panorama of the valley. It would be a house of fireplaces, plush rugs, and a private library.

"So when will everything be finished?"

"Three years," he said. "Maybe four."

"*Three years?* When did construction begin?"

Gerhardt counted it out in his head. "Eight years and five months ago."

"Eight years?"

"And five months."

"Who did you hire, Gerhardt? The Really Slow Unionized Construction Company?"

"Ah, but that is just it. I do not have anybody working for me. I design and build this house by myself. Of course, I hired some people to help me with putting in the foundation. But everything else I do on my own. The blueprints. The plumbing. The wiring. Everything.

And when I am done, no mortgage and at half the price. But more important, it is by *me* for my family."

"You've been doing this for eight years."

"Longer. I began to buy the land piece by piece after I was coming to Canada. Maybe twenty years ago."

"Where did you find the time?"

"Oh, on the weekends. In the evening. A few holidays. It is amazing how much time we waste, sleeping in, watching television, getting in arguments."

"You built a house in your spare time?"

"Patience," he said. "Patience and persistence."

6

GERHARDT FOLLOWED LAKESHORE DRIVE back to the barn. I could tell he missed the autobahn. At one point he pulled out to pass a sports car, but—faced with the oncoming grill of a Mack truck—he was obliged to return to his side of the road.

"Watch this," said Gerhardt.

As soon as the truck went by, Gerhardt pulled his workhorse out alongside the sports car. The other driver checked his speedometer and then gaped at us. He let us pass.

"You see?" said the Baron. "He is surprised we can pass him. Why? Because my car looks a little bit beat-up, ya?"

"You could say that." If Gerhardt's Chevy was a tenement house it would have been boarded up and condemned.

"But I tell you something. It only *looks* to be in bad condition. Under the hood she is a beauty. With everything—people, places, everything—it is inside that counts. Always look under the hood." He laughed. "And now I am ending my theology lesson. Now you know everything it has been taking me fifty-seven years to learn."

"Patience. Persistence. Check the carburetor. Keep your focus on the mountains, not the garbage. Never take your foot off the accelerator. Is that it?"

"It is so simple, don't you think? But sometimes it is the simplest

things that we have most trouble to learn. We have to keep learning them over and over and over again. Why is that?" And then, to the car that was dawdling along ahead of us: "Come on, move it! We don't have all day!"

Gerhardt dropped me off back at the barn. Everything was just how I'd left it, but everything had changed. Instead of a cul-de-sac, Kati-mavik seemed like a road out of a valley. Instead of a trap, an opportunity. Instead of a—

"William?" It was our intrepid Group Leader.

"Yes?"

"I hate to interrupt your daydreams but there *is* work to be done. We're having a little problem with the toilets."

I could see it coming. Wait for it. Wait for it.

"The plumbing backed up, and I need someone to clean out the sewer line. This wire thing is called a snake. You crank it through the pipes. Have fun."

Katimavik! Le défi! See the nation at the lawn-roots level! (If not lower.)

I went to work, mucking about with a balding mop before twisting the wire through the pipes to clean out whatever (ick) was clogging the drain. I rechanged my mind, decided Gerhardt was squirrelly, and vowed to quit, go home, and get a real job. Gradually, however, I calmed down, re-rechanged my mind, and decided to stay. The toilet gurgled and this foul stench bubbled up and punched me in the stomach. I retched and cranked the snake some more. I decided to leave Katimavik.

As it turned out, I decided to stay more times than I decided to quit, and I never did hand in my resignation.

That night, Lysiane and I stood on the shore of Lake Okanagan and watched the sun set.

"Youth," I said, "is a terrible thing. And yet, it is beautiful."

She looked at me and frowned. "How do you mean?

"Well," I said, "youth—that is, being young—is beautiful but at the same time, well, it's kind of terrible."

"That does not make any sense."

"Well—"

"How something can be both terrible and beautiful?"

"But, but you said—"

She held a finger to my lips. "Let's go back, okay?"

Lysiane gave me a kiss on the cheek and, being an English Canadian, I took this as something akin to foreplay and made an awkward attempt at an embrace. She slid away, flashed me a smile, and said, "Relax, *mon cowboy*."

She left me standing there, alone, with every gland in my body pounding.

7

JANUARY 21

Somewhere in the Heart of British Columbia

Dear Assorted Siblings and Various Other Members of the Clan Fergus:

This is a letter to let you know that #4 son is still alive and with us, and doing well in the wilds of British Columbia. I have even learned what "Katimavik" stands for: it is an Inuit word meaning "confused teenagers living in close proximity and bad personal hygiene." Those Inuit, they have a word for everything.

Not that everyone is still in their teens. Many are wizened old silverbacks in their twenties. Our group leader, Joyce, is practically a fossil. The other members of the chain gang are:

Sarah: From Vancouver, a twenty-one-year-old with the IQ of a twelve-year-old.

Marie-Claude: conversely, a nineteen-year-old from Québec who *looks* like a twelve-year-old. The Energizer Bunny of the group.

François: Nineteen, from Montréal. Works hard.

Duncan: Nineteen as well, from Somewhere in Newfoundland. Affable, rotund, the Energizer Turtle of the group.

Lysiane: From Ste-Foy, Québec. Twenty, Nordic-looking, strong, beautiful blue eyes.

We live in a barn. True, the land around it is scenic—an old pioneer home, an abandoned cabin, a church, a mountain stream, and Indian graves—but we are still living in a barn. And what are we doing to earn

the dollar a day our government is so generously providing us with? We have three work sponsors in Kelowna.

1. The Benvolin Church Restoration Project

A landmark in the area, this old kirk needs a new steeple, refurnished woodwork, and hand-carved pews. We will be doing none of that. We get to peel wallpaper from the inside of the church, all day, every day. Or rather, François is peeling wallpaper. This is his work placement.

2. The Kelowna French Cultural Association

This is a new organization catering to the surprisingly large francophone community in the Okanagan. They need help with sorting and arranging a French library. Duncan and Lysiane work here, 9:00 A.M. to 4:00 P.M., Monday to Friday, just like in the real world, and they never carry anything heavier than a really heavy book, let alone a chain saw.

3. The Kelowna Centennial Museum

The museum is our main sponsor. Our barn is museum property and our landlady, Mrs. Romolliwa, is also the museum director. Marie-Claude and Yours Truly will be working here on a number of projects: research, restoration, etc. And at the end of March and the beginning of April, we will be helping out with Pioneer Days, which involves riding herd on groups of elementary students who will come to our barn and "experience the hardships and joys of pioneer life first-hand."

Sarah, meanwhile, is on Cooking Detail. When Sarah finishes her week as homemaker, Lysiane will take her place. And then François. Which means they will eventually get to me. So you can see the flaw in the system. I only make two dishes: Kraft Dinner and Kraft Dinner Supreme (i.e., Kraft Dinner with hot dogs cut into it).

There's more. We only work five days a week, and the government, wanting to get the most out of its seven dollars, requires us to spend our weekends and evenings in Educational Group-Orientated Activities. There are seven categories:

1. Second-Language Learning
2. Active Leisure and Recreation
3. Nutrition and Well-Being

4. Environmental Awareness and Alternative Technology
5. Group Dynamics and Communications
6. (Wake up! I'm not finished.) Work Skills Development
7. International Awareness and Current Events

Don't these topics sound positively heart-stopping? Don't you wish you could take part in them as well? Can't you just tell that Katimavik is a government-sponsored program? Don't you just want to puke?

Joyce decided to concentrate on the first three categories during our Kelowna rotation and leave the others for our next group leaders to worry about. (After Kelowna we will go to Ontario and then Québec.) Joyce has divided us into "committees" to organize workshops on the topics mentioned above. Can you guess which committee I'm on? Can you? You will never guess in a million years. A billion, maybe, but never in a mere million. I am the Chairman of the Second-Language Committee. There is only one other person on my committee: Duncan. So I am the chairman and he is the vice-chairman.

Still not confused? There's more.

Billeting. Once each rotation, Katimavik participants are dispersed and sent to live, and sometimes work, with local families for two weeks. This is to create Direct Involvement with Community Lifestyles (whatever that means).

But wait, that's still not all! Let's not forget the *Code of Conduct.* They run us ragged with cooking, cleaning, work projects, committees, meetings, and billeting. And when we do find some free time, they expect us to follow a code of conduct that no teenager in the real world would be expected to follow. The code, which hangs over us like a dark, oppressive cloud, excludes such harmless and carefree activities as possession of firearms and illegal drugs, abuse of alcohol, wanton sexuality, and hitchhiking.

This Code of Conduct applies to Katimavik participants night and day, during the entire nine months, except during . . . *the Free Weekend.* Three days, once a rotation, you become a free citizen. Kind of like parole, or rather, "time off for bad behaviour."

And there you have it. This year alone, there are more than 5,000 participants in various groups scattered across Canada, all as confused as I am. (I thought all I had to do was show up, wear a lumber jacket,

and try not to cut off any vital limbs or organs while wielding my mighty chain saw.)

During our first week of (dis)orientation, we were each presented with massive Katimavik manuals outlining thousands of other arcane operating principles and goals. These manuals are about the size of a city telephone directory—and just about as much fun to read. Other than François, most of us haven't even *opened* our manuals, let alone *read* them. They do, however, make excellent ballast.

Yours truly, sincerely, and in addled agitation,
Will

8

THE KEROSENE NEVER ARRIVED.

After shivering through several nights of frost and chills, the three male parts (namely Duncan, François, and myself) began sleeping in the living room. The female parts stayed cosy in their hammocks huddled around the extra electric heaters that Joyce had managed to scrounge up. The boys were left to their own devices.

The first night, François built a fire in the wood stove and we unrolled our sleeping bags on varying levels of floor. The smell of wood smoke filled the room as I drifted off to sleep.

It would have been a good night, really, if only Duncan hadn't started singing. Well, it wasn't actually a *song*. It was more of a sea chantey:

The first marines
They ate the beans,
Parrrlay-voo!
The second marines
They ate the beans,
Parrrlay-voo!

I sat up and stared across at him in disbelief.

The third marines
They ate the beans,
And shit all over the submarines,
Inky-dinky parrley-voooo!

He dragged that final "voo" out over several beats: his grand finale.

"Duncan?"

"Yes, Will?"

"What are you doing?"

"Singin'."

There once was a lovely maid
Who said she wasn't afraid,
To lie on her back
In a tumbledown shack
And—

"Duncan?"

"Yes, Will?"

"*Why* are you singing?"

"Oh, it's just that with the fire and the knapsacks and all, it reminded me of Junior Forest Rangers. We used to sing these. They're great."

"You were in the Junior Forest Rangers." It was a statement, not a question.

"I made Third Rank Woodchuck."

"Of course."

Duncan went on to sing the other three hundred verses of "The Fearless Maid" until François got up and threatened to kick him in the head, which greatly reduced his enthusiasm.

"You two are just a pair of sourpusses," said Duncan, drawing an unfair comparison between me and François. For one thing, François had a keen work ethic.

9

OUR WORK ROUTINE was well established within a few weeks. Joyce discovered that being a Katimavik group leader often amounted to little more than being a referee and chauffeur, and the rest of us realized we were in for a long haul. François had it the hardest. Imagine peeling wallpaper five days a week. Still, he accepted the challenge in what we now realized was typical François fashion.

"No half measures," as my grandmother used to say. Every morning Joyce dropped him off at the Benvolin Church, where he climbed a wobbly scaffold to vertigo heights and—hoisting a long pole with a blade on the end—began methodically scraping off patches of paper from the uppermost ceiling arch. Flecks of it drifted down like lazy confetti. On a good day he could clear maybe four square metres, and all the while with his arms up above his head. He often staggered in at the end of the day in paroxysms of muscle pain.

"I peel wallpaper in my sleep," he told us.

By contrast, Duncan and Lysiane's stint at the French library was sedentary. It didn't sound any more stimulating, however. They spent their days sorting, stacking, and cataloguing books, which ranks right up there with peeling wallpaper for excitement. But at least they worked as a team, right? I mean, François was all alone, but they had each other to talk to, right? So it wasn't all that bad, *right?*

"Wrong," Lysiane informed me.

We were standing on the pier, our nightly ritual, and Lysiane was going on at length about Duncan.

"Talk, talk, talk. He never stops. He just do the speaking all the time. Always talk. Never stop. All the time about Person Pond. I am tired about Newfoundland. *Tired.* He tell me everything possible to know about the fishing technique. *Everything. Tout!* I am sure I can make the career out of catch the fish after Katimavik is over. *I-yi!* He never stops."

"Cheer up, Lysiane. Parson's Pond is only so big. I'm sure he'll eventually run out of things to talk about."

"He did! On the first day he ran out of stories. He just repeat many times the same ones."

And on it went. Lysiane never tired of telling me about how repetitive Duncan was.

After hearing testimonies like this from Lysiane, and having witnessed François's arthritic posture, I couldn't help but feel the slightest twinge of guilt over the hand I had been dealt: work at the museum with Marie-Claude, the Mighty Mouse of the group.

On our first day of work, Joyce dropped Marie-Claude and me off

at the museum's front door, where we were welcomed aboard by Jimmy, our elderly, stoop-shouldered supervisor. He was a barrel of laughs right from the start.

"You're late."

"We had to drop the others off first." I looked at my watch. "We're only five minutes late."

"Late is late."

How could I beat such airtight logic? "Sorry," I said. "It won't happen again."

"You're damn right it won't."

After further introductions and such pleasantries as "Katimavik, that's kind of like welfare, ain't it?" Jimmy put us to work inside on the museum's Pioneer Walk, which was part of the Pioneer Display of their Pioneer Village. (They were very big on the pioneer concept.)

The Pioneer Walk was a street with a boardwalk and re-created stores—a blacksmith shop, a barber, a hotel, a "Gen. Store"—all steeped in the past tense. The first task Marie-Claude and I were given was converting a clothing store into a hardware shop. We had taken down the flowery wallpaper and removed the boutique furniture when Myles, the Bird Man of Kelowna, arrived on the scene.

Myles had studied taxidermy, but his role at the museum had either evolved, or drifted, into that of all-round expert. From repairing stuffed animals to researching Native rituals, Myles was a man who loved his work.

"I love my work," he said, confirming my suspicions. In spite of this, he was a likable chap. It was a relief to find someone who appreciated us and Katimavik in general.

"I really appreciate you," he'd say. "And Katimavik in general."

Myles was also the man responsible for the museum's collection of exotic birds.

"Planning on stuffing them?" I asked, the possibility of Kentucky Fried Peacock naturally suggesting itself.

"No, no, no. We'll use them for educational purposes. And *then* we'll stuff 'em."

Once we had finished our reconstruction, Myles sent us out with

Jimmy to pick up an artifact—a *pioneer* artifact—at a local farm. When we arrived, we found the artifact covered in authentic, pioneer-style mud and manure.

"So what is it?" said Jimmy, coming right to the point.

"Artifact," said the farmer as he chewed thoughtfully on a piece of straw.

Jimmy flicked some tobacco from his tongue—he smoked roll-your-owns—and considered the relic for a moment. I think he suspected that the farmer was using the museum as a convenient junk remover.

"It's a donation," said the farmer. "No charge, just so long as you take it away."

This only deepened Jimmy's suspicions. "Artifack, you say?"

"Absolutely."

Jimmy's eyes narrowed, but there was little he could do short of calling the man's bluff. "Hey, you!" he motioned to me with his chin. "Load this artifack onto the pickup. The kid can help you."

Marie-Claude and I struggled with the mud-heavy, rust-dirty piece of machinery for nearly half an hour. Jimmy and the farmer leaned back and watched. Now and again Jimmy would spit, or the farmer would select a fresh piece of straw, but for the most part they just watched.

The farmer looked up at the sky. "Gonna rain," he said.

"It's January," said Jimmy.

"Gonna snow," said the farmer, correcting himself.

Meanwhile, sweating and frustrated, and with shins well scraped and patience sorely tried, Marie-Claude and I managed to wedge the monstrosity into the pickup. And Jimmy said: "Took you long enough." I seethed the entire way back.

At the museum's loading dock Myles came out to help us unload, and his first reaction was one of puzzlement. "So," he said. "What is it?"

"Artifack," said Jimmy.

Myles knocked off some of the caked sediment from the front. "Even diamonds can be found in mud," he said. (Myles had a knack for aphorisms). "And I do believe this is an old horse-drawn weed-puller. From the looks of it, I'd say around 1920."

"Nineteen-twenty," said Jimmy. "That ain't old."

Marie-Claude and I were put to work removing the bigger chunks of mud. After that, we scraped the weed-puller with metal brushes and steel wool and then hosed it down. We then applied rust-removing Naval Jelly, and once that was washed off, we added a coat of paint. Jimmy supervised.

By the time we got the second coat of paint on, the transformation was complete; the apparatus could have just rolled off an assembly line. It took us the rest of the day, and we congratulated ourselves heartily.

"Our plow!" said Marie-Claude, and she insisted we take a photo of it. We were still glowing when Myles returned to check on our progress.

"Our plow!" I said.

"It's no good," said Myles.

"What?"

"Too new. Sorry. You'll have to scrape off some of that paint with steel wool and let it age. You might even try rubbing some mud on it. First rule of restoration: don't do *too* good a job."

"Once more?" asked Marie-Claude sadly.

I nodded. "Once more."

"Hey," said Myles with a smile. "If at first you don't succeed, try a new strategy."

What I didn't realize just then was that I was about to experience the pioneer lifestyle at much closer range.

10

"GOOD NEWS," SAID JOYCE. "The kerosene still hasn't arrived."

She was talking to Duncan, François, and me, and by now we had learned to be wary. "How is that good news?" we asked. The boys were still without proper sleeping quarters.

"Well," she said—and then, with a deep breath, she plunged headfirst into Joyce Logic, swimming to depths we could not follow. "No kerosene means you can't sleep in your bedrooms. Which means

you have to find another place. One with heat. You can't continue sleeping in the living room. So—good news—I have found you your very own spot!"

There was a long, dubious pause on our part. "Where?"

"Think of it as an adventure," said Joyce.

"No. You don't mean—you can't mean—"

"That's right," said Joyce. "The pioneer house out back. It has two lovely wood-burning stoves."

"And clay caulking," I said.

"Just think," said Joyce. "You boys will be sleeping in a genuine historical site."

François gathered his belongings as Duncan and I walked over to scan our new abode. The door opened with a Dracula's castle–type creak, and we all but expected to see bats fly out. This was a house built by our ancestors, who were a great deal more stalwart than we. And remember, they lived in these places because they had no choice. Had someone offered them a condominium with a hot tub and central heating, they would have leaped at the chance.

The Pioneer House was not a masterpiece as far as architecture went. The logs were hand-hewn in a rustic fashion, which is to say, haphazardly. The entire place looked as if it had been drawn by a six-year-old, right down to the skewed laws of perspective that children operate under. You know, like when you can see both the front *and* the back ends of the house at the same time.

The interior was lined with dusty antiques and, sure enough, was heated by two antique stoves. (Our ancestors just loved antiques, you ever notice that?) In one corner was a large lumpy bed, complete with sheets and pillows supplied by Mrs. Romolliwa. Above it was a goat's head—not a mountain goat, just a plain old farm goat—that leered down at us with misaligned glass eyes. A shaggy fur rug, mangy and grey with dust, was laid out in the centre of the room. At least, I consoled myself, it wasn't a dirt floor.

"I'll take the bed!" said Duncan

"Not so fast," said I. "We'll flip a coin."

"Sorry, my friend. It's first come, first served."

"Now just a second—"

The door swung open and Joyce stepped in, a foam mattress under each arm and a lantern in one hand. "Ah," she said. "I see you've found the old bed."

I frowned. "When you say 'old,' Joyce, do you mean 'second-hand-but-still-in-generally-good-condition old'? Or do you mean '*pioneer* old'?"

"Pioneer old," said Joyce. "An authentic horsehair mattress. It must be sixty, maybe seventy years old."

"Horsehair?" said Duncan.

"*Authentic* horsehair," I reminded him. "And she's all yours."

Duncan was suddenly very gracious about the whole thing. "I've reconsidered. *You* can have the bed. I'll take one of the foamies."

"I couldn't, Duncan. Really. That would go against the entire principle of 'first come, first served.'"

Just then, François entered, cursing the cold and carrying his sleeping bag and backpack. He was baffled as to why Duncan and I had so generously reserved the bed for him, but he crawled in anyway.

That night, the three of us got into a fire-making frenzy and built roaring infernos in both of the potbellied stoves. It wasn't until their sides were blushing orange and their bottoms actually began to sag that we stopped. Sparks were flying out from between the pipe joints and the stoves were sucking in air like wild beasts. The Pioneer House had become a sweat lodge.

"I think maybe that's enough," François conceded.

Until the feverish heat subsided, we had to sleep on top of our sleeping bags. Through the cracks in the roof we could see stars, and the cabin walls glowed and flickered in the firelight. Shadows rippled across the room. A wood knot popped in the flames, and the smell of smoke permeated everything—our hair, our clothes, our pillows. Amid all this, I drifted into cosy slumber, thankful, in my last drowsy moments of consciousness, that Duncan wasn't singing . . .

It snowed during the night.

When I woke up, the fires had died and there was frost on my sleeping bag and snow in my hair. C-c-c-c-cold, to coin a phrase. There was a pocket of warmth that followed the contours of my body exactly, but if I moved even an inch I was touching ice.

"Hey, Duncan," I called over.

"Yeah?" he said, groggily.

"Be a pal and make us a fire."

There was a pause while Duncan thought this over. You could practically hear the gears and cogs slowly grinding away. "Why me?"

"Because you, my friend, are the closest." This wasn't entirely true. In fact, I was the closest, but I was hoping Duncan wouldn't see through my clever ruse.

"Nice try, Willy m'boy," he replied. "But my calculations put *you* nearer the stove."

"Really?"

"Really."

"Have a heart, Duncan. The floor's cold."

"That's a fact. And the sooner you make the fire, the sooner we'll be getting some warmth in here."

At which François kicked off his covers and angrily said, "*I* do it, okay? You are happy now?"

He began stuffing kindling and split wood into one of the stoves, and was soon stoking a flame.

I leaned up in my bed. "You're a swell guy, François." But he just muttered something to himself in French. He soon had a grand fire going.

We lay there awhile, basking in the warmth. Duncan stretched and sat up.

"François?"

"*Oui*, Duncan?"

"How'd you sleep last night?"

"Fine," he said, then scratched his back. "But I have a bad itch."

Duncan leaned over to me and whispered, "That's funny. You wouldn't think horse fleas could live eighty years."

11

THE WORST THING about Katimavik? The very worst thing? It wasn't the drudgery or the granola or the primitive living conditions. No, the worst thing was the sincerity. The *officially sanctioned* sincerity. The type that is dreamed up in committees. The type that is handed down from above. I'm talking, of course, about the designated committees: Active Leisure, Nutrition, and Second-Language Learning.

Committee work involved both sincerity and government-funded activities. We contacted resource people, planned film presentations, scoured the local library, and estimated expenses according to the official budget guidelines, which were as follows: sweet bugger all.

François and Lysiane had it the easiest; it's almost impossible to go wrong with something like "active leisure." They usually got the whole weekend to play with as well, and were always announcing fun stuff like mountain hikes and trips to the pool.

The Nutrition and Well-Being Committee (that is, Sarah and Marie-Claude) had a tougher time of it. Nutrition may be important and it may be meaningful, but it's difficult to pass off as fun. We tried calisthenics, but Sarah got all out of breath and quit halfway, saying, "This is too hard." She then went to her room and ate potato chips. They later gave a presentation on "The Importance of Fibre in Your Diet," which was memorable only because Sarah recommended french fries as a source of said fibre. (Sarah also insisted that french fries belonged among the Four Food Groups as one of the recommended vegetables. "French fries?" we said. "Are you sure?" To which she angrily replied, "Potatoes grow in the ground, right? So they count as vegetables.")

Nutrition was a big deal in Katimavik. We were expected to be as rugged and self-sufficient as possible, and to that end we mixed our own granola, we blended our own mayonnaise—we did everything short of churn our own butter. We even bred yogurt in captivity, and—naturally—we made our own bread. When Joyce explained this to us, I was taken aback.

"People don't still make bread, do they?"

"Yes, Will," Joyce sighed. "People still make bread."

"No kidding. I thought it was a dead art, like Latin."

Bread-making proved deceptively simple: you just throw some warm water, brown sugar, dry yeast, salt, and whole-wheat flour into a bowl; punch it up; let it rise; punch it up; then toss it in the oven. Like I said, deceptively simple. For the first month, we ate rubber. For the second month, we ate soggy dough wrapped in burned essence of crust. It wasn't until well into our third month that we had something resembling what they sell in stores.

Once we had mastered the basics of bread-making, however, we quickly moved on to more extravagant variations. We made sourdough bread, braided bread, banana bread, corn bread, raisin bread, French bread, and even—when we were feeling particularly daring—regular white bread. We ate a lot of dead weight along the way, and I swear some of our earlier attempts are still sitting in a lump in my stomach, undigested.

We made peanut butter to go with our bread by crushing up a bunch of peanuts until they had the texture and taste of a bunch of crushed-up peanuts. We also made a gooey syrup vaguely reminiscent of strawberry jam, so you see the kind of quality sandwiches we were getting in our lunch bags every day.

The evenings spent learning these nutritional techniques were excruciatingly boring. Forget the water-drop torture; if the Khmer Rouge wants to break down a society's free will, all they need do is send in Sarah and Marie-Claude for a Nutrition and Well-Being seminar. (Personally, I would recommend that the Khmer Rouge ask for the workshop on making "real homemade country-fresh style apple juice." This involves spending four hours—I repeat, *four* hours—boiling down a bushel of apples to make one single, solitary glass of apple-flavoured water. With seeds.)

But if the Nutrition and Well-Being workshops were the epitome of boredom, a new word has to be invented for Second-Language Learning. I had the thankless task of running this committee all by myself. That is, I worked with Duncan.

The French/English workshops I attempted to organize were so bad. *How bad were they?* They were embarrassingly bad. The notion

of someone as English as I trying to learn French is ridiculous enough, but expecting me to *teach* it is pure lunacy. We sang songs, we congratulated verbs and declined invitations, we learned body parts, and we memorized phrases: OPEN THE DOOR. CLOSE THE DOOR. PAINT THE DOOR. KICK THE DOOR. BLOW UP THE DOOR WITH EXPLOSIVES. As well, we yawned a lot and looked at our watches. We never did learn a damn word of French. It took me a long time to realize that the mistake was in trying to learn a second language through organized lessons, when in actuality a person will master more French in an afternoon of "artifack restoration" with Marie-Claude than in a month of Second-Language workshops. The francophones, meanwhile, were organizing their own classes in English.

In the middle of all this state-sponsored boredom, Joyce announced that she had more good news. We braced ourselves for it. Sure enough, the male parts were once again being evicted. The Pioneer House had been deemed a fire hazard (in our enthusiasm with the wood stoves, we had set the rug a-smouldering) and Joyce was moving us to—

"The abandoned cabin? Are you crazy?"

"It's not that bad," said Joyce. "Mrs. Romolliwa was renting it out just last summer. And it's in much better condition than the pioneer house."

"There's an Indian pit house out back that's in better shape than the pioneer house," I said. "But it doesn't follow that we should move in there. Sorry! There I go, being linear and logical again."

Joyce slapped a key on the table. "This is for the front door. You boys can move in tomorrow. Meeting adjourned." The girls made taunting faces.

"One moment, please." It was François. Everyone stopped. "In Katimavik the girls are at the same level as the boys, *c'est correct?* The girls cut trees, and the boys share in the cooking. *C'est bon.* So, why should the girls be getting the special privilege? Three boys. Three girls. We should toss the coin for the cabin."

Duncan and I adamantly agreed.

The ensuing battle over sleeping quarters was more of a shouting match than it was an Information Session, and when the smoke

cleared, the boys had lost. It had been a valiant effort, but we were outgunned. Sarah refused to take down her posters, and Lysiane and Marie-Claude stubbornly insisted that they were well settled (and warm) in their corner of the barn and would not even consider changing. Besides which, the boys lost the coin toss.

So it was, amid the jeers of the girls, that François, Duncan, and I trudged out to our new and final home, dragging our clothes and bedding behind us like Bedouins in retreat. We followed the stream into the woods, and as the cabin slipped into sight, our spirits sank even lower. François unlocked the door and pushed it open. The escaping smell knocked us back three feet—"*I-yi!*"—and we entered our new home holding our noses.

It was awful. Worse than a hotel after a Shriners convention. It was dim and dark and dank. Crates of rotting peaches were everywhere. Mice pellets were on the kitchen counter. Cobwebs were draped like dust covers. A couch with the obligatory spring sticking out was covered with piles of soggy magazines, the pages of which were mushed together. The place was fairly large, mind you, with a separate kitchen and a living room, and another room leading off from this.

We opened both doors to air the cabin out, and we tossed the rotting fruit onto the back porch. And, being guys, that was pretty much it as far as our cleanup went. While rummaging around in the refrigerator, Duncan came upon several well-chilled bottles of pear cider and we voted unanimously to take a break. François found a bottle opener in one of the kitchen drawers and we raised a toast.

"Gentlemen," I said. "To Katimavik. *Le défi!*"

Then, simultaneously, it hit us; the cider was *chilled*. Therefore, the fridge was running. Therefore—

"Electricity!"

Within minutes we had found the thermostat and cranked it up to maximum. We flipped on every light in the place, and we doused our coal-oil lamps—*forever*.

"The girls," said Duncan. "In the barn. In hammocks. With heaters."

"*Little* heaters."

We broke into boisterous laughter and the pear cider tasted fine, fine, fine.

It got even better. The couch folded out into a bed. Another mattress was discovered beneath a pile of old newspapers. And when we searched the rest of the cabin, we found—

"A bathtub! And a shower!" yelled François. "And a toilet! And"—*flush*—"it works!" No more standing in line for endurance-test showers, no more backed-up sewer lines, no more, no more, no more.

"We can't be letting the girls find out about this," said Duncan.

He was right. If the girls were ever to discover that we had proper plumbing, heat, and beds . . .

"Spiders."

"And bugs, everywhere." I laughed.

François joined in. "And at night we hear the wolf calling. It is terrible, this cabin. Please, girls, please change the place with us. Please. Very much please."

We laughed a mighty cabalistic laugh, and the pact was sealed. For the next two months we would keep our luxuries a closely guarded secret. We always made sure to lock up when we went out, and we never breathed a word about the showers or the electricity.

As night fell, we unpacked and prepared for bed. Duncan disappeared into the next room, and a moment later he stuck his head out of the door just long enough to say, "This room is mine, okay?"

François and I exchanged looks, and I went to investigate.

"Nice bed, Duncan."

He looked up from where he was lying and quickly protested. "But there are other beds out there. I just like this room, that's all."

"Don't worry. I don't want your bed. I've got the couch. François has the mattress. What I want to know is, what are you hiding?"

"Nothing. Why?"

The nearer I drew, the more agitated he became. I leaned on his bed. It rippled. Puzzled, I pushed down on the mattress with both palms. Waves rolled away. What the—

"Duncan?"

"*Shhhh*," he hissed. "Just you and me, eh b'y? We don't need to tell François. We'll take turns. One night you, the next night me."

"It's a waterbed," I said, still struck by the incongruity of it all.

"And it's warm."

"Someone left the heater on. Probably all winter. Must have been Mrs. Romolliwa, afraid it would freeze. But no one need know about this except you and me. We need never tell François."

"Tell me what?" asked François, who was now standing in the doorway.

"Duncan has a waterbed," I said.

François and I dragged Duncan off the bed—he was in his underwear—pushed him outside, and wedged the door shut. We then stretched out and cracked open a couple more bottles of cider. Outside the bedroom window, snow was drifting slowly downward. Duncan was tapping on the glass.

"You've had your fun, now let me in. Come on now, I'm not foolin'. It's cold out here. It's snowing!"

Electric heating, a bathtub, a toilet, *and* a waterbed. It just doesn't get much better. In the end we did let Duncan back inside, just before he turned blue. And as for the girls, our stories grew: rats, bats, bugs, even—we suggested—noises at night that sounded not unlike those made by a Sasquatch.

12

THE PIONEER HOUSE, from whence we had been evicted, needed repairs. Wood shakes needed replacing, gaps between the logs cried out for fresh chinking, insulation along the eaves was sagging, and the whitewash inside was crumble-dry and falling off in scabs. So much so that the interior was dusted like a bakery shop with flour. It was just as well we were no longer sleeping in it.

The museum assigned Marie-Claude and me to the job of scraping the interior of the Pioneer House and then painting it with a less authentic, but more durable, white latex. The main advantage of working on the Pioneer House was that it was a mere thirty paces from the barn. So, as the other parts climbed into the van each morning for the long drive to their work sites, Marie-Claude and I sipped tea and waved good-bye from the front door. No one ever waved back.

Before the scraping and repainting began, Marie-Claude and I had to remove the contents of the house. These included the flea-infested

fur rug, which, we were told, was the hide of a Highland cow. Why they skinned and displayed a shaggy cow skin is beyond me. Even more puzzling was the goat's head. For the life of me I couldn't—and still can't—figure out why anyone would want to shoot a plain old everyday nonpredatory goat, let alone mount its head as a trophy. "He was a real man-eater. We tracked him for days, and when we finally cornered him, he turned on us. We lost two men."

Goats—and stop me if I'm wrong—are not prized among big-game hunters. Which means the fearless hunter who brought down our lit-tle friend was either an idiot or a poor shot. "*Oops!* Dang. There goes Jethro's prize goat. Well, what the heck, might as well decapitate it, remove the brains, replace the eyes, and hang it up on my wall." What is it with the hanging up of animal parts, anyway? Isn't there some-thing morbid about this? I mean, if I were to, say, hang up a plastic baggie full of deer intestines, you'd think I was sick. But I chop off its head and I'm a trophy hunter.

Marie-Claude, for one, didn't even want to look at the goat's head, let alone move it. "You take dat. Me, I don't like."

This was a dangerous admission, and after chasing her around the house with the head for several minutes, I asked her why.

"He probably won't bite," I said. "Heck, he's even kind of cute, in his own goatlike way." I nicknamed him Maurice. Sure, one of his glass eyes leered inward, and his chin trailed sawdust, but for the most part Maurice was one good-looking goat. A goat's goat.

Marie-Claude stomped her foot. "I don't like him! Take him away."

"So, you have an aversion to cross-eyed goats. Very Freudian."

Having tormented her long enough, I eventually did carry the goat head out of the cabin—and hid it in her hammock. (I am such a card.) This, of course, gave birth to the ol' "goat-head-in-the-hammock" routine, which I pulled on Marie-Claude at regular intervals over the next few days. She could scream louder than anyone I'd ever met.

She could also work very hard. She made two trips for every one of mine as we hauled the last of the furniture and "artifacts" from the Pioneer House. What couldn't be moved (like the wood stoves) and what we couldn't be bothered to move (like the horsehair bed) we draped with sheets of plastic in preparation for the latex paint.

Jimmy, meanwhile, had shown up and given us a rousing motivational speech.

"Try not to screw up," he said.

Thank you for your support.

"Jimmy, he are *de mauvaise humeur, non?*"

I nodded and taught Marie-Claude a new word: "coot."

We worked long hours, grinding away at the walls with metal brushes that somehow managed to scratch the hell out of the wood without actually removing any of the whitewash. It was quite remarkable. For days and days we scraped, and still the whitewash remained in the cracks and wood grain. Our shoulders throbbed and our arms threatened to drop off. It probably would have been easier just to *build* a new pioneer house from scratch. The white dust we kicked up, fine as talcum powder, turned our hair grey—a distinguished-looking grey, if I may say so—and rimmed our lips and nostrils with paste. We inhaled it no matter what kind of protective masks we wore; it was everywhere. Even my spit was white.

In between spitting and scraping, I taught Marie-Claude the polka and the two-step, and *tried* to demonstrate the butterfly, but for that you really need three people (it's a circle dance). I wanted to bring Mr. Goat Head in as our third, but Marie-Claude would have none of it. She in turn taught me the meaning of the words to the song "Alouette." Get this, it's about plucking a bird. I'd been singing that song since grade school and had never known just what I was singing. I'd always assumed it was about a football team.

Marie-Claude wanted to learn an English song. "A nice song." So I taught her one from my childhood.

Nobody loves me
Everybody hates me.
Think I'll go and eat some worms.
Yum, yum.

"It is not so *romantique*," said Marie-Claude.

"Are you kidding? Back in Alberta this is like the number one courting song."

"About the worm?"

"*Oui oui*, about the worm."

Short fat greasy ones,
Long thin slimy ones,
Fuzzy-wuzzy caterpillars.
First you bite the heads off,
Then you suck the juice out,
Then you throw the rest away,
Yum, yum.

She had a little trouble with "caterpillar" but she handled the "yum, yums" with a definite gusto.

"Now I know *la chanson romantique de l'Alberta!*"

At the time, the premier of British Columbia was a man named Bill Bennett. His father, W.A.C. Bennett, had also been premier, and the press of the day had taken to calling the younger Bennett "Mini-Wac." This inspired my own nickname for Marie-Claude: Mini-Mac. When I was feeling in a generous mood it became Big Mac, and sometimes even Mighty Mac, but over time I settled on simply Mac. It wasn't long before everyone started calling her Mac as well, and the name stuck. (If Marie-Claude is out there somewhere, a high-powered business executive no one takes seriously because she is called Mac, I would like to take this opportunity to apologize. I'm sorry, Mac.)

13

"HEY, YOU. DON'T YOU remember me telling you not to screw up?"

The inside of the Pioneer House had been scraped from top to bottom, and now Jimmy was inspecting our handiwork.

"Wheel," said Marie-Claude. (She never did learn how to pronounce my name.) "What are the matter?"

"I don't know, Mac. Perhaps Jimmy will be so kind as to tell us."

"You didn't go deep enough," he said. "You only took off the first

layer of white. You see this—that isn't wood, that's brown paint. It has to come off, too."

My arms immediately cringed with anticipated pain. "You mean . . . "

"Scrape her out again, and this time do a decent job of it."

"*Encore?*" said Mac.

"*Oui,*" I sighed. "*Encore.*"

As we watched Jimmy drive his wheezing pickup truck out of the yard, it dawned on me that I had never actually seen him do anything. The next time Myles came out to check on things, I asked him about it.

"The museum couldn't run without him," said Myles, his voice reverent.

"You're serious."

"I sure am. Mrs. Romolliwa is the museum director. Helga handles the financing, and I organize the exhibits, but without Jimmy, well—" He didn't even want to consider such an awful scenario.

"But what exactly does Jimmy *do*? What's his job description? Hell, what's his job *title*?"

Myles scratched his chin a bit. "Well," he said, "now that you mention it, I don't really know."

"But whatever it is," I said, "it's vital to the museum's operation."

"Exactly."

Who knows, maybe it was the way Jimmy drove his pickup truck around all day; maybe it was the way his sunshiny disposition brightened worker morale. I never did figure it out. He returned a week later and passed final judgement on Mac's and my work.

"Well, I suppose it's better than nothing."

Thanks, Jimmy. You should have been a cheerleader.

"If you're gonna paint these walls, I suppose you'll need some paint," said Jimmy. "There's brushes for you and the kid back at the museum. But first you gotta scrape the ceiling. Get the rest of that whitewash out of the way. You can do the ceiling," he said to me. "The kid's too short."

Mac exclaimed, "I yam not the child! *Tu es un vieil homme ignorant!*"

Jimmy smiled, the first smile yet recorded in our presence, and said in a heavy accent and a thick voice, "*Je ne suis pas si vieux.*"

Mac and I performed a manoeuvre known as the Simultaneous Balk, and Mac said, "You speak the French?"

"Sure," he said. "I grew up in St. Boniface. That's in Manitoba. Lotta Frenchmen out there. They say I've got some Metis in me. Maybe some of Louis Riel's blood. Who knows?"

"But your last name is Davis," I said.

"That's right. And my mother's name was Thériault." Then he grinned a crooked grin and said, "Kick over a rock and you never know what you'll find."

Now, I would like to report that our relationship with Jimmy was transformed after this and that he started telling us poignant tales from his youth and that he began bringing us hot chocolate in a gruff but endearing manner and that he shyly offered Mac a bouquet of flowers he had picked for her, but none of these things happened. However, you are free to imagine them as having happened if you wish. In fact, all that changed was that Mac had to watch what she said in French when Jimmy was around, and I downgraded his status from "coot" to "codger"—a lateral move, some might say. Worst of all, I even sort of started to kind of almost maybe like the old guy. Who knows, he might have been the long-lost heir of Louis Riel.

14

THE FOLLOWING DAY, Mac and I received some unexpected help. I use the word "help" loosely. It was Duncan. He had been temporarily reassigned to our work site. That is, he slept in and missed the van. When Joyce returned, she sent him out back to help Mac and me, though why we should be punished for his misdemeanour was not clear.

It didn't go very well.

First of all, Duncan couldn't help us scrape the walls because of his asthma. I had never heard of his asthma before, and I was never to hear of it again. He was, how shall I say, a selective hypochondriac.

That is, his ailments were calculated to obtain the maximum benefit per affliction.

As Mac and I laboured away, Duncan sat outside eating an apple from his lunch bag. It was ten o'clock in the morning. He was still there an hour and a half later when I stepped back outside. I knocked powder from my clothes and glared down at him. He smiled up at me.

"We're finished," I said. "And we are going to take a break."

"Good," said Duncan. "I could use one."

"Let me rephrase that. *Mac and I* are going to take a break. *You* are going to start vacuuming between the logs inside. It's a one-man job, and since you didn't do any of the scraping—"

"Asthma," he reminded me.

"Yes. Well. The vacuum shouldn't kick up any dust. Most of it has settled—on me."

Duncan thought for a moment. "But we don't have a vacuum cleaner."

"A week ago, Duncan. Joyce bought one a week ago."

"But there's no electricity out here."

"Use an extension cord, Duncan."

"But we got no—"

"*Find one!*"

Slowly, ever so slowly, Duncan got up and slowly walked in a slow manner to the barn, slowly. Time dragged by, glaciers crept down mountainsides, continents drifted, and eventually Duncan returned with neither an extension cord nor the vacuum cleaner. Mac and I were sitting on the steps of the Pioneer House. Duncan sat down beside us.

I waited a moment. "Duncan?"

He shook his head sadly. "Couldn't find no extension cord," he said with a sigh.

I snarled and stormed off to the barn, where I found several bright orange extension cords neatly wrapped on top of the tool box. They were in painfully plain sight.

"Well, I'll be," said Duncan. "I never thought to look there."

I ran the cord out and handed the vacuum cleaner to Duncan. Mac and I stayed outside to mix paint.

"I yam sure," said Mac, "that Duncan have the realization of another way to avoid having the work."

"How?"

"This, I don't know. But Duncan, he will find the way."

"Impossible. He tried and he failed. I'm too sharp for him."

And then, from inside the cabin, we heard Duncan holler in obvious pain. Too obvious. "Darn!" he said loudly. "That hurt."

I sighed and looked at Mac. She beamed back at me. "I *knew* he find the way! I have the faith in Duncan."

I, on the other hand, was not amused.

"What is it now?" I said as I entered the cabin.

"Oh," said Duncan as he turned around, rubbing his hand. "Sorry, did you hear that?"

"Of course I heard that. That was the whole point, wasn't it? So what's wrong?"

"Nothing. Never mind." He heaved a mighty, noble sigh. "I'll carry on."

You're really pushing it, Duncan. "What's up, Duncan?"

And he said—and I quote—"I got an electric shock from the vacuum cleaner."

"You got an electric shock from the vacuum cleaner."

"Yup."

I turned the machine on and held the handle for several minutes. "Duncan?"

"Yes, Will?"

"Do you see any electricity arcing into my hand?"

He examined the machine and my hand carefully. "Nope. I guess not."

I left him with the vacuum cleaner and (naturally) he had another severe electric shock a few minutes later.

"I guess I just attract electricity," he said. "Metabolism," he said. "Body chemistry," he said.

"You realize, Duncan, that this is utterly ridiculous."

Mac intervened and agreed to do the vacuuming instead. Duncan and I went outside to stir the paint.

"You're a special kind of guy, Duncan."

"Gee, thanks."

Needless to say, I made sure that Duncan was up on time and off to work the next morning, and Mac and I finished the job without any additional "help." We painted the interior with latex, rechinked the walls, and moved everything back in. That night, I crawled off to bed with the tired exhilaration that follows a long day of physical labour. Something furry was hidden in the mess. I pulled off the covers, yelled, and fell backwards onto the floor. Looking down at me, with one eye slightly skewed, was Mr. Goat Head. Maurice.

Pinned to my pillow was a note: "Sleep good!" And thus ended the ol' goat-head-in-the-hammock routine.

15

MAYBE IT WAS JUST the midwinter blahs, but near the end of February, most of the group slipped into an extended round of Surly. The battle lines, roughly drawn, were Lysiane vs. Duncan, Duncan vs. François, François vs. me, and me vs. Sarah. We took to snapping and snarking and generally being annoyed. These were the kind of alliances that led to World War I.

Marie-Claude, however, was the Switzerland of our group. She refused to lose her temper and stubbornly insisted on being cheerful, which only irritated the rest of us. The barn could have burned to the ground, and Mac would have found humour in it.

Once, while she and I were cleaning up the back yard, I very nearly *did* set the barn ablaze—not to mention the entire yard. Mac had watched, quietly stifling laughter, as I tried to light a bonfire. All day long I had tried, and all day long Mac had held back her laughter. I must have thrown a hundred matches onto that pile of wet planks and soggy cardboard.

"The wood, she don't get the fire so good," Mac pointed out.

I gave her a cold look. "This isn't funny."

"No, of course. The fire, she is very serious."

In frustration, I doused the wood scraps with kerosene (which had *finally* arrived) and systematically threw another forty matches on the pile. Nothing. Not even a tiny puff of smoke.

I grumbled "*Tabernac*" under my breath.

Mac raised an eyebrow. "How you learn that word?"

"François."

"It is a very bad word!"

"Yeah? Well, I'm in a very bad mood."

Gnashing my teeth, I tried gasoline on top of the kerosene. It was a volatile mix. It took only one match, then there was the sound of a gunshot and the woodpile exploded. For an instant I was standing in a world of heat.

"Wheel!"

Pieces of wood and cardboard fell back to earth; others were presumably launched into orbit. I dropped to my knees, my head reeling. My hair was singed. I could taste gasoline. There was an odour of sulphur and my ears were ringing.

"*Tu es bien?*"

My pulse was doing an extended improvised jazz bongo number, and the adrenalin was coursing through my veins. I pushed Mac away and stumbled off, drunk on fear and anger. For some distant reason, I felt like crying.

I staggered down to the stream and splashed ice water across my face and rinsed out my mouth. Leaning back, I closed my eyes and tried to reestablish equilibrium. I lay there for a long time.

"Wheel?" Marie-Claude had followed me, and she now hopped across stones to reach me. We sat in silence for a few minutes as I fed twigs into the stream.

"Wheel, why you are so angry all the time?"

"I don't know. Why are you so damn happy?"

"Because I *want* to be 'appy."

"It's not as simple as all that."

"Are you sure, my friend?"

No, I'm not. "Of course I am. If it was that simple, everybody would be happy, and then where would we be?"

"Well," she said with a half-smile, "it's sure we would have less fires in the world."

Marie-Claude and I sat beside the stream for the rest of the afternoon. Something shifted, something just below the surface—and then

it was gone. It was only years later and half a world away, while lost in the mirrored corridors of a failed attempt at Zen, that I realized what I had missed—the moment, an understanding of one's self that implodes deeper than words. It was an opportunity, and, like a balloon, once released it was gone forever.

16

FEBRUARY SLIPPED AWAY and March arrived on a warm mountain wind. Pierre Trudeau came out from his burrow, saw his shadow, and decided to resign. On a snowy night, Trudeau had gone for a walk, looking for some sign of his destiny in the sky. All he saw was snowflakes. The following day he announced his decision to step down as prime minister.

Lesser mortals such as myself had more mundane things to deal with. Mac and I were sent downtown to the Laurel Building, a sprawling warehouse not far from the museum. The Laurel had stood vacant for decades and had, over the course of time, become something of a communal storage bin, with thousands of forgotten items stuffed into its basement. With the Laurel slated to be renovated as the future home of the Fruit Growers' Museum, Katimavik was called in to sort through these relics. It was a dingy, dungeonlike place.

"Go down there," said Jimmy, "and separate the garbage from the artifacks."

And how will we know the difference?

"Generally speaking, the artifacks don't smell."

Armed with flashlights and dust masks, and led by the ever-intrepid Myles, we made our descent. The air was damp with the smell of wet earth and mould. The entire basement breathed mildew and menace. Myles found it refreshing. He found everything refreshing. Myles should have been a motivational speaker.

"This is wonderful," he said. "You never know what you will find in a place such as this."

"For example, rats," I said.

A few lightbulbs hung on frayed cords, like eyes from sockets, illuminating small pockets of gloom. As our pupils adjusted to the dark,

shapes slowly emerged. Around us in all directions lay wooden crates and boxes. To one side, a mound of lumber was piled up. Beside it was a stack of old ceramic toilets, and beside that a jumble of metal piping. Corroded machines were leaning drunkenly against each other for support, and everything from old pinball games to wash-basins was crammed in between. Over all of this lay a pall of grey dust, like a winding sheet.

"It's as though we're entering the tomb of an Egyptian pharaoh," whispered Myles.

The pharaohs had pinball?

We found crates filled with old letters, city records, moth-riddled clothing, newspapers condemning Kaiser Wilhelm, store signs, and—in one—a child's toy chest. The little girl who had once played with those hand-carved horses and cloth dolls was probably a grand-mother today. When I pointed this out to Marie-Claude, she got all misty-eyed.

"The life," she said.

"Yes," I said. "The life. It is terrible—and yet, beautiful."

She agreed, nodding through tears of joy and smiles of sadness.

Mac and I spent a week in the Laurel, and at week's end the base-ment was well ordered and no longer mysterious. We never did see a single rat. On Friday, when we came out of the Laurel for the last time, it was snowing—marvellous wafting storybook snowflakes. Kelowna was blanketed with the stuff. The snow continued through the night, and the following morning we woke up to find the barn deep in splendour.

François could hardly contain himself. As a member of the Active Leisure Committee, he decided to organize a cross-country skiing expedition. And so, with the snow still flying around us, we crowded into the van and disappeared into the white.

17

I HAD EXPECTED great things from cross-country skiing: the solitude of a hushed forest, the beauty of nature, maybe a herd of elk springing by (if, in fact, elk do spring). I had snowshoed back home—winter hikes across the frozen Peace River, campsites in the snow—and I figured skiing would be much the same, only smoother and more lyrical.

The trail was high in the woods, and other than François and Joyce, none of us had skied before. We lined up—eager, demographically varied Katimavik participants that we were, filled with youth and innocence—and awaited instruction. Our guide, a wiry man with a trim red beard, taught us how to do "the shuffle." This involved sliding one ski along the snow followed by the other ski. I mastered this technique with ease. Unfortunately, as the instructor was quick to point out, I should have been moving *forward* and not backwards. Shuffling in place was a breeze, and shuffling backwards wasn't too difficult, but shuffling forward was out of the question. For me. All the others had sailed blithely off and were already disappearing from sight.

I asked the instructor if maybe I had the skis on backwards, with the forward ends pointed the wrong way. He assured me that this was not the case, and he also nixed my suggestion that I simply ski backwards along the trail. He even went so far as to suggest that the problem was somehow connected with me and not the equipment.

Employing a technique known as "violently jerking your body forward," I managed to advance a few feet. The instructor decided that I was now an expert on the shuffle, and went on to explain "the cross-country glide," something the others had already mastered.

"It's simple," he said. "As easy as walking." He then launched into an explanation only slightly less complex than the formula for cold-water fusion. "With your right leg extended, bring your body weight forward onto your right ski and then, at the same time, slide your left ski forward past the right. When your body weight shifts onto your left foot, slide your right foot forward. Make a slight arc as you do this, in order to propel yourself along—but without undue strain. Make

sure you maintain a natural rhythm. That rhythm is right foot, left foot. Right, left, right, left, right, left, right, left, right—"

I interrupted to assure him that I understood the pattern. He seemed surprised.

"Remember," he said, "don't drag the skis when you move them. Lift each ski as it passes the other. Use only gentle pushes to go forward, otherwise you'll—See what I mean? You wouldn't have fallen down like that if you had followed my instructions. Now give it another try."

I performed a leg-flailing motion reminiscent of someone trying to run very fast on a waxed floor while wearing nylon socks smeared with bacon grease.

"Close enough," said the instructor, and he set off to catch up with the rest of the group.

I had, as I mentioned, envisaged vistas and epic scenery—herds of squirrels and flocks of black bears frolicking in a winter wonderland. I saw two ski ends alternately sliding forward in the snow. I had no choice; the only way I could keep the rhythm going was to concentrate all my attention on the skis. For all I know, I passed a dozen moose, several lynx, and Bambi's mother; I saw nothing but those two skis moving in front of me.

Gradually other skiers began to pull up behind me. Little kids with shit-eating grins appeared out of nowhere and skied past on either side. It got so bad that I took to stopping and bending down to critically examine my skis in a thoughtful manner whenever I heard someone approaching from behind. As the other skiers went by, I would adopt a suitably expert frown and mutter to myself about how the skis "just weren't responding properly." Once they were out of sight, I would continue.

My strategy eventually backfired. I was crouched over, frowning away, when a skier stopped. Of course, she had to be young and pretty. This was a major crisis—her being pretty and all—because it is anathema for any male to ever appear fallible in front of any attractive female. This is written right into our DNA.

"What's the trouble?" she asked.

"Trouble?" I replied.

"With your skis."

"Oh. You mean *these* skis. Yes. Well. You see, it appears—or I should say, it *seems* to appear, that my, ah, *bandings*"—that was what the instructor called them, wasn't it?—"have been improperly secured to the, ah—Anyway, it's all very technical. You know how it is."

But of course she didn't.

I kept yammering as she slowly inched away from me and then bolted down the trail, swinging and swishing like a pro. I cursed myself, not for lying, but for lying poorly. What I should have done was assume a Swedish accent and pretend I didn't speak English. She might even have found it sexy. Women just love foreign accents.

Eventually, I did catch up with the rest of the group. They were at an intersection of ski paths at the bottom of a hill, waiting for me and apparently considering sending out a search party.

"Sorry," I said as I slid into their midst. "Had to stop to help a girl with her skis." And I proceeded to slide right past them. No one had shown me how to stop.

"Come on!" I yelled back. "We haven't got all day."

Unfortunately, the trail levelled off, and one by one they filed past me. François first, then Mac, and then Joyce.

"I'm having trouble with my bandings," I said as they passed.

"That's *bindings*," said Joyce.

Lysiane skied beside me for a while and tried to convince me that she was also having a difficult time. She even fell down once or twice, but I knew she was just trying to make me feel better. By now I was moving ahead more by digging my poles deep into the snow and then dragging myself forward than I was by gliding with my skis. As a result, my arms began to give out. I had worn layer upon layer of clothing, and as I started to overheat I performed a gradual striptease of sweaters, toque, and scarf. Truly a *Canadian* striptease. At least I was getting somewhere.

Then I came to a hill. It was at least a metre high. A real killer.

The "herringbone" is a manoeuvre of ascent developed by ski instructors so they would have something to laugh about after work. It involves taking giant steps with your skis pointed outward at ridiculous angles. The more ridiculous, the better. When you plant

your first ski, you must make sure to overlap the back of the other ski, so that the second ski is firmly pinned down. That way, when you attempt to lift your second ski, you will find yourself unable to do so. All of this should be accompanied by much swaying of body and swinging of arms, preferably in the manner of a penguin standing on the edge of an abyss. At best, you will topple to one side and tangle your skis and maybe twist your ankle. At worst, you will slide backwards down the hill and have to do it all over again.

A second technique is to take small sideways steps up the hill with your skis parallel. This was described by our instructor as being exactly the same as walking up a staircase sideways. If your feet happen to be seven feet long.

The last modus operandi† is one only recently developed: the Ferguson Manoeuvre, which involves taking *off* your skis and simply *walking* over the hill. It isn't pretty, but it works. I ended up walking most of the way. It was a lot like snowshoeing.

To this day, Joyce remembers our cross-country outing. "We could always tell where you were," she said to me years later. "We just looked for the black, vile cloud that was hanging over your head the entire way."

18

ONE OF THE WORLD'S longest floating bridges connects Kelowna to the community of Westbank. Westbank is located on the—well, you can probably deduce that yourself from its cleverly chosen name. (There is another town nearby called Peachland. You'll never guess what they grow there.) The floating bridge lies flat across the water like a piece of unravelled ribbon. So when you cross Lake Okanagan you do so at water level, and you look across the surface as you might across a giant ping-pong table.

The Okanagan Valley is a desert. Not a sand-dune-and-camel–type desert, but a snow-covered, low-rainfall, science-classification–type "mid-latitude" desert. In other words, it is not a desert. Not unless

† I have always wanted to use this term, and this may be my only chance.

you are a scientist, and what do scientists know anyway—they classify tomatoes as fruit. If no one told you that the Okanagan is a desert, you would never guess. But there is a stretch of scrub grass and tumble-weeds not far from Westbank that might make you wonder.

It was on the drive back from our field trip to the Great Okanagan Desert that Joyce told us the big news: Katimavik's Vancouver office had arranged for us to have an additional member. This would bring our number to seven, which was still small for Katimavik, where most groups had ten to twelve parts. The prospect of new blood was far more exciting to us than the seminar on rainfall we had just listened to, and we peppered Joyce with questions: Would the new participant be male? Female? French? English? And from which province? Joyce tried to be coy, but we gang-cajoled her into telling us. We would receive a male, named Yves, twenty-one years old, from Trois-Rivières, Québec.

He arrived the following Wednesday, and Joyce went to meet him at the airport. He shuffled into our living room and sat hunch-shoul-dered at the table. Yves was thin and waxy-looking. His hair was unwashed and stringy. What we didn't know—what we couldn't have known—was that Yves had been encouraged to apply to Katimavik in a last-ditch attempt at therapy.

Yves lived in a desert of his own. His eyes flickered around the room without making contact with anyone. We had a cake and a ban-ner to welcome him, but the big event was all false fronts and balsa wood. It was the quietest welcome party I have ever attended. Yves didn't speak except to mumble "*Il fait froid*" over and over and over again. It's cold. It's cold. Mac added wood to the fire with each mum-bled complaint, and in the end we ate our supper in silence and at steam-bath temperatures. *Il fait froid, il fait froid.*

Yves stared at his hands and began to mouth the word "*merci*" every time someone passed him something, or whenever someone passed something to someone else, or whenever there was a lull in the conversation. There were a lot of lulls. "*Merci, merci, merci...*" His own private mantra.

After supper, a heavy disappointment descended upon the group. A new element had been thrown in and no one, not Joyce, not

François, not anyone, knew what to make of it. Only Duncan was undaunted.

"Come on, Yves, you've got to see this yard of ours. I'll take you on the grand tour."

He followed Duncan out of the room like a small child, and I went along—intrigued. Duncan walked Yves to the top of the hill to show him Lake Okanagan, but Yves didn't even lift his head to look. As we walked along the trail, a cold wind blew up and Duncan and I pulled our jackets in closer. Yves said, almost to himself, "*Il fait chaud aujourd'hui.*"

Duncan turned to me. "Did he just say it's hot out?"

"I think so."

We looked over at Yves. He had taken off his scarf and was loosening his collar. "*Qu'il fait chaud.*" A few steps later, he unzipped his jacket, and by the time we reached the bottom he had taken it off and was dragging it and his scarf behind him, the sleeves trailing through the mud and slush. His upper lip had a sheen of perspiration.

That night we put Yves in the waterbed room, with the three of us pressing upon him that it was only for one night and that after that we would be rotating. With a jumbled string of "*mercis*" and "*bonne nuits*," Yves unpacked and went to sleep.

"*Bizarre*," said François under his breath.

We turned out the lights and settled in for the night. Even with Duncan's fitful snores and the wind against the windows, I managed to fall into a deep, warm slumber. I was lost in heavy dreams when the screaming began.

With a start I awoke, fog-headed from sleep, and my first terrifying thought was that someone was inside the cabin trying to kill us. A silhouette jumped up in front of the window. I screamed. Someone screamed back. I was fumbling for the light switch when something grabbed at my leg. I kicked back, my heart slam-dancing against my ribs. The figure grabbed at my leg a second time. I kicked back harder.

"François!" I shouted. "Help me!"

But François was scrambling for the door on the other side of the room. Swinging my leg harder, I heard a familiar voice cry out in pain.

"Stop it!" Duncan shrieked. "It's me!"

Light flooded the room, hurting our eyes and revealing in an instant the following tableau: François with his hand on the switch, breathing hard, as Duncan and I cowered away from each other in mutual fear. The axe murderer was nowhere to be seen.

François pushed open the bedroom door. We peered inside. Yves was curled up in a fetal self-embrace, hugging his knees with claw-rigid hands, and he was screaming. After a moment the screams subsided and he drifted into erratic sobs, then silence.

"Lord Jesus Almighty," said Duncan.

"*Y'est fou ce gars-là,*" said François.

Yves screamed each of the following nights like clockwork, and we almost became used to it, waking up momentarily before nodding off again. Our dreams became tainted with vicarious terror. But worse than the screams were the moans. They built up slowly, a kettle coming to boil, and never really woke us but threaded into our subconsciousness instead, stirring up nightmares like a stick in swampy water. It was the moans that got to us.

What it was that Yves had left behind, and what it was he was hoping to escape, we never found out. All we knew was he'd failed. Five days after his arrival, he was quietly "deselected" and returned to his home. The rest of us let out a quiet sigh of relief.

The evening of his departure, Lysiane and I walked down to the lake and watched the sun fall into cold water.

"Will," she said after a long silence. "Do you know what I like best about Katimavik?"

"Me?" I guessed.

"What I like best is that here nobody knows of me. The paper is empty, and all things are possible. Everything *c'est possible*. Our past doesn't have us so much. It is like . . . " She took a deep breath that turned into a sigh. "It is like to run away. Run away from ourselves. From the thing that happen to us back at the home, at school. Maybe Yves—maybe he was looking just for that. *Je ne sais pas.*"

"And you?" I asked. "You never talk about your past. Is there some horrible, tragic secret you are running away from?"

"No," she said. "That is the problem." She turned and laughed. "If

you don't know about me, I seem the mystery, no? But there is no mystery. I live in the suburb. My little sister is very nice. I miss her. My mother is the housewife, but she has the work part-time. My father is a government cheese inspector."

"And you?"

"I am not a government cheese inspector."

By the time we got back, the barn was empty. We made a pot of tea and sat beside the wood stove, where the wood was crumbling into embers.

"Honey?" said Lysiane.

"Yes?" I answered, a bit too eagerly.

"Honey," she said. "You like some?"

Oh. Of course. Bee poop. She stirred it into my cup and then in an incredibly, unintentionally erotic manner—she licked the spoon. She smiled. "It's good, my friend."

"Lysiane," I began awkwardly. "I don't think of you as a friend. What I mean is, you are a friend, of course. But what I mean is that love itself is a—"

"Don't. I don't want that you lie."

And then, next thing you know, she's leaning forward and her lips are on my lips and my lips are on her lips and there are lips just *everywhere*. And then Duncan barges in.

"Whoooops-a-daisy!"

Lysiane and I broke from our embrace, our mouths separating like two wet suction cups. Duncan made a big, elaborate production out of pretending not to have noticed.

"Just came to get a little snack. Don't mind me. Nope. Just be a minute."

Lysiane laughed to herself, and I sat staring at the floor and turning various shades of red.

"Beat it," I snarled.

"Sure thing, Willy m'boy. Not a problem. Just get my snack and I'll be out the door." Then, as he was leaving, he looked over and said, "Oh, Lysiane! I didn't see you there. How the heck are you?"

"I am fine."

"Great. I'll see you later then." He closed the door softly as he left. Lysiane and I reembraced and Duncan stuck his head back in. "Have fun!" he yelled.

Duncan, your days are numbered.

Lysiane stood up, straightened herself, and said, "I think maybe I go to sleep now. This isn't good, you know. Two people in a close group. I think we have to stay just the friends."

I nodded in a calm, mature manner, but inside my mind was screaming: To hell with *days*, Duncan. Your *hours* are numbered. You may not make it through the night. God knows, I won't.

19

JOYCE ALWAYS GOT A certain smile on her face when-ever she had something Really Big to tell us. It was a smile that somehow went up and down at the same time, like a paradox. Like Joyce. Not long after Yves's departure she came to breakfast wearing that very smile.

"Two things," said Joyce. "First, the bird cages. Myles from the museum has decided to release the peacocks and whatnots into the enclosures two weeks from today, so we'll all get a chance to see them before you guys leave for Ontario."

"And every Sunday we can eat fowl," I said. "Though I imagine we'll have to leave the parrots alone. I, for one, couldn't possibly cook anything that yells, 'Please don't eat me! Please don't eat me! *Squawk!*'"

Joyce ignored my suggestion. She had become very good at doing this. "Second item," she said, moving on. "We will be getting a replacement for Yves. A male, nineteen, from Toronto."

"New blood!"

We cheered. We hollered. We were excited. We thought it would be fun to have a new part. We couldn't wait to meet him. We didn't have a clue what we were about to get ourselves into.

It was on the premise of celebrating the upcoming arrival of the new participant that we convinced Joyce to drive us into town for a cultural survey of Kelowna's taverns. Joyce joined us in our studies.

She even picked the first bar. A bass-heavy band was playing juke-box rock at a volume just past the limits of human tolerance, but we didn't care. We were celebrating. Mac was asked for ID, but everything else went smoothly. Joyce bought the first round. There was no second round. We nursed those drinks as only someone making a dollar a day can.

At the second pub, Joyce again bought the first round, and again there was no second round. At least in this bar we could hear ourselves think, and what we were thinking was "How can we get Joyce to buy another round?" We eventually succeeded by using a clever ploy, wherein we asked her, "Hey, Joyce, can you buy us another round?" She did, and then announced that the bar—or more accurately, the bank—was closed. This was fine with us. No one was drunk, but we were all feeling good.

And then Benny arrived on the scene. Benny was a small, rodent-esque man who had taught us carpentry during our orientation. What I remembered about Benny was how he kept trying to look down the girls' shirts during the workshop. I hadn't seen him since. Not until now. I ran into him, appropriately enough, in the washroom.

"Hello there!" he said.

"Hello, Benny."

Big grin. "So how are ya?"

"I'm at death's door."

"Terrific. And how's everybody else doing? How're the girls doing?"

"We cannibalized our group leader."

"Terrific. Mind if I join you?"

"What, *here*, in the urinal?"

"No, back at your table. I saw you guys out there. That French girl is with you."

I had finished my business and was drying my hands on a hygienic roll-down towel. Except, as usual, the towel had run out, and the last two hundred people to use it had been drying their hands on the same two inches of remaining towel, making it more of an *unhygienic* towel.

"What's that girl's name, anyway? The French one."

"Marie-Claude?"

"No, the other one. The one with the big tits. She's a little chubby for my liking, but hell, I take what I can get."

"You know, Benny, I'm not very strong. But then, you're not very big."

He backed off, spouting apologies as he followed me from the toilets. Getting rid of Benny was like getting rid of a cockroach. Mac and I were out on the dance floor, and when we came back, another round of drinks had arrived. Benny followed them over a moment later. Joyce was very civil to him—he was what we call a "community supporter"—and invited him to sit with us. Sarah thought he was cute. He smiled broadly over at me.

Large groups tend to dissolve in a bar as the night goes on. Benny invited Lysiane up for a dance, and when the song ended, they sat down on the other side of the room. With everyone coming and going, no one seemed to notice. But I did. As the night went on, I counted more and more glasses on their table. In a corresponding move, Lysiane had moved closer and closer to him, and before long, he had his arm around her.

I excused myself from our table and walked to the bar. "I will go over to their table," I told myself. "And if Benny's arm is still around Lysiane, I will break it off."

Stiff-legged and almost shaking with anger, I walked across the room. Benny was gone. So was Lysiane. I checked the dance floor, the parking lot. Nothing. When I came back inside, Duncan yelled in my ear, "It's midnight. Joyce is taking us back."

When we got to the parking lot, Joyce discovered that Lysiane was missing. She was going to send someone back in to look for her, but I told her not to bother. "She went home. With Benny." Joyce winced.

Lysiane didn't come back until the following morning, and when she did, she slipped into the living room unannounced and sat down at breakfast. The silence was so thick we were practically choking on it. Joyce stood up. "Lysiane, when you're finished, I want to see you in my cabin. Alone."

Joyce gave Lysiane a written warning—which put her one step away from expulsion. She did this by invoking a lesser rule: No Abuse of Alcohol. Apparently, Joyce reasoned that Lysiane had to have been drunk to spend the night with someone like Benny. Technically, Joyce

could have deselected Lysiane right on the spot. What Lysiane had done was grounds for instant dismissal.

"So why don't you?" I asked.

Joyce was taken aback. I had come to her cabin later that night.

"Rule Number Three," I said. "No warnings. Immediate expulsion. Lysiane should be given the boot."

Joyce took a moment to answer. "People make mistakes. Lysiane has been a good participant, and—"

"Rule Number Three," I repeated. "No warnings. No exceptions."

Joyce was now getting angry. "And what would that solve? Lysiane will go home feeling worse about herself than she already does—*and you'll still be an asshole.*"

I stood up, straightened my shoulders, and left.

Lysiane asked me quietly if I wanted to walk with her to the lake, but I couldn't. I couldn't. I never really knew who Lysiane was. But I knew what she wasn't: she wasn't mine. And sometimes that is all we can hope for, to know what somebody isn't. Sometimes it is enough to know that someone is *not* a government cheese inspector.

20

THEY SAY YOU CAN chart the interpersonal relationships in a group with a circle diagram. My relationship with Lysiane took a long time to recover, but eventually she forgave me. François and I, try though we might, could not sustain a conversation lasting more than thirty seconds. We were polite to each other. *Too* polite. It was the kind of forced politeness people adopt when they suspect that, deep down inside, they can't stand each other. Duncan liked everybody, but not everybody liked Duncan. François thought Duncan was lazy (he was) and François thought this made Duncan a bad person (it didn't). I had slowly come to like Duncan, had come to appreciate his sense of fairness and even temper—qualities I knew I lacked. Sarah didn't like Lysiane. Or Mac. Or me, for that matter. But she did seem to have a crush on François. François, of course, despised her.

So, if you were to make a circle diagram with each participant in our group represented by a dot and then carefully connect the dots according to the relationships involved, what you'd end up with is—

let me see—a complete and utter mess. Our group diagram looked like a hairball a cat had coughed up. But at least it was stable. I mean, it was *our* hairball. Our formative phase had passed, and we all knew where we fit in. The machine, so to speak, was slowly beginning to move.

Then Erik arrived.

But he didn't merely arrive, he exploded upon the scene, shaking the foundation of our little group and turning its entire dynamic on its head. With only four days left in March, and only twelve days left in Kelowna, Erik neatly circumvented one third of Katimavik. He was like ground support parachuted in after the initial battles are over and, as befitted his role, he showed up in the dead of night.

It was my turn on the waterbed. Ah, yes, the waterbed. Pure luxury. I lay out like a Persian king, falling slowly into sleep in a series of languid yawns and stretches . . . And then came the rocket attack. It was deafening. It rattled the rib cage and sent dishes tumbling from the cupboards. It was horrific and sadistic and brutal, and to the untrained ear it might even have sounded like music. Heavy-metal, head-banging, guitar-screeching music, with all the melodic flow of a sustained automobile accident. A voice of indistinguishable gender screamed out the lyrics:

I woke up this moooooooorrrrning!
My dog was dead!
Somebody cauuuugggghht him,
And shot him in the head.

I didn't so much get out of bed as I was blasted out. I crawled into the living room and there, standing at the threshold of what had once been a peaceful little cabin, was a long, lanky young man with a tangle of blond hair hanging over his eyes and a T-shirt that read: "Ass, gas or grass. Nobody rides for free." Perched on his shoulder, like a parrot on a pirate, was a high-volume, maximum-output, harmful-in-high-doses, super-testosterone ghetto blaster.

I stared at the young man. He grinned back at me. Duncan was sitting up in his sleeping bag with that neck-back, sleepy look people get when their eyes will only open a crack.

François pointed at the ghetto blaster. "Turn that off."

"What?" Erik mouthed, unable to hear us over the roar of his music.

I staggered over and killed the power. The silence that followed wasn't deafening—Erik's alleged music had taken care of that—but it was startling. This tall, rangy fellow was unfazed. He grabbed my hand and shook it like a piece of overcooked asparagus.

"Good to know you. I'm your latest instalment. Erik Hjellerman, T.O."

"T.O.?" I asked.

"Toronto."

I staggered back to the waterbed and rocked myself to sleep. "Oh my God," I whimpered. "Oh my dear God."

21

THE FOLLOWING MORNING, Erik was piped in to breakfast by the dulcet sounds of Steppenwolf. At Joyce's suggestion, conveyed primarily through pantomime, Erik turned the music off, and the sudden vacuum this created caused a great *swoosh* of silence. Joyce's group-leader-welcoming-a-new-participant smile faltered.

"Erik," she said. "The female participants were asleep when you came in last night, so I thought maybe we would start the day with a self-introduction in order to—"

"No need for intros," said Erik. "I met 'em all this morning. Lisa-Anne. Sarah. And let me see, Mary Clod, right?"

Joyce wavered. "When did you . . . "

"He woke us up," said Lysiane flatly.

"With noise," said Mac.

"Hey, that wasn't noise," Erik protested. "That was a dual track of Hendrix feedback. It's a classic."

"With *classic* noise," Mac amended.

"I didn't mind," Sarah quickly interjected. "I just love music."

"Well, then," said Joyce as she tried to regain her composure. "Marie-Claude is cooking this week, so I'll put Erik with—*you*, Will."

I choked on my coffee. "*What!*"

"Spacious!" declared Erik in whatever strange moon-dialect he spoke. He slapped me on the back. "You and me, Will. Overdrive."

I looked into his mop of hair, to approximately where his eyes were located. "Overdrive," I said weakly. Oh joy.

22

THE FIRST TASK ERIK and I faced as work partners was helping to put the finishing touches on Myles's bird enclosures. It was meant to take two days, but Erik moved like a whirlwind and we finished before lunch.

"Where did you learn so much about carpentry?" I asked as he stapled down the last sheet of wire mesh.

Erik tossed the staple gun to one side. "Reform school." He stretched out on the ground.

"Oh. I see." I cleared my throat. "So, Erik, when did you, ah, get out?"

He flipped his hair back out of his eyes and thought for a moment. "What time is it now?"

I checked my watch. "About one o'clock."

"Well, then. Almost exactly seventy-two hours."

Wonderful.

"What did you, ah, *do* exactly?" I asked as nonchalantly as I could.

"B 'n' E," he said, then leaned over and plucked a stalk of grass. He began to clean his ear with it.

"BNE?" I asked.

"B 'n' E," he replied, nodding sombrely.

This, I found out, was reform school lingo for Break and Enter. My partner was a criminal. Spacious.

"So." I scratched my own ear, annoyed by Erik's action with the grass. "Where did you, ah, B 'n' E into?"

"Church," he said.

"Church?"

"They're the best 'cause if you get caught, the priest will, like, almost always forgive you."

"You broke into a church."

"And a school." He pulled a package of rolling papers from his hip pocket. "And a couple of offices. And a warehouse." From his other pocket he produced a small bag of what appeared to be oregano. "And a hotel. And a couple of restaurants. But nothing major."

I shook my head. "Nothing major."

Then I looked at what he was doing. "Ah, Erik?"

"Yes?"

"What is it you're doing?"

"Rolling a joint." He looked up at me. "Why?"

"Did anyone happen to mention to you—you know, just in passing—that we have rules in Katimavik?"

"Rules," he chuckled. "I don't believe in them."

A man of principle.

"Yes," I allowed. "*You* may not believe in rules, but Joyce most certainly does. And what about the goals of Katimavik? Do you even know what they are?" (True, I still didn't know the various goals of Katimavik myself. But what's the point of having seniority if you can't lord it over the new arrivals?)

He lit one end of his thin cigarette and inhaled deeply. "Wanna toke?" he gasped, offering it to me as he fought to keep the smoke inside.

I took one long drag—just to be neighbourly, you understand—and handed it back. One week, I thought to myself. One week and you'll be gone, Mr. Erik "T.O." Hjellerman.

I was, however, dead wrong.

23

THE NEXT EVENING, Myles came out from the museum with his menagerie of birds. We gathered around the caged enclosures and watched as he released them. They were magnificent creatures, all plumes and feathers and primary colours, as bright as frozen fireworks and very, very loud. It was only then that Joyce realized just how close to her cabin we had built the cages.

"Think of it as a holistic wake-up call," I said to her.

The show was not over. Myles brought out a small wooden box. "In here," he said, "is my pride and joy. One peacock and two peahens. All winter long, these birds have been confined in an environment which we in biological conditioning would refer to as 'a confined environment.'"

"That would be the box," said Erik.

"Yes," said Myles. "In layman's terms, a box."

Myles set the confined boxlike environment on the ground, then placed a plate of seeds and a container of water in front of it. Inside we heard the birds calling. "Water," said Myles, pointing to the water. "Seeds," he said, pointing to the seeds. "Birds," he said, pointing to the box.

"Let me see if I understand," said Erik. "Those little round things, they would be the seeds. And that wet liquidy stuff, that would be the water."

Myles looked at Erik, unsure if he was genuinely interested or just pulling his leg. "That's right," said Myles. "Those are the seeds and that is the water. Now then, by keeping these birds tightly cramped inside this box, I have successfully conditioned their concept of the world. For them, the world *is* this box. It's all a matter of conditioning. The mind of man versus the mind of bird."

Erik whispered in a voice just loud enough to be overheard by Myles, "I'll bet on the birds."

Myles coughed self-consciously and continued. "You may have noticed we do not have cages for the peacocks. You may ask why."

No one asked. Myles continued.

"The reason is simply this: we have no need for a cage. That's right, there is absolutely no need for a cage." No one had contested this, and Myles went on with renewed confidence. "I can now release these birds from the box and they will never run away. Why? Because they have been *conditioned* to accept it as their world."

With that, Myles opened the front of the box and the three birds emerged, looking somewhat dazed as they blinked and peered about. They immediately scurried off into the bushes.

The smile on Myles's face took a long time to fade. "They'll be back," he assured us with much the same confidence I imagine Noah's

neighbours had when they said, "It's just a wee shower. It'll soon pass."

We waited. Joyce checked her watch discreetly. The sky began to darken almost as if the earth were turning away from the sun. Lysiane excused herself. Duncan wandered off in search of a snack. Mac went to bed. Eventually, only Erik and I remained.

Myles hung his head. "I don't understand. It makes no sense whatsoever." You could tell he felt betrayed.

Erik patted him on the shoulder and asked, "You ever been in jail, Myles?"

Myles shook his head.

"Didn't think so. Trust me. Those birds aren't coming back."

The peacock and the peahens never did return. Occasionally we'd cross paths with them as we walked out to our cabin at dusk, and often we would hear them calling at night—with an odd mix of fear and elation, it seemed to me. At times, we would also come across Myles as he tromped about in the undergrowth, armed with a big cartoon net and with a distraught look on his face, as he tried desperately to recapture his lost pride.

24

IT WAS SHORTLY AFTER the peacock episode—also known as "Myles's comeuppance"—that the group was split up to begin billeting. During each three-month rotation, Katimavik participants were dispersed to live with local families for two weeks. Depending on the family you got, billeting could either be the high point of the program, or a crushing disappointment. My family was somewhere in the middle. Middle-class, middle-income, middle-of-the-road, fair-to-middling: it all applies. I spent two weeks in the heart of suburbia.

Living with the Stallworthys was a succession of evenings spent in front of the television, alone. Or baby-sitting their six-year-old (I can't remember the gender, so bland was this family) while Mr. and Mrs. Stallworthy attended their Rotary Club functions. Or was it Lions? Or Kiwanis? Or Elk? Or the Loyal Order of the Muskrat? Or maybe

PTA? Or the school board, or the neighbourhood volunteer knitting society. They had clearly only agreed to billet a Katimavik participant out of a certain Protestant sense of civic duty, and boy, didn't it show.

Mrs. Stallworthy had labelled every section in her fridge with little strips of masking tape carefully cut off with a pair of scissors: MILK. EGGS. BREAD. And Heaven help you if you misfiled something. Their fridge was like a little grocery store, and the suburbs the Stallworthys inhabited were singularly alien to me, growing up as I did in a town of near-illiterate poverty. The Stallworthys' world was cold and comfortable and vaguely exotic. Something like a sitcom with the laugh track and punch lines removed.

I had little to do and the house was often empty. In my wilder moments, I considered running around recklessly ripping off pieces of tape and labelling the rest of their house: DOOR. OVEN. WALL. LIGHT-BULB. PET. (It was either a dog or a cat, I can't remember. Maybe a fish.) But I decided against it. It might have been misconstrued.

Instead, I continued to work for the museum. With Mac off at an orchard somewhere having a grand old time, I was assigned Erik for the duration.

It was going to be a long, hard two weeks.

25

APRIL 3
Lost in British Columbia

Greetings, Assorted Ones:

I am still here. And I am still, stubbornly, alive—in spite of an attempt to blow myself up, which left me without eyebrows. We (not the royal "we" but the Katimavik "we") are now in our final two weeks of our first rotation. And then it's off to southern Ontario.

Our small band received a new member last month, a young man from Québec who screamed in his sleep and talked about extraterrestrials as though they were personal friends. He was soon replaced. Whether this was a good move on our part is hard to say. His replacement was Erik, who comes to us straight from the penal colonies of Toronto. Just what we needed, a young Capone to round out our

"cross-section of Canadian society." All we need now is a left-handed Albanian Moonie and our ranks will be complete.

Erik joined Katimavik on the recommendation of a family court judge. That is, Katimavik is Erik's parole. If Erik screws up, he goes to jail. Katimavik, of course, is not a prisoner rehabilitation program, nor was is it ever meant to provide therapy for delinquents. Unfortunately, this was not explained to the good people in juvenile corrections, who have a habit of trying to slip in one of their problem cases now and then. So Joyce is fully within her rights to dismiss Erik. *But she won't do it.*

Why? Because she knows that by giving Erik the ol' heave-ho she would, in effect, be sending him to jail. My response, predictably, was "So what?" It's not as though Erik was framed by his evil stepmother. No. This is a guy who stole money from a church. Granted, it was a *Baptist* church, but it is still probably a crime. Or at least a misdemeanour.

Nothin' doing. Joyce won't budge. She said she doesn't want it on her conscience and that everyone deserves a second chance in life and that we have to help one another and other such malarkey. So Erik is still with us, and I'm his work partner.

Tomorrow, the museum's Pioneer Days begin, and Erik and I will be helping to educate herds of young schoolchildren who are probably just as anxious to learn about the pioneers as I am to teach them. It will be very realistic. We will be peeling logs, baking biscuits, splitting wood, and spreading infectious diseases among the Indians. Erik, no doubt, will be teaching the kids how to pick pockets and do time.

Wish me luck.

Will

26

PIONEER DAYS WAS an annual event for the Kelowna Centennial Museum. Ten-year-olds from all over the valley made the pilgrimage to our glorious barn to discover Canada's past through a process Myles referred to as "active participation," which seemed a bit repetitively redundant, if you know what I mean.

Jimmy put it a bit differently. "It's a day off school, and we have to keep them entertained."

The first morning, Myles went about assigning us to our posts. Erik was put in charge of not minor larceny but log-peeling. Mrs. Romolliwa was in the Pioneer House, where she would teach biscuit-making followed by square-dancing. (There was nothing our forefathers liked more than to whip up a batch of cookies and start dancing. This is why they never got anything done.) Myles himself was in charge of splitting wood. And Jimmy? Well, Jimmy would wander about doing whatever it was that made him so indispensable. With everyone in position and battle-ready, Myles led me over to the woodpile and handed me a pair of branding irons.

"You're in charge of the hands-on demonstration of Pioneer Branding Techniques."

"Whoa. Time out. I don't know the first thing about branding."

"Nonsense," said Myles. "You're from *Alberta*. Cattle country. Big sky. Rodeos." He turned to go.

I grabbed his arm. "Myles, listen to me. I'm not a cowboy. I've never chawed tobacco. I've never rustled up varmints, and I have never ever branded a cow or a pig or a goat or anything, so if we're going to be branding some poor, screaming farm animal, somebody had better make sure it's tied down first."

Myles looked at me in disbelief. "Did you really think we were going to brand an animal?"

We weren't. What the children branded was a cedar shingle that they got to take back home with them as a souvenir. And cedar shingles, Myles assured me, were not known to scream.

Jimmy came over as I was trying to get a fire going. The first bus would be arriving at any moment, and all I was coming up with was smoke.

"Kids'll be here soon," said Jimmy.

"*I know!*" I wiped my forehead. What was it with me and fires?

"Try some gasoline," said Jimmy.

"No, thanks."

"Seems to me gasoline would work just fine."

I was ready to throw a stick at him. "Oh, I don't know, Jimmy. A fella could get himself blown up using gasoline."

"Have to be a pretty stupid fella to—" He stopped in mid-sentence, considered what he was about to say, and then conceded. "Maybe you're right," he said. "You better stay away from the gasoline."

I eventually got the fire going, and in my joy, my absolute joy, at having won, I threw log after log on the fire until I had a veritable Hades on Earth blazing away. I stared at my raging bonfire with pride.

"Fire's too big," said Jimmy.

"Look here," I snapped. "You ever do any branding?"

"Can't say I have, but I can tell you this: that fire is too big."

"Is that so? Well, just remember something." I pounded my thumb against my chest. "I'm from Alberta. Big cattle country. And I've branded horses and cows and sheep and everything. And I say this fire is just fine." I threw on another log, defiantly.

"You don't brand sheep," said Jimmy. "They'd catch on fire."

"Yeah?" I challenged him. "*Yeah?*"

Jimmy nodded. "Nobody brands sheep."

"Well, *we* did."

The first wave of children arrived. They were divided into small groups that rotated between posts. I lined up the first bunch and gave them each a cedar shingle. "This is how our hardy ancestors used to brand cows. *And sheep.*" (That last comment was directed more towards Jimmy, who was standing, impassively, to one side.)

I pulled an iron from the fire. It was white-hot halfway up the handle. The first student stepped forward and nervously took the brand from me. As I coached and coaxed her, she slowly lowered the brand onto the piece of cedar. The instant the iron touched the wood—*swoosh!*—the entire shingle went up in flames. I grabbed the branding iron from her, flung it back into the fire, and stomped out the shingle. Jimmy said nothing.

"There you go," I said, picking up the charred chunk of blackened wood. "You take that back home and show your mom. She'll probably put it up on the wall or something."

"But it's just a stupid piece of burned wood."

"No, no, no," I said. "It's an authentic pioneer brand just like our hardy ancestors used to make."

"Maybe I'm no expert," said Jimmy. "And maybe I've never branded a sheep or cow or anything, but I could swear that fire is too big. And maybe I don't come from Big Sky Country, but I'd also say you've gone and thrown your branding iron a bit too far into the fire."

It was a good thing Myles had provided me with two. Jimmy was right, damn his leathery old hide. (We should have been branding *him*.) In my haste I had indeed tossed the first iron entirely in, handle and all. It wasn't until late that evening, when the fire was long dead and the iron had cooled off, that we were able to retrieve it. In the meantime, I had impressionable young minds to mould.

I eventually got it right, and the students were making distinct Circle K marks on their pieces of cedar to treasure all their lives—or to toss back into the fire to watch them burn, as most of the boys did. The girls were more polite. They no doubt waited until they got home before they tossed their pieces of wood away.

The only other mishap occurred when a little girl swung the hot end of the iron back too far and melted the toes of her rubber boots. She didn't hurt herself. Mind you, her boots were now welded together. She began to cry, but it wasn't until I tried to separate her boots with a hatchet that she wet herself. It was a bad day all round.

I finished early and sat down on the woodpile. Across from me, Erik was holding log-sawing championships, and there was much laughter and cheering. Erik, no doubt, was taking bets on the side. It wasn't fair, I decided, as I watched the teachers gather up their ragged hordes and head off. It just wasn't fair; the children actually *liked* Erik. They didn't even *trust* me.

Four more days of pioneer fun lay ahead. My neck ached, and my clothes reeked of smoke and sawdust and someone else's urine. Myles was closing up the Pioneer House, Erik and Jimmy were passing a thermos and cup between them, and Spats was sniffing my pant leg inquisitively. The snow had long since melted, leaving great puddles and patches of mud behind. I felt like throwing myself into one of them.

Erik came over and offered me a drink from Jimmy's thermos. It wasn't hot chocolate. "Rye," he informed me, a bit too late.

I bent over, hacking and coughing until my eyes began to bleed and steam shot out from beneath my fingernails. When my breathing became normal again, I turned and tried to speak, but all that came out was a tortured gasp.

"Want some more?" he asked.

"No, thanks," I squeaked.

Erik's voice dropped to a conspirator's hush. "Joyce is out of town."

"I know." I coughed. "So?"

"*So?* So let's have some fun. What say you and me and Duncan pick up some beer, find some girls, and have a little party. Tonight."

"Tonight? Forget it."

27

DUNCAN AND I WERE on our second six-pack when Erik arrived with the girls. We had each told our various billeting families we were spending the night at another's, and with our alibis carefully cross-referenced, we had reconvened at the cabin. Where Erik managed to find three young ladies who were willing to drop everything and attend a party in the middle of the night deep in the woods is beyond me. He also produced a ludicrously large jug of cider.

"Liquor store was closed," he said. "You know, in T.O. they stay open till midnight."

"So where'd you get this?"

"I stopped by my billeting family's house."

"Jeez," said Duncan. "Your family let you have some of their home brew?"

"I didn't exactly ask."

"Christ," I said.

"Hey, they were asleep. What was I supposed to do, wake them up? I slipped in the basement window and left without bothering them. Anyway, I practically live there. But enough of that." He waved an arm towards the girls. "We have guests."

I soon discovered what kind of girls would come to a cabin deep in the woods in the middle of the night: very stupid girls. Of course, it

wasn't their cerebellums we were hoping to fondle. Duncan drank himself into a stupor, and the girl who was supposed to be paired with him stuck with Erik instead. Erik soon disappeared into the waterbed room amid a flurry of giggles and flying innuendoes, leaving me alone with the remaining girl—and Duncan. There has got to be an easier way to mate.

"Well," I said with the wry sophistication that has made me famous on four continents. "Here we are."

She smiled at me. A warm smile. Very warm. I could have toasted a marshmallow on that smile.

"Yup," she said. "Here we are."

Having agreed on our location, we moved on to other things.

"Does he always snore so loudly?"

"Duncan? Oh, yeah. There are foghorns quieter than him."

There was a long pause. "So," she said. "You wanna go for a walk?"

I knew what *that* meant. A walk. Tongues. Hands. Possible contact with breasts. "Sure," I said. "Why not?"

We climbed the hill under a full moon. I tried to recite some poetry, but she didn't seem interested.

"You guys are so lucky," she said. "You get to travel and everything without your parents telling you what to do."

"That's not really true," I said. "We have far less freedom in Katimavik. Someone's always around. We have all kinds of rules, curfews. This is one of our few free nights, and even then we're probably breaking some rule right now."

"Your hand is on my breast."

"Is it? Sorry."

"That's okay, I don't mind."

She then turned and looked out across the moonlit lake, and the beauty, the exquisite beauty of the scene before her, made her think of Hawaii, where she had gone with her family last winter, and the beautiful red car that the man who worked at the hotel had driven, and how her parents had forbidden her to ever get in the car with him, and how she had anyway in the middle of the night and the moon was just like this and they had gone to this nightclub even though she was

underage, not by much, and how no one had even asked her for ID and then her sister squealed on her even after she promised not to tell, and how the man never answered her postcards, but that's just because he travels light and is always on the road, and what can you do?

She went on like this for most of the night. My hand was still on her breast, but my heart was no longer in it.

It was nearly morning when Erik and I drove the girls home. They snuck in through back doors and blew us kisses from the porch. Erik drove away very slowly, trying not to wake anyone inside.

On the way back, I asked the obvious question. "Erik, where did you get the car?"

"Fly low and stay clear," he said. (Your guess is as good as mine.) "This car was entrusted to my care."

"By whom?"

"*Whom?* By whom? Listen to you." He shifted gear, revving the engine well past the manufacturer's suggested parameters. "By my billeting family, that's whom."

"The same ones who entrusted you with their cider?"

"The very same. But this is legit."

He gunned the motor and we drove down the deserted predawn streets of Kelowna, riding the centre line all the way.

"One of our lovely guests gave me a present," he said, and he pulled from his jacket pocket a small clay pipe and a glass vial. "Let's go sailing."

"Goddamn it, Erik. We have rules."

"Hey, we've got six more months to serve, we might as well make the best of it. Am I right? Of course I am. I'm always right. Six more months, man. Overdrive."

I didn't say anything. I figured his estimate was too generous.

Across the sky, a pale violet dawn was seeping into the air. Erik thumped the car into the yard, revved the engine once for luck, then turned the motor off.

"Let's not end the night on a bad note," he said, and from beneath the car seat he pulled out a bottle of rum.

I shook my head in disbelief. "What are you, some kind of magician?"

With his other hand he produced a bottle opener/corkscrew. "Always be prepared," he said. "Now, let's go kill this bottle."

28

IT DIED A QUICK DEATH.

Erik and I ended up sleeping in the main room of the barn because we weren't altogether sure our legs would get us back to the cabin. I lay down on the dining-room table and Erik stretched out on the floor, the near-empty bottle still in his hand.

"People say I can't hold my booze," said Erik. "But you jus' try and take it away from me."

This broke us up. We managed to laugh so long that we forgot what we were laughing about.

"Hey, Will?"

"Yesh?" I was having serious trouble with my tongue.

Erik lurched up on his elbows. "What would you say if I tol' you that I shlept with Joyce the very firs' night I got here?"

"You got it on wif Joyce!" I exclaimed.

"No," he laughed. "I jus' asked what you'd *say* if I told you that."

I laughed myself into a fit of hiccups and then, eventually, to sleep.

It was funny that Erik should mention Joyce in our final few moments of relative consciousness, because Joyce, as it turned out, was no longer away. In fact, she was due back any minute.

"Will? Erik?"

My eyeballs lolled open and slowly I focussed on . . .

"*Joyce!*" I shrieked. "How are you!"

Erik sprang up and immediately regretted moving so fast, managing to say only "Hullo" before toppling back to the floor. Dragging himself up, he gave Joyce a feeble smile. It did not win her over.

She crossed her arms and somehow turned her face into stone. "What. Is. Going. On."

"Good question," I mumbled.

"Yes," Erik agreed. "Very good question."

"An excellent question."

"You look drunk," said Joyce. "Why aren't you with your billeting families?"

"Gee, Joyce," I rubbed my neck. "That's another good question."

"Sure is," said Erik. "Two in a row."

Joyce was about to snort flames when Erik drooped his head and looked up at her with big Bambi eyes. "Well, Joyce, I might as well tell you. Last night I was really depressed and I didn't know what to do, so I called Will."

Joyce cast a suspicious look in my direction.

"Depressed!" I chimed in, anxious to play along with whatever Erik had dreamed up. "*Really* depressed. So depressed it was just depressing."

Joyce turned her gaze back to Erik, but her cold demeanour had already softened. "Why were you depressed? Aren't you happy here?"

Erik shook his head. He choked back tears. He fought to keep a straight face. "No. I wanted to quit. And Will said to meet him here, and maybe we had a little to drink, but mainly we were talking—"

"Talking!" I nodded my head in an earnest manner.

"And Will gave me some advice, and then—"

"Advice!" I repeated, bubbling with enthusiasm.

Erik glared at me. "Anyway, Joyce. Maybe we did drink a bit too much. But it wasn't like we were trashing the place. There was just me and Will, all alone, talking about stuff. And in the end Will talked me out of quitting. You know, into staying on—*and not going to jail.*" He dropped that last line like a bag of wet cement.

An uneasy silence followed, while Joyce considered what Erik had said and I squirmed.

"Will?" said Joyce.

"Yes?"

"You are a very special and caring person. I never saw that side of you before."

"Thank you, Joyce."

It would have worked. It really, truly, would have worked. Joyce was almost out the door, and Erik and I were almost home free, when in came Duncan.

"Whadda party," he said, holding his head. Erik and I were making frantic facial gestures, but to no avail. "I never drank so much in my life. Where'd all the girls go?"

Just then, Duncan looked up and saw Joyce.

"*Oooooopps,*" said Duncan.

Ooops, indeed. All three of us got written warnings for alcohol abuse, which put us just one step away from expulsion. But as a wise man once said, a miss is as good as a mile.

29

ERIK AND I HAD terrific hangovers all day—the longest day in recorded history, I believe—and the unwashed throngs of schoolchildren did nothing to ease the situation. Pioneer Days came to an end, as did billeting, and our group reconvened for the final few days in Kelowna. It was a pleasure to be back in our old, familiar surroundings.

"There's a dead mouse behind the counter," said Sarah. "It's really gross."

"And there is poop of the mouse all over the food," said Mac as she scanned the jars of lima beans.

"Well," I said. "At least we know what he died of."

We scrubbed down the main room and removed any mice carcasses we found. (Do mice have carcasses? Or are they too small? And what about pelts? Can you skin a mouse, and if so, does that constitute a pelt?) As soon as we left, another group would arrive. Joyce would pick them up the same day, and everything had to be cleaned before our departure. Or at least made as clean as a barn can ever be. Inventories were taken, all five levels of floor were vacuumed, shelves were washed. And then, abruptly, it was over.

Our plane tickets arrived, and in a semi-sentimental ceremony, Joyce handed them to us one at a time. That night, François built a fire

out back, and various sponsors, work supervisors, and several billet-
ing families dropped by. Myles thanked us on behalf of the museum,
and Jimmy gave Mac and me some sage advice: "Don't get in a plane
crash." I told him I'd do my best.

Gerhardt arrived with several bottles of Grey Nun wine and
we toasted our farewell. Mrs. Romolliwa got sentimental, and I
swear even Spats was sad to see us go. The next morning we once
again crowded into the Katima-van, fitting ourselves in among
the backpacks and duffel bags, and Joyce said, "I'm going to miss
you guys."

"What about the girls?" asked Lysiane.

"All of you," said Joyce. "I've never met a group of people quite like
you."

But that, of course, could be taken many ways.

Part Two
ST. THOMAS
ONTARIO

1

IT WAS ALL MADNESS and fluster at the Vancouver airport. Katimavik had a bizarre and unduly complicated system of rotating participants. There were more than a hundred separate groups divided into three subcategories, each with a different schedule to follow. Every three months or so, Katimavik heaved and rolled, dispersing and relocating participants. The result? Mass confusion. Every group in a given category was rotated from town to town and province to province *on the same day*.

Which is how Group 216 found itself struggling through the Vancouver terminal as wave upon wave of bedraggled Katimavik groups churned about—checking in, tagging luggage, asking moronic questions, and looking lost. Somehow we broke through, and I found myself sitting on a night flight to Toronto, eating honey-roasted nuts and drinking styrofoam-slicked coffee with edible oil products stirred in—and I was thankful for it. Thankful to be airborne. Thankful to be on the move again. And thankful even for the coffee. (After a tour with Katimavik, even airplane food tasted good.)

We flew back over Kelowna on our way east, but none of us cared. We were washed out, burned out, and barely awake. At least we weren't on a bus.

It was a drab grey morning when we landed at Toronto's sadistic airport. (Terminals One and Two seemed to be located in different time zones and connected to each other by twenty million miles of corridors.) We waited, like a group portrait for National Sullen Week, beside a sluggish luggage carousel for backpacks that had become burdens. Travel long enough and you develop a pathological hatred of your own luggage. None of us had slept yet. Not even Duncan, who could usually sleep standing up in a wind tunnel.

An elderly man and his wife saw our Katimavik buttons. "Katimavik, what's that?"

"It's a religious cult. Bug off."

From the airport, we caught a reserved minivan to Union Station in downtown Toronto. We came in along the harbour front, past a skyline that no one except Erik cared to admire.

"Overdrive and out-of-bounds, boys!" (?) "Take it in: T.O. in all its glory. What a city."

"Erik, you've been gone less than three weeks."

"That's three weeks too long. Greatest city on earth. Too bad we can't take a couple of days off before we get shipped out to the boonies. Look, the CNE!"

"Is that anything like B 'n' E?"

"The Ex, my friend. What a party. And there's Ontario Place. There's the IMAX." Erik began pointing out the window and talking (basically) to himself. "There's the Royal York. There's the CN Tower."

"Thanks for pointing that last one out," I said. "I was having trouble finding it."

The bus pulled up on Front Street and we straggled into the train station with a collective migraine. Everyone was in everyone else's way, and in lieu of a group leader, François took charge and herded us to the ticket counter. Same routine all over again. We picked up our tickets, retagged our luggage, and shuffled back into line, all with the slow, deliberate motions of the undead.

The station was packed, absolutely *packed*, and if you had thrown a stone in any direction you would have hit a Katima-victim. They were everywhere—haggard, unshaven, halitosis-stricken—and every one of

them sporting the buttons and badges that proudly proclaimed to the public, "Yes! I represent the youth program Katimavik!" No wonder the public was so ambivalent when the program was finally cut. We should have travelled incognito.

Sometime after lunch, more than fifteen hours after we had left Kelowna, we boarded a train for London, Ontario. By the time we arrived, we were ready to kill the first person who dared speak to us.

"Hello there. I'm your new group leader."

We turned and found ourselves faced with a moustache. A huge, handlebar moustache that talked like a man. Look up, look *waaaay* up.

"My God," I said. "It's the Friendly Giant."

On top of the moustache, a farmer's cap with the mandatory herbicide logo was perched at a jaunty angle. The man was wearing a stiff, possibly starched, lumberjack shirt and blue jeans with creases ironed down the front. He looked like an advertisement for wholesome living. He looked like the *Harrowsmith* Man of the Year.

From below his prodigious moustache the bottom half of a smile appeared. None of us returned the smile or extended our hands, and Mr. Clean Jeans was getting nervous.

"Your name," said François.

"Hal," he said. "The name's Hal. And may I ask—"

"Hal what?"

"Hal Vanbreesenbrock."

"What kind of name is *that*?" said Sarah.

"Vanbreezenburger. It sounds like something Ronald McDonald would barf up," I said.

"It's, ah, Dutch, actually. You know what they say, 'If you ain't Dutch, you ain't much.'" He started to laugh, but nobody joined in.

"That's a big moustache," said Marie-Claude.

"Yes." Hal cleared his throat. "It certainly is."

And thus began our St. Thomas rotation.

2

AT THE LONDON TRAIN station, Hal loaded us into his station wagon and headed south. Our first glimpse of St. Thomas was a billboard proclaiming the town the future home of a Jumbo the Elephant Memorial Statue.

I had read about this on the plane. (Katimavik had provided us with tourist pamphlets and background information on St. Thomas prior to our departure, and in desperation and sheer boredom, I had actually read them.) What I had discovered was disturbing to say the least.

This sleepy little town's main claim to fame was its link to Jumbo, the legendary elephant of the Barnum and Bailey circus. Jumbo was not born in St. Thomas. Jumbo did not live in St. Thomas. Jumbo did not perform in St. Thomas. But Jumbo was *killed* in St. Thomas, and for this the townspeople are eternally grateful.

It happened one foggy night in 1885, when circus wagons from P. T. Barnum were passing by just outside of town. Jumbo—already a circus legend and the inspiration for the word "jumbo" itself—was acting jittery. His handlers let him out of his cage and were walking him across the train tracks when all of a sudden a locomotive came bearing down. The engineer on board pulled hard on the brakes, but it was too late. The train rammed into Jumbo and derailed. (Though legend has it that Jumbo actually *charged* the train to save the life of a smaller elephant. This is the version of events P. T. Barnum preferred, and gosh, if you can't trust P. T. Barnum, who can you trust?)

You would think a town would try to live down the fact that a gentle circus animal was killed within its municipal boundaries, but not St. Thomas. No sir. In fact, there is a certain morbid fascination with the more gruesome details of the accident. Here is a passage from the Official St. Thomas Souvenir Program describing "that fateful night":

> Dr. Tweedle, the local Medical Officer of Health, was present at the site, and after examining the fractured skull of Jumbo, stated that the blow the beast sustained in the collision forced one of his tusks into his brain, and this was the cause of death.

The hide was divided into sections . . . the process of skinning the beast went smoothly . . . much of the dissection had to be done from *inside the body* [emphasis mine] . . . As the job continued, various articles such as coins, stones and nails were found inside Jumbo's stomach. These were picked up by onlookers and as the years passed, became treasured mementoes of the great disaster.

The burning of the mountain of flesh was described by local papers as "the most tremendous roast of the season." Six cords of wood were used. "Carving juicy slices from the bloody flanks," a local youth astonished many by eating roast elephant steak.

The hide of Jumbo alone weighed over 1,600 pounds and when removed from the beast, was transported to Griffin's Pork Factory where it was pickled . . . Jumbo's heart weighed 46 pounds.

Is that sick or what? And this is from the official tourist pamphlet, remember. I had the uncomfortable feeling that we were about to enter the type of town Stephen King would set one of his novels in.

"Next year's the hundredth anniversary of Jumbo's death," said Hal proudly. "They're putting up a statue in the west end of town."

Kelowna had its statue of the Ogopogo Monster; St. Thomas was going to have a statue of Jumbo. Canadians are so weird.

"It'll weigh more than thirty-five tons," said Hal. "Steel and concrete. The largest of its kind."

That's right: *the largest of its kind.* Now, I hate to be mean-spirited, but I would imagine that Monuments to Deceased Circus Animals would be an easy category to take. I mean, how many of them can there be?

Although he's been dead and dissected (not to mention pickled) for one hundred years, Jumbo the Elephant was still a star in St. Thomas. Indeed, a sort of "Jumbo frenzy" had seized the town. As we drove along, we saw signs for Jumbo Motors, Jumbo Savings, Jumbo Deals, Jumbo Renovations, and Jumbo Diet Centres (okay, so I made that last one up). There was, and probably still is, a small museum dedicated to the "Jumbo Era." (*Era?*)

We turned down Ross Street, past oak-lined residential avenues, and then onto Maple. Hal turned in at Number 16. "Your new home," he said.

Our Cloud of Funk lifted like mist off a lake. We couldn't believe our eyes. It was—and you're going to be just as surprised as we were—a house. A regular old house. Not a barn, not a cabin—a house.

"It's a house! It's a house! It's a real live house!" we cried out.

"Yes," said Hal. "That is what we call them around here." (He was already having his doubts about us, you could tell.)

"Does it, does it"—Mac swallowed, hoping against hope—"have a toilet that works?"

Hal nodded. We cheered.

"And heating? How about beds? Does it have a kitchen—a real kitchen? What about—" We were hollering all at once, and Hal gave up and just turned us loose.

The house on Maple Street was three storeys high, brick, and dignified. We quickly divided up the bedrooms. The girls were put in the attic because they had occupied the more comfortable rooms in B.C., and fair's fair. (Somehow, it completely slipped our minds to mention the waterbed and electric heating in the abandoned cabin.) And so, once again, the boys ended up with the nicest rooms.

Duncan and I took one room, and François and Erik took the other. Hal's room was at the top of the stairs. No waterbed this time around, just bunks. We were going to have to rough it.

I stretched out on the lower bunk. Across from me, the window was open and the curtains were moving. It was as though the room itself were breathing: in, out, cool inhalations, long exhalations.

The rest of the group had discovered the bathroom, and an angry queue had formed. Sarah had locked herself in and was taking an eternity in the shower. The others were pounding on the door and demanding she come out. Then Hal let it slip that we had another shower in the basement—indeed, a whole other washroom. This triggered a stampede that resulted in several minor casualties and resentments that lingered long after the fact.

I was lying on my bed trying to relax, and all I could hear was acrimony and threats of violence. Enough of this. I went downstairs and walked out into a glorious spring afternoon. Duncan and Erik were sitting on the front porch, losers in the recent shower wars, and the three of us set out to explore this strange, elephant-obsessed town.

3

ST. THOMAS WAS working-class quaint. Picturesque. Quintessentially Canadian, right down to the small child riding his bicycle under the budding green of maple leaves.

"Hey! Watch where you're going!" yelled Erik as the tyke whipped past, almost sideswiping us.

"Screw you!" he shouted, pedalling off as fast as his chubby little legs could carry him. We considered pursuit. A good thrashing might have been in order, but it would probably not make a fitting first impression on the neighbours.

We ended up on Talbot, the main drag of Jumbo City.

"This is it?" said Erik.

Duncan's stomach led us to the Green Lantern Restaurant, a 1940s Formica-table, vinyl-booth kind of place that exuded a certain atmosphere: that of a small-town Ontario cafe. It was very authentic.

None of us had the courage, or the cash flow, to try a "Jumbo Burger," so instead we asked for water, a slice of blueberry pie, and three forks. The waitress looked at us, saw any chance of a tip go out the window, and decided she was no longer required to smile. It then became a battle of forks as we attacked the pie like a pack of jackals around a zebra. When we came up for air, wiping the grisly blue stains from our mouths, Erik froze.

"Psst. Will, look behind you and—*don't look*!"

"Erik, how am I supposed to look and not look at the same time?"

"Look. But don't, you know, *look*. You always gawk. Be cool."

There were girls in the restaurant, you see, and we did not want to frighten them away like the timid wildebeests they were. Not only were there girls, but there were lots of them. And they were drop-dead beautiful. The door opened and more girls came in. They were of every hue and race. Redheads with Irish freckles. Latina lovelies. Oriental princesses. East Indian goddesses.

"The pie was poisoned," I said. "We've died and are now in Paradise."

"Niiiccce," said Erik, not unlike a serpent.

"Sure is," said Duncan, though he may have been referring to the pie.

Another bevy of young girls fluttered in and sat down across from us. Erik smiled at them. They smiled back. We took this to be a good sign. By now, Erik was trembling. "Let's go," he pleaded. "Before I get us all in trouble."

But the streets offered no sanctuary. Everywhere we turned we saw them: the girls of St. Thomas, heart-stopping beauties who could melt your eyebrows with a half-smile and topple you over in the street with a toss of their hair.

"It's like the *Twilight Zone*," I whispered. "Or the Elephant's Graveyard. We've discovered the Valley of the Gorgeous Women."

"This is," said Erik. "This is—" Words failed him.

"Overdrive?" I offered. He nodded mutely and watched them pass.

"Jeez," said Duncan. "Will you look at all the pretty girls."

But then, like little birds, they were gone. In an instant, they had flown and we were alone again. It was traumatic.

"I knew it," said Erik bitterly. "I knew it. The pie *was* poisoned, but this isn't Heaven. We got sent the other way."

It was an awful lot like the punishment given by the gods to Tantalus—to forever reach for succulent fruit only to have it forever move out of reach.

4

THAT NIGHT, HAL called a meeting. We were stunned.

"Meeting?" we asked. "*Meeting?* Not a Group Awareness Session? Not an Introduction to District Goals and Work Objectives? Not a Discussion of Personal Developmental Skills?"

"No," said Hal. "Just a plain old meeting."

"We've never had one of those," said Duncan.

Hal, as it turned out, was new to Katimavik. The group leader originally assigned to St. Thomas had left the program for personal reasons; as in "I quit, do you hear me? I quit! I can't take it any more!" Hal was hired just two days before our arrival and—get this—he couldn't even name all the rules in the Code of Conduct. He had never been through Group Leader Basic Training, either, which is why he still talked like a normal human being.

"The first thing we do," said François, "is make the committees."

"The what?" Poor Hal. He really was in the dark. Committees were the very lifeblood of Katimavik.

François sighed. He began ticking them off: "Environmental Awareness, Active Leisure, Nutrition, Second Language—"

"Don't forget the Beer Committee," said Erik.

"The Beer Committee?" Hal was baffled, but Erik was only too happy to explain.

"Every week, the committee is responsible for buying the group's beer out of the, um, beer budget. You know, for the weekend. It's all part of the program."

"It is?" Hal was now baffled *and* incredulous.

"Sure," Erik reassured him. Duncan and I nodded in accord, but Hal was not having any of it. "Meeting adjourned until I can look some of this stuff up. I'll see everyone in a couple of hours. I've got to get back to my wife."

François interrupted. "About the work sites," he said. "Explain."

Hal stopped and looked at François. "The meeting's over."

"The work sites. Explain."

There was a long pause. When Hal spoke, his voice was quiet. "I just said the meeting is—"

"No," said François. "Not until you answer my question."

And that pretty well set the tone between Hal and François. For some reason, François took an instant dislike to Hal. Maybe it was Hal's casual approach to Katimavik. Maybe it was the moustache.

We never did get approval for the Beer Committee.

5

APRIL 16

Jumboville, Ontario

Dear Everybody:

Greetings from Ontario, land that Albertans love to hate (along with Ottawa, Québec, Toronto, Québec, those layabouts in the Maritimes, those farmers in Saskatchewan, those New Age hippies in B.C., those Damn Yanks to the south, Québec, and—of course—

Québec. In short, everyone who fails to live up to our exacting standards: namely, being Albertan).

We are no longer on the fringes of civilization as we were in British Columbia. We now live in a comfortable old house on Maple Street. How much more Canadian can you get?

St. Thomas was once a major rail town, and it remains an important transportation link. I know this because I have read the Chamber of Commerce pamphlet. (I also have it on a reliable source that the Chamber of Commerce would like to take this opportunity to welcome visitors to their thriving community in the heart of southern Ontario.)

On a lighter note, St. Thomas is also the town where Jumbo the Elephant was killed by a train. You must have read about it, it was in all the papers—*back in 1885*. Point of etiquette: it is considered bad manners to point out to the people of St. Thomas that no one really cares about Jumbo any more.

The town motto, however, is *not* "We Killed Jumbo the Elephant and We're Damn Proud of It," but rather, "St. Thomas: Garden City." The town's main attraction is a surplus of nubile young women. Within St. Thomas—and just a few heartbreaking blocks from our Katimavik house—is Alma College, an all-girls' international school for the rich and beautiful. They don't really fit in with St. Thomas's blue-collar roots, but they do add a touch of class to the place.

I was hoping that one of our work sites would be Alma College—private tutor, gardener, back-washer, that kind of thing—but no, we have three work sponsors, all of which have a distinct lack of nubile young women:

1. The Kettle Creek Conservation Area

This will involve cutting grass and then watching the grass grow and then cutting it again. There are two campsites, one at Kettle Creek and another at Lake Whittaker. Lysiane, Erik, Sarah, and *moi* will be here.

2. The Even Tide Nursing Home

Old people. Lots of them. More than you can shake a stick at. No one wanted to go here, so François got mad and said he'd go.

3. The Care Centre

A centre for severely handicapped children. Marie-Claude will be here. It looks to be an emotionally draining job, but if anyone can handle it, Mac can. She has this absurd idea about the basic goodness of life.

Our group leader is Hal Vanbreesenbröckendocker (or something to that effect). He reads Zane Grey, wears a farmer's cap, and has a superfluously large moustache. In spite of all this, he is a decent fellow. Hal received less than three days' preparation before being sent to live with us as our leader, though trying to lead us is a bit like trying to "lead" a herd of mice. Hal is enthusiastic, but you can tell he's distracted; his wife, we soon discovered, is With Child. Hal only gets to see her on Sundays.

Our group is struggling along, defying gravity and common sense. Erik has avoided being deselected. Sarah is still Sarah—much to my profound disappointment. François is moodier than ever. Lysiane is, as always, both introspective and sociable. Mac remains the group cheerleader. And Duncan has doggedly managed to endear himself to most of the group. It really is hard to dislike Duncan—you might want to throttle him occasionally, but you would never actually *dislike* him. Though we might make an exception when it comes to his cooking. Work begins tomorrow and it's Duncan's turn in the kitchen.

Luck and laughter, your brother/son/nephew/mentor/ally/leeching money-sucking grub (choose only one of the above),

Will

P.S. Thanks again for the monetary contributions (which I did not blow on pizza and beer).

6

IT WAS A COLD, moist Monday morning. Duncan had served up his infamous scramble-poached eggs (even he couldn't make up his mind what they were supposed to be). It was the first working day of a new rotation, and Sarah was my partner. Nuff said.

Erik and Lysiane were taken to Kettle Creek, and Sarah and I were dropped off at Lake Whittaker, a smaller and more isolated camping site. A few moments later, a pickup truck came barrelling down a side

road, kicking up gravel and dust as it went. It was our new supervisor in his Official Forest Ranger Truck. Expectations to the contrary, the guy inside was not some weather-beaten mountain man. He was rather pink-faced. Youthful. Clean-shaven. And—

"*Cute!*" said Sarah.

Mr. Cute introduced himself.

"Humphrey!" said Sarah. "That's a cute name!"

I introduced myself as well: name, rank, home province.

"So," he said. "Are you a cowboy?"

I didn't miss a beat. "One of the best," I said. "Won the Golden Lasso at the Red Deer Rodeo."

Humphrey nodded, suitably impressed. (And well he might be. Do you have any idea how hard it is to win the Golden Lasso? Especially considering it doesn't exist.) Sarah, meanwhile, was employing all of her feminine guile.

"Are you a *real* forest ranger?" she said, in what was presumably meant to be a coquettish manner.

Humphrey assured us that in fact he was. He then put us to work on the other side of the lake, which, curiously enough, placed Sarah and me as far away from him as possible. He assigned us to Ongoing Park Maintenance, which was another way of saying "cut the grass." The trouble began almost immediately.

"We have two mowers," I said to Sarah. "A tractor for cutting the open areas and a push mower for in among the trees."

At last, I was in my element. Having spent several summers cutting grass at various parks back home, I actually knew how to operate a tractor mower. But Sarah had already climbed aboard and was searching for the key.

"Sarah, have you ever driven one of these before?"

"What's that got to do with anything? Just tell me where the ignition is."

"Right in front of you," I said. "Just below those big orange letters that say IGNITION."

Sarah cranked the key and sailed off. In reverse. "*How do you stop this thing?*" she screeched.

"The brake! Try the brake."

She did, and the mower lurched to a drunken halt. I walked over. I took a deep breath. "Sarah," I said. "Why don't you take the push mower, and I'll—"

"Sure," she yelled. "Take the easy job! Take the fun job! You *always* get your way."

Sarah, one of these days when you least expect it— "All right," I said. "I'll take the push mower. But at least let me show you how this one works."

My instructions were not given in the spirit of camaraderie. I gave them out of concern for the safety of any campers in the area. I saw only one tent within striking distance, but I had long since learned never to underestimate Sarah.

A few minutes later, I was manouevring the push mower around a stand of poplars when disaster (aka Sarah) struck.

Out on the lake, the occupant of a lone canoe glided across the water. A warm breeze was rustling through the trees. A robin—or blue jay or magpie; it doesn't matter, since it has been added solely for dramatic effect—swept by, its song lost to the din of the lawn mower. It was a beautiful robin. (Or blue jay or magpie.) Turning, I looked over to see how Sarah was doing.

She was fighting with the gear shift. The tractor was eating the tent.

Now, when I say "eating," I mean more of a gnawing action. The rotating blades had caught a corner and were slowly dragging the tent in. I raced towards Sarah, yelling for her to stop the machine. She did, but she failed to turn off the blades, and I watched helplessly as more nylon was sucked under, chewed up, and spit out. Pieces of tent and down sleeping bag were everywhere. By the time we stopped the assault, a good chunk had been consumed.

Katimavik! Your tax dollars at work!

Sarah surveyed the aftermath for a moment. "Boy, we really did it this time, eh?"

"*We?*" I asked.

"Come on, Will. What are we gonna do?"

"*We?*" I repeated.

By tilting the mower, Sarah and I managed to unwind the tattered remnants that were wrapped around the axle. We gathered up the rest of the far-flung debris and placed it back beside what was left of the tent.

"Do you think they'll notice?" asked Sarah fretfully.

At the end of the day, Humphrey called us into his office to inform us that one of the campers had come to him in a state of near-hysteria.

Sarah was sweating unbecoming buckets. "Really?" she said.

"I'm afraid so." Humphrey leaned across his desk and stared at us. "I have a question."

Sarah had that awful pallid complexion people get just before they faint.

Humphrey lowered his voice. "Did either of you see a bear out there today?"

"Bear?"

"Don't be alarmed. But it seems that a bear mauled a tent." Humphrey shook his head. "Strange thing is, it didn't touch the food hamper sitting just a few feet away. It's the damnedest thing."

And this was how the entire staff of Lake Whittaker was put on bear alert for the rest of the summer. Poor fools. If they had realized that the park was actually under siege by Sarah and not some rogue bruin, they would have really been worried.

As Sarah and I sat waiting for Hal to pick us up at the end of our auspicious First Day on the Job, she began to cry. She didn't *weep*, exactly. She just screwed her face all up and forced out a few tears.

"It's not that bad," I said, refusing to put my arm around her.

"You didn't have to yell at me back there after we left Humphrey's office." She had given up on crying and was now content to let her nose dribble.

"What do you want, an apology? Okay, I'm sorry. There! Are you satisfied now?"

"Those were really mean things you said." She sniffled some more. "Humphrey prob'ly heard you. You were yelling loud enough."

I could think of a million places I would rather have been just then, beginning with the Black Hole of Calcutta. "Let's forget about it," I said. "Water under the bridge."

But Sarah refused to let the issue die. "Those were really, *really* mean things you said."

"I know." (I had waxed poetic in my description of Sarah's mental capabilities.) "I'm sorry. Truly."

"Are not," she said and began to pout, which is a lot quieter than snivelling, but much more annoying.

I looked down the gravel road, hoping to see Hal's station wagon coming to the rescue. Nothing. I was trapped.

"Will?"

"Yes, Sarah?"

"Why do you hate me so much?"

"I don't hate you *so much*," I said, latching onto a grammatical point in the hopes of evading the question.

"You do hate me," she pouted. "I can tell."

"Sarah," I sighed. "It's not that I hate you. It's just that I find it hard to *not* dislike you, that's all."

This succeeded in confusing her long enough to take her mind off being angry. She switched to melancholy instead. "Will, why don't you ever go for walks with me like you do with Lysiane? Or joke around with me like you do with Marie-Claude? You know, back in B.C., that first night when it was just you and me in the barn, I thought maybe we'd end up as boyfriend and—"

"Is that Hal up ahead?" I pointed down the painfully empty road.

"You know something else?" she said as she wiped her nose. "I've never even had a boyfriend, not even once. In my school that was a big deal. If you weren't popular, nobody liked you."

Huh?

"It's true," she said. "It was like pair pressure. Even my friends didn't like me, not really. At least in Katimavik I can have friends."

I gathered up all my courage and reached over to pat her hand. Much to my surprise, it wasn't clammy or covered with warts. It was actually kind of soft.

"I don't even know why I'm telling you all this," she said. Now she really was crying. "I almost had a boyfriend once, but he changed his mind."

"Come on, Sarah, being popular isn't the main thing in life. That's

high school. It's over. What we are doing here, it's—it's something else. I'm not sure what exactly, but something *more*." It didn't make a lot of sense, even to me.

In the distance, Hal's station wagon appeared, pursued by a cloud of dust. Sarah squeezed my hand. "Thanks for helping me with the tent and listening to me and everything."

"Well, I'm always around if you need someone to talk to," I said, surprising us both.

7

WE WERE STARVING by the time we got back to Maple Street. Unfortunately, Duncan had supper waiting for us when we arrived.

"You've really outdone yourself this time," I said, dropping my fork into whatever was fermenting in my bowl.

"Thanks," said Duncan. "How is it, Hal?"

Hal swallowed hard and said, "Not bad." (That was Hal's favourite evasive answer, "Not bad.") "But you might try using a recipe or something next time."

"Naw," said Duncan. "My pork-and-potato stew is the same no matter how you make it."

I picked up a chunk of bread—you could never cut Duncan's bread, you had to pry away pieces with your bare hands—and said, "You might try using yeast in your bread as well. I mean, it's not like we're being pursued by the pharaoh, right? We can spare a moment to let our bread *rise*."

Lysiane nodded. "*Oui*, I almost lose my tooth on it."

"It's supposed to be chewy," said Duncan.

Coincidentally, at our next meeting Hal set up a chart with the Four Food Groups on it and asked us to make sure we prepared well-balanced meals. Duncan's last culinary delight had consisted of bread, more bread, boiled potatoes, and white rice.

"A bit on the starchy side," said Hal.

Cooking was not the main topic of the meeting; work placements were. François was unhappy. And when François was unhappy, which

was often lately, things tended to come to a standstill until the issue was resolved. Mac was having a tough time at the Care Centre, too, but she wasn't as vocal about it.

"I like old people," said François. "My grandfather. My grandmother. But this job is not how I like. It isn't active. I am doing nothing, just talk with the old guys or sometimes help the nurses. It's not what I want in Katimavik. I don't want to sit around talking all day. This is a Duncan kind of job. Me, I prefer—"

I cut in. "François, what does any of this have to do with Duncan?" But François ignored me.

"Hey, *Frank*. I'm talking to you." And suddenly there was this chill in the air. François stared at me without saying a word. I stared back. This is how nuclear wars start.

"Come on, Will," said Duncan. "Let it go. It doesn't matter."

"Yes, it does matter. He insulted you! And you just sit there like a lazy sack of shit—"

"Don't call me a sack!" said Duncan.

"Or what? You'll get really peeved and maybe sit there some more?"

"Hey, hey, hey!" Erik and Hal yelled almost in unison.

"Calm down," said Erik. "Stay on board, okay? François, you apologize to Duncan this instant or I'll get really, really sad and start to cry."

"It's okay," Duncan insisted. "There's no need."

"François?" said Erik, and his lip began to quiver. "I'll start to cry. I swear I will. And you'll feel really bad."

François shook his head and half-laughed, half-sighed. "Okay, I apologize to Duncan. I am sorry for whatever. It was just an example."

"Spacious," said Erik. "Now, shall we continue?"

Hal exhaled like a man coming up for air. "We were discussing work sites. Is that correct?"

"Yes," said Mac quietly. "Me too, I am not happy. The work is too hard on my emotion. I need a relief, you say?"

So here's what happened: Lysiane agreed to take Mac's place at the Care Centre, and I agreed to take François's at the old folks' home, *just to piss him off*.

"Two other announcements before we adjourn," said Hal. "First of all, French lessons."

"What about them?" asked Erik.

"We're going to have some."

We groaned, but Hal went on. "And our first group outing has been arranged. I've got us tickets for *Romeo and Juliet* at the Stratford Festival, Saturday night."

"Saturday?" said Erik. "As in, tomorrow? Sorry, Hal. I'd love to, but I made other plans."

"Tough luck," said Hal. "You're going. We're all going. And we are going to have a good time." It was more of a threat than a promise.

8

IF YOU THINK St. Thomas's connection to Jumbo the Elephant is tenuous, consider Stratford, Ontario. Stratford's connection to Shakespeare is as slight as they come; it was all based on a coincidence of names. Stratford, Ontario. Stratford-on-Avon. Get it?

Originally the area was known as Appin, and the river that ran through it was called the Little Thames. Around 1830, a local saloon-keeper decorated his bar with a picture of Will Shakespeare—you know, to add some class to the joint—and the next thing you know, people were calling his place "Shakespeare's." From there it was a short step to begin—jokingly—referring to the village as Stratford-on-Avon. The "on-Avon" was eventually dropped and the town became simply Stratford.

In 1958, local newspaperman Tom Patterson came up with the idea of holding a theatre festival in Stratford solely because of the similarity in name between the Ontario town and Shakespeare's birthplace in England. The railway yards that had sustained the town were closing down, hundreds of men were out of work, and the town's economy was foundering. It is a testament to Patterson that he was able to convince the council of a depressed blue-collar town to back his scheme. They voted him a small budget and turned him loose. The first festival was held in a tent.

Today, the Stratford Festival is ranked as one of the finest in the

English-speaking world, with three permanent stages and an annual budget of over $20 million. A theatre of spectacle and energy, it has recaptured the raw energy of Shakespeare's original thrust stage, where the audience surrounds the actors and the action thrusts itself outward, breaking down the fourth wall of theatre, making the experience vivid and embracing the very essence of—

Erik was not impressed. "This sucks," he said. He thought Romeo was a bit of a wimp—and balding to boot. He did like the cleavage in Juliet's bodice, mind you.

The surprising thing about Stratford, Ontario, is just how attractive it is. Because the town was never really rich, because it never became a booming centre of industry, its old town hall and library, its churches and wonderful old brick neighbourhoods were never levelled by town planners and replaced with that horrid 1970s architecture that is the bane of so many communities in Canada. Stratford's boom, when it did come, was built as much on high culture as on commerce, and the result is a city that has been carefully reconstructed, renovated, and relandscaped. Heck, they even imported swans. (Swans. Stratford. Get it?) For a small place in the rolling countryside of Ontario's tobacco belt, Stratford has done remarkably well for itself. Mind you, they don't have no giant elephant statue.

On the drive back to St. Thomas, Lysiane couldn't contain her excitement; it spilled out like shaken champagne. She had been involved with backstage theatre production in her CEGEP and Stratford had made an impression on her. "Maybe I work there some day," she said. "Making the costumes. Designing the *scène*."

Sarah was staring out the car window. "That was so sad when Romeo killed himself."

It was past midnight when we got back, and we practically sleepwalked into the house. I yawned my way into bed and was snoring within minutes.

"Will, get your jacket." It was Erik, and he was shaking my shoulder. "Get up," he said. "You and me are stepping out."

"What?"

"*Shhhhh.* Hal's asleep. C'mon."

"Erik, the only place I'm going is back to sleep."

"Fine, be a fish if you want. I'll get someone else to come along. Maybe François. He speaks French. Allison will probably find that sexy."

"Wait a sec." I sat bolt upright. "Who's Allison?"

"Just a girl. A beautiful girl. Forget about it. I'll go get François. *Hey, François.*"

"Hang on," I said. "I'm on my way."

Erik and I doused ourselves with Aqua Velva and snuck out the back door. The girls were waiting by the railway tracks that skirted the wooded grounds of Alma College—a favourite trysting place among St. Thomas youth.

"We've been waiting almost an hour," hissed one of the girls. She was Irish, all copper and freckles, and I realized where I had seen her before.

"You were in the Green Lantern Restaurant," I said.

"That I was. And I remember you well, you and the others, fighting over a piece of pie like a gang of wee boys." She spoke with that lilting Irish singsong that is so appealing in the first five minutes and so annoying thereafter. After ten minutes it was like having my nails dragged across a blackboard. After twenty it was like chewing tinfoil.

"My name is Constance," she said. "But the other girls, they call me Corky. You can call me what you like, I suppose. And this is my friend Allison." (Rich girls always have names like that: Constance, Allison, Phoebe. We met very few Becky-Sues or Bobbi-Jos at Alma College.)

Allison, a short surly girl, was Constance's sidekick, in much the same way, I suppose, that I was Erik's. Sidekicks rarely like each other, and Allison and I were both well aware that we had been asked along to provide a cover for the other two. The four of us went to the Jumbo Bar and caught the last round. Bouncers in St. Thomas are all too aware of Alma girls trying to sneak in under age, but Constance and Allison were both legal. Barely.

The next problem came with paying for the drinks. The girls ordered frilly, frothy cocktails each of which cost more than Erik and I made in a week. I was squirming with embarrassment, but Erik announced—loudly and without shame—that he and I had no money

whatsoever and could not pay for anything. And the girls thought this was grand!

"Katimavik, it sounds tough," said Constance.

"Oh, it is," said Erik with a carefree shrug. "We get by, day by day. It's a hard life, but we like it. Don't we, Will?"

"Sure," I said. "We thrive on manual labour."

"We're just drifters," said Erik. "We're here for a few weeks, a few months, and then, who knows where we'll be?"

"St-Canut," I said. "We're going to St-Canut."

Erik shot me a cold look. "Maybe. Maybe not. Who knows? Wherever the wind takes us."

"We're going to St-Canut," I said. "It's in Québec, near Montréal."

Erik sighed—growled, really—and shifted the conversation elsewhere. Later, after we had dropped Constance and Allison off and were walking down Ross Street, Erik said to me, "You have got to work on your patter."

"Give me a break," I said. "Those girls are way out of our league."

"How so?"

"They're rich. Filthy rich. Allison told me she got a Corvette for her nineteenth birthday. I don't even own a bicycle—not even an old three-speed with a banana seat. That outfit Allison was wearing probably cost more than my entire wardrobe."

Erik looked over at my T-shirt and corduroy ensemble. "Will, her left shoe cost more than your entire wardrobe. But you're missing the point, my little friend. Think of these Alma girls as—as Juliets, locked away in a castle. Alma even looks like a castle, don't you think? They sit up there on their balconies and they wait for their Romeo to show up."

"Driving a Porsche," I added.

"Exactly. But then along comes a gypsy with patches on his sleeves and they forget all about Romeo—and his Porsche. It works like a charm. We're gypsies, Will. Women love gypsies. Don't laugh—it's true. The only thing better than being a gypsy is having some terrible problem, like being sad or lonely or an alcoholic or having an incurable disease or a really bad limp or something. Me, I prefer being a gypsy."

"But Erik," I said. "We're community-sponsored, government-funded, volunteer-program gypsies."

He shrugged. "So we're modern gypsies."

The entire house was sleeping, and as Erik and I crept up the stairs we discovered several squeaky floorboards that had gone unnoticed until that very moment. To muffle the sound we performed the always effective Tip-Toed Facial Scrunch. We were just outside Hal's room when he called out.

"There's something for you boys on the kitchen table."

Erik and I exchanged glances and went to investigate. There were two envelopes waiting for us. Inside mine was a short note.

Dear Will:

This might have been a ticket back to Alberta. Think about it. This is your first and last warning.

Have a nice night,
Hal VanB.

Erik's message was more or less the same.

Hal didn't say anything the next morning. He took Sundays off to be with his wife, and as he left, he raised his cap at Erik and me—and he smiled. It was unnerving.

Marie-Claude had gotten it into her head that we needed a garden, and she recruited several of us to help cultivate the back yard after breakfast. In the spirit of Katimavik, she planted eggplant and zucchini as well as the more traditional potatoes, tomatoes, and onions. I was in charge of tomatoes. Tomato Will, they called me. And if I had to sum up the most important thing I learned during my nine-month tour with Katimavik, it would be this: never plant tomatoes an inch apart. They have a tendency—and frankly this part baffled me—to *grow*. And before you know it, you have this living, photosynthesizing, pulsating entity. Within weeks, our garden would become a tangled, inaccessible briar patch that just kind of sat there in the corner of the yard, breathing, and defying any of us to get at the tomatoes. So I would definitely recommend planting your tomatoes a little farther apart, like in separate yards, perhaps.

None of this was apparent to me at the time, of course, and I happily went about planting the seedlings a thumb's-length apart. Even now I shudder at the innocence of the lines I wrote in my journal that day: "Planted tomatoes. Lots of fun. Looking forward to picking them later." Had I known. Had I only known.

9

MONDAY MORNING ROLLED AROUND, and with the new week came a change in cooks. We had survived a week of Duncan's culinary delights, and now it was Mac's turn. Following Duncan on the cooking schedule was always a breeze because you were guaranteed a positive comparison. "Wow, spices!"

I was feeling uneasy all through breakfast (scrambled eggs with actual pepper). This was my first day at the nursing home, and I was having serious second thoughts. I wasn't sure if I wanted to be around old people all day. True, I got along great with my grandmother, but she wasn't sick, senile, or suffering from Alzheimer's. She was a tough old doll who drank brandy, painted landscapes, and wrote a gossip column for a local paper back home. You could kibitz with my grandmother; you could laugh and joke and try to beat her at Scrabble—which was impossible, because she tended to use triple-score words that didn't technically exist. Words like "paperize." ("If someone puts wallpaper up in their room, they have paperized it," Grandma would insist.) If the seniors at Even Tide had been like my grandma, I wouldn't have been worried. But a nursing home is not the same as an old-age home; everyone at Even Tide needed medical attention. Many were dying.

Lysiane was as nervous as I. She was starting at the Care Centre, and we walked to work together. We parted company at the centre. I wished her luck and continued on alone, down Mary Bucke Street to an innocuous-looking building surrounded by a wide lawn: Even Tide. My first impression of the place was its antiseptic, medicinal smell, like someone had been washing the walls with Listerine.

My supervisor was a lady named Mrs. Bergman. "Have you ever worked with seniors before?" she asked. "No? Then I'll give you the

same advice I gave François. Senior citizens, incredibly, are human beings. They aren't made of glass, they aren't children, and they aren't wizened old sages who know the secret of life. They're people. It's true, some of them are in very weak condition and many *are* quite childlike, but they have all lived full lives and chalked up a lot of experience. There is a world of difference between childish and childlike. Many of the seniors here at Even Tide are disabled. We have stroke victims. Parkinson's. Alzheimer's. Diabetes. You may be asked to help the nurses feed some of the residents, or bathe them, or take them to the bathroom, but your primary responsibility is simply to interact with them."

"Meaning?"

"The nurses at Even Tide work very hard. They don't have enough time to stop and chat. Many of the seniors here are lonely. They need someone to spend time with them. Quality time. That's where you come in."

Quality time. Terrific. "Any last words before I enter the fray?"

She smiled. "Don't put yourself above them. And just as important, don't put yourself below them. We have more than a few characters here. They may try to manipulate you, or even push you around. Just treat them with respect and good humour, and you'll do fine. You may even learn something."

"About old people?"

"About yourself."

My first assignment hurled me right into things. I was sent to change the bedding along one wing. This was easy enough until I arrived in the room of one Mrs. McLeod, who sat with regal disdain, watching me from her wheelchair. She reminded me of an old duchess who had long since lost her fortune and estate but still— defiantly—kept her title.

"What are you doing!" she demanded. She rolled her r's in a classic Scottish burr, right out of Dialects 101.

"I'm, um, changing your linen."

"Stealing it, more likely. Where's yer badge then?"

She meant my name tag. I showed her and she scowled. (This lady

knew how to scowl.) I was pulling the sheets off the bed when she pounded a fist on the side of her wheelchair.

"I can do tha' myself! I don't need some young snot doing it for me. D'ya hear what I'm saying?"

I continued without responding, in the hopes that she would just go away.

"Are you deef or something? I said I can do tha' myself."

I stepped back. She was really starting to piss me off. "Fine," I said. "Go ahead. Drag your sorry carcass out of that wheelchair and change your bed. Let me see you do it."

"*I can't*, you daft fool. Anybody can see that."

"And that's why *I'm* changing the bed." I unfolded a fresh sheet and began to tuck it in.

"What's yer name?" she demanded. "I'm gonna report you."

I fluffed up her pillow. "William."

"William *what*?"

I sighed. "Ferguson. William Stener Ferguson."

A transformation took place. She smiled—she actually smiled—and, leaning forward, she asked, "Scottish, then?" Her accent had inexplicably grown thicker.

"On my father's side."

Mrs. McLeod was now beaming at me. "Always a pleasure t'meet one of yer own. Now then, be ye Highland or Lowland?"

"I don't know. Highland, I suppose."

This was definitely what she wanted to hear, and she flung her hands up in glee. "It's a pleasure indeed. Everywhere I go in this awful place, I see nothin' but Englishmen and Irishmen and God knows what else." She dropped her voice even though we were alone in the room. "This place is overrun by Irishmen. It's even owned by an Irishman."

"Wait a minute. I met the owner when we first came to St. Thomas. He's from Trinidad. He's black."

"He's Irish, I tell you. Irish." Then, with a sidelong glance at the door. "Yer father, then. He's an Orangeman, is he?"

"I guess." (At nineteen I had never heard of the Orange Lodge.)

"I thought so," said Mrs. McLeod. "You've got fine Orangeman bones about you."

The janitor followed his broom into Mrs. McLeod's room just then, and with great, bored motions, he began to sweep up. Mrs. McLeod snapped her face back into Scowl Mode. "Ask him his name," she said to me from the side of her mouth.

"Pardon?"

"You heard me. Ask him his name."

I did. It was Phil.

"His *last* name. Ask him his last name."

I did. It was Murphy.

Mrs. McLeod nodded sagely and didn't say another word till poor Phil left the room.

"Do you see wha' I'm gettin' at?" she asked me. "Irish. They're everywhere."

I decided, just then, that I wouldn't mention I was a quarter Irish on my mother's side.

By the time I finished changing the rest of the beds, the dinner bell had sounded, and I had to hurry and help round up the residents, most of whom were in wheelchairs, and bring them down to the dining room. It was during this that I met another volunteer. He was an older, silver-haired man who helped get everyone in position around the tables. Once that was accomplished, he spent his lunch hour spoon-feeding a lady who had suffered a stroke and was now barely able to swallow. He fed her puréed baby food, he wiped her chin and gave her cold tea for dessert, and she sat looking off into the middle distance like a sad-eyed mannequin.

The man's name was Andrew Crumm and the woman was his wife. He was retired, and volunteered at Even Tide to be near her.

"When we were married," he said, "it was for better or worse. Good times and bad. In sickness and in health. Well, Dorothy and I had some wonderful times. Would hardly be fair to back out of the deal now."

"Does she recognize you? Does she even know who you are?"

"No," he said. "No, she doesn't. And I do miss the old girl."

"You come in every day?"

"She's my wife," he said, as though that explained everything. And

his smile deepened. "Sometimes, when I'm holding her hand, she turns just a bit and looks into my eyes. And she squeezes my hand, and at that moment, I'm sure she knows. And remembers."

"Does that happen often?"

"Well," he said, and there was a long pause. "To tell the truth, it hasn't ever happened. Not yet. But that's what I'm waiting for."

10

WHEN I LEFT Even Tide at the end of the day, I was strangely elated. My steps had a buoyancy. I wanted to stop people on the street and tell them about Margaret McLeod and her Irish/English conspiracy. I wanted to tell them about Andrew Crumm.

Lysiane was waiting for me outside the Care Centre, and she was far more subdued than I about her first day.

"How'd it go?" I asked.

"Not so good."

We took a short cut through a schoolyard empty of children but echoing still with their passage. A swing was moving without a wind, as if someone had run from it just a heartbeat before. The lawn had patterns of pursuit and escape worn into the grass. Lysiane sat down on one of the swings and didn't say anything. I was still feeling exuberant and would have given her an under-duck, but she was clearly not in the mood.

"The persons in the centre," she said. "They are, how you say, *très sympatique*. Very sad. Before I went in, I had many idea of have fun with the children. To do the dramatics or the game, but it is not possible. They can't do the children's theatre. They can't even feed themselves or to use the toilet."

"I know," I said. "There are old people like that at—"

"*No,*" said Lysiane sharply. "No. It is not the same. Not at all."

"Don't get angry, I was just—"

"The person who are old, they *had* the life, no? With the child it is a different sadness. None of them had the life. None. How—how does God let that happen? How does Heaven let that happen?"

"I don't know. You'll have to ask God. Rumour has it he's got a secret plan that explains everything."

Lysiane tried to continue, but her voice was wavering too badly. When we left the playground a mistlike rain began to fall. It followed us all the way home, and when we got inside, Lysiane went upstairs to be alone and I sat on the chesterfield. Erik flopped himself down beside me.

"Guess what?" he said.

"What?"

"No, really. Guess what?"

"*What!*"

"Come on, guess what happened."

I took a weary breath and slowly let it out. "The Mafia has a contract out on you."

"Be serious."

"I am being serious."

"Forget it. I'll just tell you. I think—I'm not sure, but I think—I've found a girl."

This is news? "Congratulations."

"No, man. I mean it. It's Constance. You remember Constance? I think she's the one. I'm thinking about seeing just her, you know. It's off the edge and half the same."

"Which means?"

He took a deep breath and made the plunge. "I'm only going to see Constance from now on."

"I don't know, Erik. One girl? Sounds kinky to me. And besides, she's Irish. They're taking over. If you read the papers, you'd know that. Reagan's in the White House, and with Trudeau gone and John 'I Am Not a Robot' Turner holding down the fort, it will just be a matter of time before what's-his-face, Mulroney, gets in, and then where will we be? Up shit creek without a paddle, that's where."[†]

† For the record, I want it noted that the above prediction was taken directly from my original journals. At the age of nineteen, I prophesied that Brian Mulroney would ruin Canada—or go down trying. Which, by my calculations, gives me a psychic score of exactly 100 per cent. Anybody wishing to pay me huge, ridiculous sums for further political forecasts may contact me via my agent.

"What are you talking about?" asked Erik. "The Irish aren't taking over."

I narrowed my eyes. "Y'know, Hjellerman sounds almost Irish to me."

"It's not. It's Swiss. Or Swedish. Or something."

"So your cover story is falling apart, is it now, Hjellerman? Or should I say—*O'Hjellerman!?*"

"Sometimes, Will, you are just too weird to talk to."

"Well, some of us don't have the gift o' the gab—like some people I know! Tell me, Taffy m'boy, when you kissed the Blarney Stone, *did you slip it the tongue!?*"

"Will, whatever the dosage is, cut it in half, okay?"

11

AT EVEN TIDE the next morning, I filled my cup with coffee and went for my soon-to-be perfunctory visit with the marvellous and batty Mrs. McLeod. She stopped me in the doorway.

"Don't move!" she said. "Let me look at you. Och, but you're a bonny lad. Typical Scot. Handsome, that's what you are."

"Why, thank you, Margaret."

"But your eyebrows . . . " She squinted at me.

"What about them?"

"They're bushy! And your nose. Turn around." I obliged only to hear her gasp. "It's flat! You've got a flat nose!"

"I do?"

"And yer teeth." She wheeled over and craned her neck. "Let me see yer teeth."

I opened my mouth, feeling a wee bit foolish.

"Oh, my Lord." She turned away. "Close your mouth. You've got horrible teeth."

"I do?"

"But don't you worry. Looks aren't everything."

Five minutes ago I was handsome. "Boy, you sure know how to cheer a guy up."

"Think nothing of it. Have a seat."

I sat down and placed my cup of coffee on her side table.

"So where's my tea?"

"Your tea?"

"Yes, my tea. When a gentleman caller sits down with a lady and *he* has something warm to drink, it is expected that he will offer the lady something of the same."

"Sorry. Would you like me to get you some tea?"

"No," she replied. "Can't drink the stuff. Not any more. Too acidy for my bladder." Then, with a smile, "But thank you for offering."

And so it was: every morning I would come to have my coffee with Mrs. McLeod and she would either compliment or criticize my features (often she'd do both), then I'd offer her some tea and she'd refuse. She would tell me about her bladder and I would pretend to pay attention, and we would both mutter darkly about the Irish.

Meanwhile, my circle of eccentrics was expanding daily as I made my rounds delivering mail. I saved the junk mail—the once-in-a-lifetime offers, the flyers, the coupons—for the residents who never got any letters, and among them was a grumpy old man named Bill.

Bill was difficult to approach at first. He'd say things that made you feel as if maybe you weren't welcome. Things like "Get out!" and "Leave me alone!" and "You are not welcome here!"

Mind you, he did have pearls of wisdom to offer. Why, on my very first visit, as we discussed politics and the Depression (two of Bill's favourite topics), he said to me, "You're ignorant and you don't know nothing."

"Double negative," I said.

"What? What are you saying?" (Bill was hard of hearing at opportune moments.)

"You should have said 'anything.' 'Don't know nothing' is a double negative."

Bill pointed his cane in my direction. "No one likes a smart-ass."

"Make up your mind, will you? First I'm ignorant. Now I'm smart."

Deliberately, slowly, he said: "You are ignorant. You know nothing. *And* you are a smart-ass."

Bill Stuart was as coarse as canvas and damn near as durable. He came of age in the Dirty Thirties and the tenacity he needed to survive

and raise a family had lingered on in anger and in stubbornness—the trace elements of harder times. He watched his father's farm turn to dust, he fought back, he lost. He fought again in the fields of France, and when the war was won, the battle had been lost. Bill Stuart had become a hard man.

I have a theory . . . (In fact, I have a theory on most things. Give me a moment and I will whip one up to suit any circumstance.) Here it is: the Great Depression and the war that followed provided an entire generation with an alibi for being sour. This is why they hold their hardships so near to their hearts. It was these hardships that both defined who they were and justified it.

Bill carried his past like a martyr's yoke. He suffered, but seldom in silence. He had a whole repertoire of clichés. They must hand them out at Grumpy Old Man School: an entire list of bellyaches. "You kids today have it easy." "Everything on a silver platter." "Makes me sick." "I had to walk twenty miles to school through snow and ice and dust storms *every day*!"

Needless to say, Bill was not popular with the nurses, and the nurses were not popular with Bill. They had no tolerance for his temper, nor for the dank mildew smell of his pipe. Bill, in turn, had no tolerance for their absolute ignorance. I fared only slightly better. In spite of Bill's repeated assertions concerning my incurable stupidity, when I came to visit he never failed to rummage around and hand me a peppermint or candy cane from Christmases past. Coming from Bill, these were tantamount to a declaration of friendship—or at least a truce.

One morning, I found Bill in a fret. "Got to get spiffed up," he said. "My son is coming today. Probably bring his kids, the little monsters."

I helped him with his tie and then gave him an arm to lean on as he stood up from his wheelchair and got behind his walker. "It's my birthday," he said, almost—but not quite—hazarding a smile.

It must have taken him ten minutes to get down the hallway to the reception area, but he refused to let me help. "I'm not dead yet, goddamn it." He always said that: "*I'm not dead yet, goddamn it.*"

"Fair enough," I said. "But if you fall over, I'm the one who will have to mop you up."

He sent a salvo of anger rays right at me.

"I know, I know. I'm ignorant, etc., etc."

Bill sat down facing the entrance, so his son would see him right away. I adjusted the knot in his tie, and he struck his most aristocratic pose.

"If you need anything, Bill, just tell one of the—"

"Do you mind? My son will be along any moment."

So I went off to help the nurses with the linen, and when I passed the foyer again an hour or so later Bill was still there, proud as ever, his back straight and head up, cane resting neatly across his lap.

"Looking good, Bill!" I called as I passed.

He just harrumphed some more and left it at that.

At lunchtime I brought Bill some food, which he didn't want. "I gotta leave room for the cake." And by two o'clock I was beginning to worry.

"Are you sure they're coming?" I asked.

"Of course, you ninny. It's my birthday."

A car pulled up in front and Bill brushed me away. But it wasn't his family, it was just a delivery van. I realized then that he didn't even know what type of car his son drove.

"Do you want me to stay with you?" I asked. "We could wait together."

"No. Go away. You're bothering me."

It was late in the afternoon when Bill sent for me. I helped him up and supported him all the way back to his room. The saddest thing, the very saddest thing—and I don't know why it hit me so hard—was how very carefully he had parted his hair. I asked him if he was going to be all right, but he didn't say anything. Not a word.

I took his supper to him in his room, but he didn't feel like eating. He was sitting by his bedside, and his necktie was still on. I went to see Bill the next morning but he stayed in bed all day. I never did meet his son.

Today, as I write this, I think of Bill and how he always snarled, "I'm not dead yet, goddamn it." I used to assume this was a cry of defiance, but now I'm not so sure. In retrospect, it seems as much a cry of regret.

12

BEFORE I KNEW IT, April had slipped away and the program was halfway home. Life on Maple Street continued: we attended French lessons, we took courses in massage, we studied solar energy. We even went on a tour of a ball-bearing factory, with its great molten vats of fire and smoke—the message of which is, never work in a ball-bearing factory. We wrestled our garden into submission. We held meetings. We planned events. Activity after activity rolled up and by, and our calendar was booked solid, covered in a chaos of scribbles, corrections, and countercorrections.

The biggest event coming up—and you could tell it was big because it was highlighted in yellow and underlined three times with a large asterisk beside it—was International Day. François and Sarah were the International Awareness Committee, and François had invited six other Katimavik groups in the area to come down to St. Thomas. The day's program included one of those ubiquitous Ukrainian dance troupes that pop up every time an event like this is held, a Japanese martial arts demonstration, and a man from Nicaragua who would speak about the ongoing crisis down there. (This was back in the days of Contras and Sandinistas.)

The Katimavik groups attending were asked to bring an ethnic dish representing one of Canada's many cultures, making for one big happy multicultural potluck supper. Erik arranged the martial arts demonstration; Sarah, the Ukrainian dancers; and François, the guest speaker. I was in charge of supper. The country I chose to represent was Italy, because I have always felt a deep affinity with this ancient Mediterranean culture. That, and the fact that spaghetti is just about the easiest meal there is to prepare for seventy-odd people. (And when we're talking about Katima-victims, the operative word truly is "odd.") I congratulated myself on being so darn clever. Unfortunately, the six other Katimavik groups had likewise congratulated themselves, and on Saturday morning, as the participants began arriving, they handed over—one after another—six vats of spaghetti. Every single group had made Italy its culture of choice. There was spaghetti and meatballs. There was spaghetti with tomato sauce. There was

spaghetti with the obligatory tofu. There was *more* spaghetti with tomato sauce, as well as spaghetti with mushrooms and spaghetti with herbs.

I made a mental note: next time assign cultures.

The potluck dinner was still many hours away, and I resolved to enjoy myself on what could very well be the last day of my life. I had a vision of everyone staring down at our spaghetti-and-spaghetti buffet and going into open revolt. As I was the one responsible for this feast, I would surely be the first to suffer.

Most of the day was spent at Lake Whittaker, where the dancers could spin and the black belts leap with lots of room. At noon, we broke for a lunch of soup and sandwiches that had taken Mac and me most of the previous night to prepare. All told, we had seventy-two visitors, not including group leaders.

Seventy-two participants. One day. Good-bye. This was Katimavik. It certainly taught us interpersonal communications skills. Mass activities such as these tend to bring out the gregariousness in people, and you have never seen a crowd mingle like a Katimavik crowd.

According to the unwritten social protocol that had developed, the opening questions were—in order:

1. Where are you from?
2. Where's your group stationed?
3. How are the work sites?
4. What's your name?

The last question was optional, because with so many people milling about, it is important first to decide:

(a) Do I like this person?
(b) Do I want to know this person?
(c) Do I want to perform the Dance of the Overactive Teenage Glands with this person?

Once you had checked off all of the above, you could decide whether or not to waste your time learning names. First names only, please, so as not to strain memories.

It got worse. With people from every province, region, and territory of Canada in attendance, it was inevitable that participants from the

same stop on the track would meet. Protocol had it that this should be greeted as a miracle. What followed was a game of D'yaknow? and it went something like this:

"Hi, where you from?"

"Minnedosa."

"Minnedosa, Manitoba? I'm from Brandon!"

"No kidding! I have friends in Brandon."

"You do?"

"Sure. Do you know Jon Dunnill?"

"No. Do you know Susan Bradley?"

"No. D'you know Beelzebub Brown?"

"No. How about Pierre Pamplemousse? D'yaknow him?"

"No. How about Potato-head Panchyk? D'yaknow him?"

"No. How about—" and so on.

These conversations could go on for hours, with both parties flinging names at each other until they finally arrived at one that was mutually recognizable. At that point, both people were required to shake their heads in a wise manner and say, "It's a small world, isn't it?" And unless the two participants were of opposite sexes, there was no reason to continue talking, and both could now move on. After several rounds of D'yaknow? some people had begun to agree frantically with whatever name was first offered, just to put an end to it as quickly as possible.

"Summerside? No kidding. I'm from Skinners Pond. D'yaknow Peter—"

"*Yes!!* Yes, I do. Good ol' Pete. How is he? Great. Good. Gotta go. See you. Bye."

It was during these social interactions that I met Geneviève. In retrospect, the poet in me can't help but be disappointed. The clouds didn't part, violins didn't sigh, and we did not gaze intently at each other in Extreme Close-up, nostrils flaring and lips twitching. Instead, she came by the campground kitchen to drop off ladles for the spaghetti, and that—I suppose—is as good as it ever gets.

She was bright and tan and full of life that day. And when she saw the other cast-iron pots of spaghetti sauce she laughed out loud. "Oh," she said. "You are certainly in trouble now." (Though it wasn't

clear if she was referring to the supper or to the fact that she had burst into my world like a firecracker tossed down a well.)

Geneviève was from the Acadian coast of New Brunswick, from a small village named Petit-Rocher. "You're the first Acadian I ever met," I said. "Didn't the British expel you guys way back when?"

"Yes, but we came back."

"*Evangeline*," I said. "That's where I heard about it. We studied the poem in school. 'This is the forest primeval.'"

"You are a poet," she said. "A spaghetti poet."

Geneviève had that slightly rough, slightly raw, slightly alluring Acadian accent—part French, part Maritime English. Her group was based in London. Her work sites were tough. Her group was agreeable. But I knew I was really getting somewhere when she told me her full name: Geneviève LeBlanc. "LeBlanc is like Smith," she said. "All the Acadians in New Brunswick are either a LeBlanc or related to a LeBlanc."

"Still, it's a nice name," I said. "Can I call you Genny?"

"No."

What is it with this need I have to assign nicknames? "How about Gen? Can I call you Gen?"

"No."

"So I guess Genny-poo is completely out of the question."

She laughed, and I noted that, even in laughter, she had a slight accent. A touch of the forest primeval.

Geneviève had stayed to help me in the kitchen. Suddenly she declared, apropos of nothing, "This is boring. Let's run away. I saw a canoe by the lake." And she was off and running, with me trailing behind like a flag in the wind. "Over there," she shouted as she ran down to the water's edge. "Hurry up!"

Geneviève pushed off from the shore, with me scrambling in just in time, and we paddled out onto the lake in a series of indecisions, turning this way and that, our paddles out of sync.

She called back to me, "I think our canoe is drunk." And then, "Do you think our reflections look up at us? Do you think they find us strange?" And then, "Did you ever think Katimavik is a canoe?" And a

laugh. "Look. Over there." She pointed low across the water. "Do you see her?" A young mallard had come skidding to a halt on the surface of the lake.

"Do you think," whispered Geneviève, "we are able to get close to her?" (Whenever Geneviève saw something lively or wild or free, she always assumed it was a she. Cows, on the other hand, were always he's, all evidence and social conventions to the contrary.)

"I want to pet her," she said. "The duck."

We paddled closer. "*Shhhh,*" said Geneviève, even though she was the only one doing the talking. "We must be very quiet."

Geneviève lifted her paddle out of the water and carefully stowed it inside. I held mine tight to the side and arced the canoe silently towards the duck. We floated forward, into shallow waters thick with lily pads and cattails. The bow slid closer and Geneviève shifted forward, leaning farther, reaching out, reaching out—

We tried to right the canoe, but it was swamped, so we left it there, upside-down and caught in the weeds. Climbing onto the bank, we collapsed on the grass like two big puddles. My running shoes were so soggy they squished.

"Well, that's just great," I said. "You didn't even touch the damn duck."

"*Mais, non!* It is you that are the problem. You are a terrible navigator." She pulled off her shoes and began to wring out her socks.

I shook myself like a wet dog, and looked up to see Hal staring down at me.

"Will, there are a lot of hungry people up there waiting for you to serve them something." His voice had a distinct edge to it.

"We were, um, trying to catch a duck," I said.

Thank God for Italy. Heating up the spaghetti sauce took all of ten minutes, and fortunately the mob was so tired from the events of the day they didn't stage an impromptu riot. Variations on a theme: it became a kind of joke, seeing which group had brought the best spaghetti and which the worst.

Geneviève stayed behind and helped me wash up and put away the pots, in appreciation for which I let her beat me at badminton after

supper. The crowd of participants had retired to a school gymnasium at the end of the day, and Geneviève and I played eight games. I was a true gentleman; I let her beat me every time. It was the same with table tennis. And shooting hoops. And everything.

"More badminton," she cried.

My lungs were on fire and I was sweating like a pig in a sauna. (I had let her win again, this time by a considerable margin.)

"We better quit," I gasped. "You're looking tired."

She bounced around with her racquet poised before her. "I'm fine. It's your serve."

So I did the only thing a man with pride could do in a situation like this: I developed a sudden limp. "I can't, Geneviève. It's my knee. An old hockey injury."

She laughed. "I don't believe you."

"It's true."

"One more game."

"All right. One more."

Six games later, she finally relented and we went to our separate corners, her to the ladies' changing room and me to the men's. I couldn't quite make it to the bench, and I collapsed on the floor instead. Erik was just stepping out from the showers.

I leaned back against the lockers. "At times like this," I said, "I think the Chinese had the right idea when they bound women's feet. Probably some courtesan beat the Dragon King one too many times at badminton. That's probably how it began. Like a golf handicap."

"You've got a live one," said Erik.

"How about you? How is everything with Corky?" I began massaging my calf muscles, which were twitching like a frog in an electrode experiment. "Is widdle Corky still slumming with her bandit boy?"

Erik looked down at me, and you could tell he was considering kicking me in the ribs. "Her name is Constance," he said. "And she isn't slumming."

"Ah," I said. "'The dear dead boyish pastime! But *this*—ah God!—is Love!'"

"That's not bad," he said. "You write that?"

"No." I crawled to my feet. "Some guy named Rupert Brooke beat me to it."

The other Katimavik groups descended upon our house, turning our once-placid abode into Grand Party Central. The group leaders were prowling about, keeping everything on the up-and-up, but Geneviève and I managed to escape to the second-storey alcove.

"My private balcony," I said as we crawled out through the window. She sat down beside me, and when I didn't react she pulled my arm around her shoulder.

"It's cold," she said. "And you are still warm from badminton."

We stayed out on the balcony until dawn. From below us came the subterranean voices of the others, as though from the bottom of a mine shaft. The moon was caught in branches overhead, ripe and full. Geneviève fell asleep beside me, which would have been romantic except that my arm went numb and I woke her up with my limb flopping about like a dead fish. I kept getting sudden vicious cramps in my calves as well, which was not exactly conducive to romantic romps either.

From the front yard, I heard my liege calling. "Will!" It was Erik. "Where the hell are you?"

I stuck my head over the edge of the alcove and startled him.

"What're you doing on the balcony?" he asked.

Geneviève's sleepy head appeared beside mine. "Hello, down there," she said.

Erik grinned back in obvious approval. "Listen, the group leaders are making the rounds, taking a head count and making sure no one's breaking Rule Number Three. Better hurry."

Geneviève slipped back inside just in time. "Thanks, Erik," I whispered.

"On a balcony," he said, proud of his protégé. "Not too shabby."

"It's not what you think."

"It's *always* what I think," he said, and with one last grin he went back inside.

13

THE NEXT MORNING, once the other groups had gone (some had stayed at the community centre, some had stayed on our living-room floor), Hal called us together to offer his congratulations. "You all did a heck of a good job. Nobody got drunk or disorderly. Everyone had a good time. The dancers were terrific. The karate guys were great. The spaghetti was"—he thought for a moment—"not bad. And except for a few scheduling glitches, it all went well. It was a shame the guy from Nicaragua didn't show up, but those are the breaks."

"Maybe if you had helped us," said François, "it would have been a better day."

"That's not my job," said Hal. "The more you guys do together, the better it is."

"For who?" François asked.

Hal let it pass. "Does anyone have anything else to add? If not, the wife's waiting for me." (Hal always said "the wife," as though she were the only wife in the whole wide world.)

Lysiane put up her hand. "The Care Centre, it is too hard for the emotion. I want to work in the park, at Kettle Creek or Lake Whittaker, if that is possible."

"I understand," said Hal. "The Care Centre's a tough job. Anybody want to take it on? Will?"

"Nope. I'm happy where I am."

"I'd like to give it a try." It was Duncan, standing at the back of the room.

François laughed. "Sit down, Duncan. It's not for you."

Hal gave François one of his Zane Grey, high-noon gunfighter stares and said, "Fine. It's settled. Duncan's at the Care Centre. And I am out of here." He donned his cap and was gone.

With Hal off tending to his pregnant wife, we found ourselves without supervision. This might have meant a festival of gratuitous rule-breaking and gleeful cohabitation, but none of us had the energy. We relished the chance to spend a relaxing day with absolutely *nothing* on the schedule. It wasn't raining, but it might as well have been.

In lieu of television, most of us curled up with a book: Sarah with some Gothic melodrama, Duncan with something called *Winning through Intimidation*, Mac and Lysiane with—let me see—something French, and François with—yes, something French as well. (You can see that the language lessons weren't going to waste on me.) As for myself, I had my trusty *Penguin Book of Love Poetry*, purchased at a neighbourhood garage sale. It had cost me a day's wages, but what the heck, I was in the mood for something classic and uplifting and titillating. "*Forsooth, thy moistened flank doth quiver anon.*" I was drowsy by the time I got to the second page.

Only Erik had any vigour left. "What is this?" he demanded. "Our first free day since we got here, and you guys just want to waste it?"

No one paid him any heed, and he left shaking his head, off on his eternal Quest for Fun. Where he got his energy from was a mystery. The boy had copper-topped batteries.

Whatever diversion Erik was looking for, he must have found it, because he didn't show up for supper. Not that he missed much; we were trying to finish off the leftover spaghetti. Hal returned that evening and noted Erik's absence with mild concern before retiring to the living room to do his own Sunday reading—a Zane Grey masterpiece entitled *Coogan's Anger* or *Gideon's Vengeance* or *Percival's Pet Peeve* or something to that effect.

"Why do you read that stuff?" I asked him.

"Hmmm?"

"Those books," I said. "It's the same story every time. Some dirty, smelly rustlers kill the hero's father/brother/mother/cousin/dog/whatever. The hero rides out after them. He meets a couple of token Indians and a cancan girl with a heart of gold. He has a big shoot-out—"

"With the cancan girl?"

"No, with the rustlers. The place gets shot up, the villains die, and frontier justice prevails. And all without a Mountie in sight."

"Well, don't tell me how it ends," said Hal as he went back to his book. "The big shoot-out is about to begin."

This is no fun, I thought. I can't even get a rise out of him. I turned my attention to Sarah, who was moving her lips as she read.

"Why do you read that stuff?"

"Hmmmm?"

"Those twenty-pound romance books. They're all the same."

"Are not!" she said, going for the bait.

"Sure they are. The titles are all the same. *The Price of Passion* or *The Wages of Wickedness* or *The Cold and Cruel Cost of Cohabitation.* And on the front cover there's always a picture of some woman in a frilly dress with cleavage down to here."

"That's not true!"

"And on the back cover they have the character breakdowns written in breathless, incomplete sentences. *Venus-Adele*: heiress to the Herringbone fortune, forced to choose between wealth and the man she loves. *Caroline*: the fiery half sister, a she-devil no man could tame. *Clifton*: a mysterious stranger, back from the dead with large biceps and a duelling scar. Death has been very good to him. *Randolph*: the insanely jealous husband of Lady Herringbone. *Lord Fluffy Pillow*: keeper of the family secret—"

"Stop it!" said Sarah. "It's a good book!"

"Will?" It was Hal.

"Yes?"

"Shut up, okay?"

I should have gone with Erik. I picked up one of Hal's westerns and went to my room. The book was entitled *Dakota's Rage*. Within three chapters Jesse Dakota had met Misty, the cancan girl, and already he was "aimin' to leave town."

"I'm shore gonna miss yuh," said Misty.

"Yup," Jesse replied.

I had skim-read almost the entire book when Erik pounded on my door. "Will! Come quick!" He was laughing hysterically.

When I opened the door, he yanked me into the bathroom across the hall. He was doubled over with laughter, and when he came up for air, I checked his eyes. His pupils were dancing pirouettes.

"Erik, what have you been smoking?"

He switched instantly to Paranoia Alert. "Can you tell? Can you? Can you? Do you think Hal will be able to tell? Do you? Do you?"

"Relax. Just fill me in on what's happening."

Erik scratched his head. "What was it? Oh yeah!" He began

laughing again, in long staccato bursts like a machine gun backfiring. Between bursts he managed to say, "It's gonna be so funny. I'm telling you."

"No. You're not. What is it?"

I was afraid he would forget again, but the few synapses still firing in his brain made the connection.

"I went to the park," he said. "And I got us a group mascot."

Suddenly, behind me, something quacked, and I jumped in shock. There was a duck in the bathtub.

I took a deep breath. "Erik," I said. "Why is there a duck in the bathtub?"

"Isn't it great?" Erik flung his arms apart. "A Katima-duck! I named him George."

I closed my eyes. I shook my head. It was no use. There was a duck in our bathtub. A little duck, true. Not much more than a duckling, really. But still a duck.

"Erik, how on earth did you—"

"I tossed my jacket over him and then bundled him up. It was easy."

"Erik, you realize that you are a madman. What are we going to do with a duck?"

There was a knock on the door. We froze.

"Who is it?"

"It's me, Duncan. What's going on?"

Erik was adamant. "No! Don't let him in. He'll eat George, feathers and all." With that he bent over and laughed until his face went red. Hunched over like a contortionist on nitrous oxide, Erik finally waved for me to let Duncan in.

"Meet George," I said. "Duncan, George. George, Duncan."

Duncan's eyes widened.

"Duncan," I said. "You're a man of infinite jest. How do you feel George would best be utilized?"

"The toilet," said Duncan. "Definitely the toilet. Let one of the girls find him."

Erik and I were impressed. "Good thinking," I said. "It has every-thing you want in a practical joke: surprise, humiliation, toilets."

George fit into the bowl with room to spare—and don't worry, the

bowl was clean, and with our meagre budget, the last thing we could afford were those packages of silly blue dye.

"But remember," said Erik with sudden earnestness. And he pronounced those words that would become our rallying cry and credo for the next four months, words that have inspired me throughout my life and that, even now, are worth repeating: "Whatever you do, don't flush the duck!"

Erik stayed upstairs in his bedroom while Duncan and I walked downstairs whistling in an innocent, hands-in-your-pockets sort of way. As a clever ruse, we began to play checkers. It was a quiet evening: Hal and Sarah were still curled up with their respective genres, Lysiane and Mac were at the dining-room table writing postcards and chatting softly. We waited. And sure enough, Lysiane excused herself and went upstairs. We heard the door open, we heard her footsteps—and then the screaming began.

"*Un canard! Un canard!*" Lysiane came crashing down the stairs, tripping over her feet all the way. "There is a duck in the toilet."

Hal looked up from his novel. "A duck?" he said.

"Yes yes yes! In the toilet."

Hal sighed and returned to Zane Grey.

Marie-Claude came into the living room. "*Qu'est-ce qui se passe ici?*"

"*Il y a un canard dans la toilette!*"

Lysiane dragged Mac up the stairs, and the two came running back down moments later. Now they were *both* jumping up and down and screaming.

Hal looked up once more. "In the toilet?" he said.

"*Oui oui oui!*"

Hal went back to his book.

"Will! Duncan!" they implored. "Come!"

I turned to Duncan. "What are they screaming about?"

"Beats me," he said and moved a checker.

Lysiane and Mac finally convinced Sarah to go upstairs, and soon we had *three* hysterical people on our hands.

"Come on," I told them. "You don't expect me to fall for the old duck-in-the-toilet routine, do you?"

"It's true! It's true!" they yelled. "It must have flown in through the window."

Hal placed his book to one side. "Ladies," he said. "If I have to put down a Zane Grey classic and go all the way upstairs, there had better be a duck in that toilet. *Comprenez?*"

"But there is one, Hal. There is." They began to tug and pull at him, and reluctantly he followed them upstairs.

By this time, however, Erik had retrieved George, and when Hal flipped back the lid—

"Nothing," he said.

The girls were dumbfounded.

"But, but, but . . . ," said Mac.

"There was a duck," insisted Sarah.

"He was right here," said Lysiane.

"Hold it." I looked around the group crowded into the bathroom. "Did one of you flush the toilet?"

The girls shook their heads adamantly.

"Sure," I sneered. "That's what they all say. Right, Duncan?"

"Right, Will."

"And I say we have a duck-killer in our midst. Nobody is leaving this room till I hear a confession."

"I've had enough of this," said Hal, and he left.

"Lock the door, Duncan. We'll sweat it out of them."

"But, but, but . . . " It was Mac again. She wasn't making any sense.

"Let's see, now." I stroked my chin. "Locked windows. No sign of a struggle. No sign of a duck, either. What could possibly have happened?"

"We did not flush him," said Sarah angrily.

"Maybe he's still in here," said Duncan.

The girls froze.

"An excellent theory, Doctor Watson." I cautiously opened the bathroom cabinet—then screamed and pointed.

Sarah jumped back. "What is it?"

I shuddered. "Someone left the cap off the toothpaste."

"Again?" said Duncan. "I hate that. It gets all crusty."

I closed the cabinet and moved on to the bathroom closet. But just as I was about to swing the door open, there came from the other room the unmistakable sound of a quack, followed by the equally unmistakable sound of Erik cursing.

"What was that?" said Lysiane.

"Nothing," I said. "Nothing at all." But it was too late. The girls had already charged off to the bedroom, where they found Erik and George in the midst of a spat.

Erik looked up. "George pecked me!"

"Ducks don't peck," I said. "They bite."

All three of the girls, with perfect synchronization, crossed their arms and frowned.

Thus ended the gag. Hal made Erik return George to the pond, and the girls refused to talk to us for a week.

"Next time," I suggested, "we should use a stuffed goat's head. They're quieter."

"And," said Erik, "they don't peck."

14

THE NEXT DAY, I fell in love.

It was at Even Tide, and I was on my way to the main nursing station. In the hallway, I passed a woman so tiny it looked as though her wheelchair were being powered by a hand puppet. I stopped and watched what was sure to be a slow-motion collision. The wheelchair was heading straight for the wall. Then it wasn't. Then it was. Then it wasn't. With great, but inconsistent, effort, the lady caught up with me and rolled by.

"Excuse me. Ma'am?"

She coasted to a stop and peered up, squinting at me through granny glasses. It was the sweetest little wrinkled face I'd ever seen.

"Have you been drinking?" I asked. "Because if you have, I'll have to give you a ticket for dangerous driving."

"Oh dear," she said and laughed. "I'm sorry, officer, but I'm new at this. Can't get it to work properly."

"You have to push with both hands at the same time. Otherwise you'll zigzag."

She tried again, but she still couldn't get it to work. It was only then I noticed the faint, frail tremble in her hands. Her arms. Her face. It was Parkinson's disease. I introduced myself to her and she held out a hand. It was delicate in mine, like a bird's wing. Her name was Rose Sherman.

"I'm running a taxi service," I said. "Best rates in town. Where would you like to go?"

"Paris," she said.

"And your second choice?"

"Room 210, please."

I wheeled her back to her room, and what a room it was. She had doilies on all her furniture and knickknacks along her dresser and dried flowers and photographs spanning eighty years. Her bed was deep in thick quilts and embroidered pillowcases. It was no wonder I hadn't met her yet; she wasn't using the Even Tide standard-issue army sheets.

"Thank you very much, young man." She locked the wheels and pulled her walker near.

I punched in some numbers on an imaginary calculator. "Lemme see. That was about five minutes, plus clever conversation, no luggage . . . There we go. You owe me two hundred and fifty dollars, plus a generous tip."

"Oh my. You told me your rates were reasonable."

"I lied."

"What a rascal!" (Old people are great. They really say things like "rascal" and "scoundrel" and "oh my goodness.")

"Come here," said Rose. "I have some sweets." She fished about in an open candy tin and came up with—*yes!*—more peppermints. My dietary quotient of stale peppermints had skyrocketed since I'd come to Even Tide.

Rose pulled down a photo album from the top of her dresser. "You remind me of my cousin Mort," she said, and she laid the album on the bed. "You look like him a bit too." Shakily, she turned a few pages

and said, "There. That's him. He was such a character. Oh, he made us laugh, my sisters and me. There he is again. That's at our cabin, though it wasn't much of a cabin. We just called it that to make it sound fancy."

Even with his high stiff collar and the olive-brown tones of sepia, her cousin Mort had a definite gleam of rascality in his eyes.

"Died," she said. "In the war. At Passchendaele. In the mud."

I turned the page and whistled. "Say now, Rose. Who is that?"

She looked. "Oh, go on with you. That's *me*."

"Rose, you were a flapper!"

"Indeed I was."

"Look at all those beads. And where did your bosom go?"

"Oh, stop," she said.

"Those must have been some swinging times."

"Not really. I was the only flapper in St. Thomas. I had to go all the way to Port Stanley just to find a fellow who could dance."

"The Charleston?"

"Of course."

"And did you find someone who could?"

"Oh, yes. And I was so impressed, I married him."

I never did get to wherever it was I was going. When lunchtime arrived, I wheeled Rose out of her room.

"I'll get to the dining room myself. I need the practice. It was so very nice talking with you," she said in that sweet trembling voice of hers, so faint you almost missed it. "I do enjoy meeting young people."

I took a few steps and stopped. I turned and came back. "Why, Rose? Young people are horrible. I know. I'm one of them. Why would you enjoy meeting us?"

She smiled, almost as if she had been waiting for the question. "Because you're still looking."

"Looking? For what?"

"Oh, it doesn't matter. Just that you're looking. Everything lies ahead for you. The good and the bad. It's all new and fresh and confusing, isn't it?"

Geneviève flashed across my mind. "I have a girl," I said. "Maybe, kind of. I'm not sure right now."

"Well," said Rose, "she's a lucky girl, whoever she is."

What a flirt. "I'll see you, Rose."

"Good-bye, Mort." And with that she started off slowly down the hallway, weaving as erratically as she had before.

I really ought to have given her a ticket, I thought.

15

WHEN I ARRIVED at Even Tide the next day, my work duties had been changed. I was now assigned to the severely disabled ward during mealtimes to help spoon-feed the residents who were unable, either physically or mentally, to feed themselves. It was not a pleasant assignment. We wheeled the patients in, fed them pablum and lukewarm tea, then wheeled them back to their rooms to sit out their day, waiting for the next meal, watching television. Game shows, mostly. Thousand-dollar give-aways.

Most of the residents were women, widows who had long since outlived their spouses. Remember this the next time you hear the statistic that, on average, women live five years longer than men. It's the *last* five years.

There were a handful of men as well, withered and fragile as old wood. I remember one man well. He was racked with spasms of pain no medicine could subdue. "It's just stubbornness," whispered one of the nurses. "Stubbornness and despair. He doesn't want to go." He would jerk in his chair, his mouth silently forming the words, "No. No. No."

The food they ate, whether meat or vegetable, was puréed into a grey, textureless mush. When you're young, it isn't death that frightens you—at that stage, your mortality is still largely theoretical—but old age. That is what shakes you to the core. The most appealing route is denial, to imagine people have always been old, have never been young, as though theirs was a parallel existence to your own. But I remembered Rose, who was once a flapper, and her cousin Mort, who died in a muddy field in Belgium.

I helped spoon-feed the seniors, and I was painfully slow. The nurses had it down pat, quickly pushing the pablum in and pausing to wipe the spattered mouths only at the end. The oldest resident at

Even Tide (the oldest in St. Thomas, in fact) was a lady named Ruby Copeman, who was 105 years old. Ruby was deaf, she spoke softly, and her eyes, clouded with cataracts, were grey and green and beautiful.

"Would you like some tea?" I'd shout into her ear.

"That would be lovely," she'd reply.

An old person's hands are the most beautiful things to hold. They are unbelievably supple, not pudgy like a baby's but soft with loose folds and cool to the touch. The skin is not taut; there are no calluses. It is the hands I remember best, and Ruby Copeman's were the softest of them all.

That evening, instead of returning to the house, I walked along the river. I ended up in the St. Thomas Cemetery, among the headstones, reading and forgetting the names and numbers. A summer sunset. The world was rolling into the inevitability of night, and colours gathered on the edge, fires that blazed and died. Across the River Thames, a single oriole was calling out—calling out and then replying to its own echo.

I returned in darkness to Maple Street. I climbed the staircase, past the yellow hall lights and the cream-coloured wallpaper. The house creaked as it settled in for the night. From the attic came the muffled voices of Lysiane and Marie-Claude and the low backbeat of Sarah's tape recorder. A faint smell of damp dust hung in the air. Outside, the temperature had fallen. The furnace kicked in and the air vents hummed. I thought: *The house is breathing.* You could feel night descending with the warmth of flannel.

I pulled the bedroom curtains shut and climbed in between the covers. I was wide awake, staring into the semidarkness, when Duncan called out to me in a stage whisper.

"Hey, Will?"

I didn't reply.

"How did it go at the old folks' home? You feeling okay?"

"Everything's fine. Go to sleep."

"Can't. I'm too tired. Makes you think, don't it? Those old folk and everything. My granddad, he stayed with us right up until he passed away. Died in his sleep, like a ghost. I remember at night hearing him

on his deathbed, breathing hard like someone straining to carry a heavy load. Wheezing something terrible. I used to lie there and listen to it."

I rolled over and feigned sleep.

"I was at the Care Centre again today," he said. "Never seen anything like that before, not in my entire life. All these children, big and small. Helpless. Everything they do is—it's a struggle. The nurses have to handle the most basic stuff for them: cutting their food, feeding them, wiping their bums. But they can still smile. You can still make them smile. They like to smile. Anyway, that's what I was thinking about. I just wanted you to know, that's all."

And we lay there, he and I, awake almost till dawn. And we filled the room with small, heroic, ordinary thoughts.

16

THE NEXT DAY, our group chose billeting families. Each family had filled out a questionnaire, and we went over them carefully. We argued and wrangled and manouevred and made deals, and in the end we managed to place each participant. Lysiane went with a pair of faded back-to-the-landers who lived on the edge of town and apparently believed "arts and crafts" to be a viable career choice. François and Marie-Claude ended up on a farm. Duncan was placed with the fish 'n' chip moguls of St. Thomas. (They owned two places in town and one out on the highway.) Erik and Sarah stayed with families in Sparta, just south of St. Thomas. And I went to the Garveys'.

I had strong reservations about going there—and indeed the only reason I chose them was because they were near Even Tide and this would allow me to continue working during the two-week hiatus. (I had no desire to paint macramé pot holders or sling bales of hay.) The reason I hesitated about joining the Garvey family was because, well, they were Mormons.

I'm not a very religious person, and all I knew about the Mormons was *(a)* they were uncomfortably Aryan in appearance and *(b)* they used to allow their men to keep full harems of stouthearted farm lasses (an idea that intrigued Erik). I was also familiar with the troupes of

young Mormon men who routinely show up at your door right when you're in the middle of supper and try to gang-save you.

I had visions of being proselytized by the Garveys: tied to a chair and made to smile in a perky, glassy-eyed manner until I agreed to tithe the church and wear a necktie. The Garveys lived in a white house with blue shutters and a view of the river. I was met at the door by what looked like an audition for the Von Trapp family reunion.

"Hello!" they chimed.

"Hello?" I hazarded.

Mormons don't smoke. They don't drink alcohol. And they don't drink coffee or tea. But Mrs. Garvey had stocked her kitchen with instant coffee especially for me—a gesture that struck me as being deeply thoughtful. I mean, how many Muslim families would think to supply a slab of pork for non-Muslim guests?

There were four children of descending height and age, and more were on the way. "Mormons have lots of kids," said Mr. Garvey. "After all, we don't drink, we don't smoke. What else is there for us to do?" And although it was clearly a quip she had heard many times, Mrs. Garvey blushed at this.

Tanya was the oldest. She had exquisite features and an enticing smile. She was also devoutly religious and engaged to a young man who was on mission in South America. I absorbed this with stoic resolve.

Tim, the second oldest and the only son, was cut from gentle cloth. They called him Moses, because, as their father pointed out, it had taken Moses some forty years to make his way across a stretch of desert not much bigger than a Texas ranch. Tim, meanwhile, took almost that long to clean his room or run an errand. A good kid. A decent kid. A bright kid. But not a particularly fast kid.

Then there was Teri, thirteen and self-reliant. Teri was nobody's fool. She had the sort of stubborn logic and naive faith in justice that only a very self-assured thirteen-year-old can have. "But Dad, it isn't *fair!*" I liked Teri right from the start. She had fallen deeply, hope-lessly, in love with Michael Jackson. Pictures of him in all his various noses were plastered across her wall—much to her parents' dismay. (In fairness, I don't think it was the fact that Michael Jackson was

pigmentally challenged that bothered her folks, but rather the fact that he was a Jehovah's Witness.)

The youngest was Tabitha, who—by her own calculations—was five going on five and a half. Tabitha had a dog named Buttons, a scruffy little crossbreed with whom she talked at great length: those grand, deep conversations of a five-year-old. The nature of Good and Bad, whether God wore gloves—important, crucial topics. (Theresa was monotheistic, but Buttons, I believe, was prone towards quietism.)

The Garveys gathered every morning at 6:00 A.M.—let me repeat that: *6:00 A.M.*—for a prayer around their parents' bed. They staggered in, sleepy-eyed, made their petition, then staggered off for more shuteye or to the shower.

My work at Even Tide continued.

Mrs. Bergman, the staff supervisor, organized an outing to the local mall. Seventeen seniors and attendant nurses and volunteers invaded the market. I was assigned a dubious character named Jack Murtha. Jack had a solid physique and strong, manly features. He looked suspiciously healthy. And he was. Jack, you see, did not have Alzheimer's, nor did he have MS, nor did he have Parkinson's. He did not have diabetes, or epilepsy, or dementia, or any other noticeable disability. What he did have was a limp. A *slight* limp. That and the gift of the gab.

Talk about kissing the Blarney Stone; for the past ten years Jack Murtha had been in and out of various nursing homes, where he was taken care of quite nicely, thank you very much, and all because he had convinced his social workers he was "socially incapable of self-care." Well, he may have fooled the nurses and he may have fooled the government, but he didn't fool me. The man had simply figured out a way to coast to the finish line.

As I wheeled him through the mall, Jack was strangely silent, in much the same way I imagine escapees try to keep cool when crossing a police checkpoint. I'm sure Jack could have gotten out and walked, but he was never one to turn down a free ride. He didn't speak until we had lost the nurses. "You must be thirsty," he said suddenly. "How about we stop for a nice cold glass of Coca-Cola?"

This, of course, was against the rules.

Jack may not have been an unhealthy man, but as a ward of the state and a guest of Even Tide, he was required to adhere to the same strict nutritional standards as the other residents. Mrs. Bergman had warned me, "Don't let Jack sweet-talk you into anything."

So I said to him, "I don't know. Coca-Cola? Mrs. Bergman said—"

"She's an evil woman," he said. "Evil. And I do believe she is out to get me."

"That may be, but—"

"Coca-Cola is good for a person. It cleans out the body. It's the 'coca' in the Coca-Cola that does that." His voice was all honey and jam. "It cleans out the body, it does."

"Oh, well. That's a different story." We stopped at a muffin stand.

Jack made a great production of searching for his wallet. "Must have left it back at the home. When you get old, your memory, well, it's not so good."

Half an hour later, we were sitting in a nearby pub drinking beer. I didn't feel guilty about buying Jack a beer because beer, you see, cleans out the system even better than Coca-Cola.

Jack borrowed a match and lit the cigar I had paid for and pulled back on the smoke contentedly. "It's good for the nerves," he noted wisely.

Jack was excellent company. He asked endless questions about Katimavik, fascinated as he was with the idea of bumming across Canada doing temporary work for the government.

"By cheese." (I'm sure he meant to say "jeez," but it always came out as "cheese.") "I wish they'd had that when I was a young man. In my day we had to ride the rails. On to Ottawa. Lookin' for work. Stealing—some of them. The bad ones, not me. And the police, oh, they didn't like us much. One of them, a big bull-chested fellow, he pulled me right off the boxcar and hit me with his stick. Crippled me, he did." (In the time I knew Jack, I heard at least six different explanations of how he hurt his leg.)

"Now then," said Jack. "This Katty-mavik, your food and all is paid for."

I nodded.

"And the transport, too? And the blankets?"

"Everything."

"They take good care of you, then. And how old's a fellow have to be to join up?"

"Between seventeen and twenty-one."

"I see. Well then, I guess I don't quite fit in that category."

He finished his beer and ordered another. I grimaced. When you're being paid a dollar a day, you don't exactly enjoy buying rounds.

"Now then," Jack leaned forward and dropped his voice. "It seems to me that if someone *inside* this Katty-mavik thing were to ask the government, nicely of course, if he could take his grandfather—his dear old grandfather—along with him, why I bet they'd say yes. By cheese, I bet they wouldn't even check to see if it really *was* his grandfather. A young fellow—a young fellow like yourself, say—why, I bet he could talk them into that without any complications." He sat back, puffed on his cigar, and watched my face for a reaction.

"Forget it, Jack. It can't be done."

It's not that I didn't like the idea of trucking off to Québec with Jack as a stowaway. I just wasn't sure if we could pass him off as a participant. If our next group leader didn't catch on, our work supervisor most certainly would. Jack sighed and let go of his dream. It floated up and dissolved like cigar smoke.

When we finished, Jack asked if I'd let him pay (with my money, naturally) because the barmaid had, according to Jack, been giving him the eye. When he handed me the change outside, I couldn't help but notice he had left her a generous tip.

17

OUR GROUP RECONVENED after two weeks, and Hal called us into the living room for an informal meeting that evening. As usual, the participants who had been placed on farms came away with sore arms and a deeper appreciation of the agricultural lifestyle. Lysiane's family had given her a chance to practise her painting skills, and she showed us one of her canvases. It was a dark forest with a dark sky and a dark figure in a dark foreground.

"What do you think?" she asked.

"It's, um, dark."

"*C'est moi,*" she laughed. "*C'est dramatique, eh?*"

Erik was in a quiet mood, almost sullen, but the person we were most curious about was Duncan. We all wanted to know how he was handling his work at the Care Centre.

"It's fine," he said. "I like it."

Marie-Claude frowned. "You are not sad? Or depressing?"

"There's no time to be sad," said Duncan. "Too much to do. Hey, Lysiane, you remember Bobby?"

"*Oui,* Duncan. It is not possible I can forget him. Bobby, he have nothing."

"He's a fine kid," said Duncan. "Last week, I taught him how to say 'Hi.' It took a couple of days, but he caught on. Only problem is," Duncan chuckled to himself, "now he says it all the time. 'Hi! Hi! Hi! Hi!' Now I have to teach him to say 'Bye.' And you know Clara, the tall girl? Guess what, I taught her how to feed herself. I still have to sort of hold her hand, but she has the general idea."

Marie-Claude leaned over and gave Duncan a kiss. "What's that for?" he asked, getting all flustered. Lysiane gave him a kiss as well. "Jeez," he said. "I don't know what I did, but I'm going to keep doing it."

The group was about to disperse, but Hal asked us to remain seated. "There is one item left on the agenda," he said. "I want your honest opinion. I want you to be absolutely frank. What do you think of Cody?"

There was a pause. "Cody?"

"What's a cody, Hal?"

"Is that like codeine?" asked Erik.

"It's a name," said Hal impatiently. "The wife is expecting any day now and I need a name."

"Cody. Is that a boy's name or a girl's name?"

"A boy's name."

"It sounds more like a puppy," said Lysiane, and we all began mimicking someone calling to his pet. "Here, Cody! C'mon, boy. C'mon, Cody! Good boy!"

"Be serious," said Hal. "I really need to come up with a name—and

fast. If you don't like Cody, how about Dusty? Or Jesse? Or maybe Dallas?"

The group exchanged glances, seeing who would be the first to laugh.

"How about Tex?" I offered. "Or maybe Slim?"

"Or Zane?" said Duncan. "And then his middle name could be Grey."

I tried it out. "Zane Grey Vanbreesenbrock. Not bad. Mind you, I do prefer Tex myself."

"Or why not just Cowboy?" said Marie-Claude. "I think that is the more *approprié*. Cowboy, it sound good, no?" She burst into laughter.

"This meeting," said Hal in a huff, "is officially adjourned."

"Or maybe Rustler," I said. "And if he's bad, you could call him Varmint. Varmint Vanbreesenbrock. Alliteration. I like that."

"I am out of here," said Hal, and he stomped out of the room, our laughter and catcalls echoing after him.

"How about Dude? Or Rawhide? Or Six-Gun? How about Six-Gun?"

18

SARAH AND MAC were making popcorn. Erik came up to me in the kitchen. "We have to talk," he said under his breath.

"Can't it wait? I mean, we're going to have popcorn. Popcorn. That's, like, the social highlight of Katimavik."

"You know," he said. "Sometimes I can't tell if you're serious or just being sarcastic."

"To tell the truth, there are times I don't know myself."

"Let's just go. I've got to talk to somebody before I explode."

"All right, all right," I said. "I'm coming. But this had better be worth giving up popcorn."

We walked up Ross Street and over to the Green Lantern Restaurant. The Green Lantern had no lanterns and was not green. It was, as noted earlier, a fly-strip-and-linoleum type of place.

"Why is it," I asked the waitress, "that we've been coming here for two months and your daily special is still the Jumbo Burger?"

The woman chewed on her gum and looked at me with the expression of someone who has to suffer fools often. "Because," she said, "we haven't *sold* them all yet. Did you want to try one?"

"We'll pass," I said. "Two coffees." I turned back to Erik. "So tell me. What's going on?"

He ran his hand back through his hair. "It's Constance."

"Trouble in Paradise?"

He nodded. "She's hooked on beans."

"Beans?" I said.

"That's right, beans. She's hooked on them."

I was baffled. *Beans?* Green beans? Lima beans? Libby's deep-brown? "What do you mean?" I asked. "Does she fart a lot or something?"

Erik gave me a look of utter disgust. "Not beans, you idiot. *Beans.* Speed. Uppers. Bennies."

I sat back and let it sink in. Our coffee arrived and I slowly stirred cream into it.

"Erik, I'm confused. *You've* done a lot of drugs—"

"I'm not hooked on anything, so drop it."

"But—"

"I said, drop it."

We sat for a long time, sipping our coffee and saying nothing. "So what are you going to do? You know, about Constance?"

"What do you think I'm going to do? I'm going to drop her. I'm going to drop her so fast her head spins. I've got problems enough on my own."

I was going to say something, but he cut me off. "What a loser," he said. "What a complete loser. She has everything. A family, a car, money. She travels first-class, I'll bet. You want to know something? Before I went on Katimavik, I hadn't even been on an airplane. What a loser."

"I thought you liked her. I thought you were in—"

"I was. I am. But that doesn't change anything, does it?"

"No," I said. "I suppose not."

And so ends the tale of Erik the Gypsy and Constance of the First-Class Tickets. It wasn't exactly *Romeo and Juliet*, but it came close.

19

A ROUTINE MORNING at Even Tide. I helped feed the residents in the disabled ward, then filled my mug with coffee and went to see Margaret McLeod. When I entered her room, her bed was neatly made and the cheap little wall hanging of Scotland (complete with the words to "Amazing Grace") was gone. How strange, I thought, and I returned to the main nursing station.

"I was in Mrs. McLeod's room and she's not around. Did they take her to the hospital again?"

The nurse looked up. "No need to," she said. "Mrs. McLeod died."

"Oh." I put my coffee on the desk. "What time did she, um . . . "

"Last night. Just after midnight."

Mrs. McLeod left the world unburdened with material clutter. What little she had was given to the Salvation Army. No family members showed up to claim her photos or her wall hanging, and they were put into storage. Even her scent was gone, that lingering smell of mothballs and incontinence—tea had ruined her bladder, you see— having been replaced with the sharp, clean odour of antiseptic.

I went to Mrs. Bergman's office. "I'm taking the day off," I said, and I left before she could answer.

I passed Andrew Crumm as he pushed his wife down the hallway. "Wonderful day," he said.

I stepped outside of Even Tide and the sun was harsh and the sky was a muggy haze of grey. I felt like going back inside and grabbing Andrew by the neck and saying, "No, it is not a wonderful day. It is a humid, hot, horrible day."

As I walked down the sidewalk, I passed a taxi with its motor running and its back door open. A frail old lady, one I recognized, was getting in. She was wearing a white knit sweater and was carrying a large cloth bag. It was taking her a long time; her movements were tiny and slow, and the cab driver was drumming the steering wheel with his fingers as he waited.

I took a few steps, then stopped. Turning around, I went back to the taxi. The lady was trying to pull the door closed, but she didn't have the strength.

"Mrs. Angelino?" I said.

She looked up, frightened. "Yes?"

"What are you doing?"

"Nothing."

The cab driver leaned over from the front. "Is this man bothering you?"

"I work at the nursing home," I said. "Mrs. Angelino is one of the residents."

"I'm going home," she said in a quavering voice. "I'm just going home."

"I put her bags in the trunk," said the driver, who was now starting to feel uneasy. "Why? Does she need to sign something before she goes?"

I felt terribly burdened by it all. "Mrs. Angelino," I said. "You aren't very healthy, that's why you're in the nursing home. We can't let you go back to your house."

"But there is no one there to take care of it. I just want to go home."

"I'm sorry," I said, and I reached in to take her by the arm. "I'm very sorry."

I walked Mrs. Angelino back into the foyer of Even Tide. The cab driver followed me in, carrying her belongings. A nurse saw us and shouted, "There she is! Mrs. Angelino, you gave us quite a scare. We've been looking all over. You know you can't go back to your house. We explained that to you. It's all boarded up and your diabetes is very serious. We have to keep an eye on you. Don't cry. Here, take some tissue."

Once the hoopla died down, Mrs. Angelino was left alone, sitting in the lobby, looking out across the parking lot.

I sat down beside her. "I'm really sorry," I said. "But I couldn't let you leave."

"Why?" she said, and I saw that she was still crying, that she hadn't stopped crying, that she might never stop. "I wasn't hurting anyone," she said. "I just wanted to go home, that's all. I don't like it here. I want to go home."

I couldn't think of anything to say. My chest was heavy and I sat there, holding her hand as she cried.

"I just want to go home."

20

WHEN I RETURNED to Maple Street that evening, I went in the front door and directly up the stairs to Hal's room.

"I need a break," I said. "Put me down as cook for this week."

Hal looked up from his Katimavik manual. "You don't believe in knocking any more?"

"I need a break, Hal."

"Well, you're not scheduled to cook until next week. If you want to juggle things around, talk to François. It's his turn now."

François was downstairs preparing supper in a spotlessly organized kitchen. He noticed me come in but chose not to acknowledge it.

"François," I said. "I want to cook this week."

He slid a casserole in the oven and set the timer. "Why?"

"Never mind why, I just want to, all right? So, do you want to switch with me or not?"

He didn't speak. He just stood there, wiping his hands on a tea towel and staring at me.

"For chrissake, François, it's not a big deal. I know you have the entire week's menu planned out and budgeted, and your shopping is probably all done—but if you do me this favour, I swear I'll pay you back somehow. I'll owe you one."

He wiped his hands again and said, "I will change places with you. But you do not owe me anything."

He began to set the table.

"Thank you," I said after a few moments of silence.

He nodded, but didn't look up. "*C'est correct.*"

21

WHEN YOU ARE ON cooking detail, you are the first one up in the morning, and that quiet, busy moment—alone in the kitchen as the sun first peers in—is almost therapeutic. In India, they believe that among the paths to enlightenment is one called karma-marga, the calm detachment of domestic duties. They may be onto

something. I set the table, made the coffee, and heated the griddle; it was routine and soothingly tranquil.

Then the group came down.

"Gross. These pancakes are soggy in the middle."

"Mine isn't cooked either. It's like eating dough."

I poured some more batter on the griddle and cranked up the dial.

"Now they are burned, *non*?"

"Yuck, these are more gross than the other ones."

"Isn't it about time you guys went to work?" I asked. And then to Hal, "Who's taking my place at Even Tide this week?"

Erik washed down my burned offerings with a glass of orange juice, which he drank the same way he did his beer, in one extended gulp. "I am," he said and burped. "You know, you ought to be cooking for youth detention centres. You got the recipes down pat."

"Seriously," I said. "Who's going to Even Tide?"

"I told you," said Erik as he got up to leave. "I am."

I raised an eyebrow. "Good luck."

For supper, I served my award-winning Kraft Dinner Supreme, but it was too similar to spaghetti and no one ate very much. You fools, I thought, finish it now or face it tomorrow. They didn't appreciate my salad, either.

"It's fresh from our very own garden," I said, trying to evoke some sort of team spirit.

"Don't you think you should have let it ripen first?" someone asked.

"No, no, no. It's chock full of vitamins this way."

Sarah pushed her plate away. "There is a bug on my plate."

"And chock full of protein as well. I've done Katimavik proud."

Mac examined a piece of radish. "Maybe you should wash the vegetables *aussi*."

"No, no, no. Dirt is very organic. It cleans out the system, so to speak."

I served Strawberry Jell-O and Alka-Seltzer for dessert, and after a large round of indifference, I cleared the table and started in on the dishes. Erik helped dry, but he didn't say anything.

"Are you all right?" I asked.

"Hmm?"

"How'd it go at Even Tide?"

"Not much to tell."

"Did you meet Rose Sherman? Or Jack? You'd like him, he used to be a hobo. Or Bill? He's a mean old bugger, he's got a cane that he—"

"Right. I'll look him up if I get the time." He put away the cutlery and left.

Strange things began to happen.

Hal and Erik left one evening, and when they returned the station wagon was loaded down with buckets of paint and stacks of two-by-fours and plywood.

"What's up?" I asked.

"Nothing," said Erik. "Take this."

He swung a rusted, secondhand tool chest out of the back. We piled everything into the shed in the back yard, and Erik padlocked the door.

"What did you guys do, hit a hardware store?"

They ignored my inquiry.

"Well, if you didn't rob a hardware store, how'd you pay for this stuff?"

"I used the rest of our Work Skills Development budget," said Hal. "And part of our Nutrition and Well-Being budget as well."

"Under fibre, I imagine."

"Something like that," said Erik.

Erik stayed in the shed every night that week, working late. We could hear him sanding and nailing and sawing all the way to the second floor, but when I checked the shed during the day, it was always locked. I pressed my face to the door, trying to peer through the cracks. I could smell varnish.

Saturday came, and Erik spent the entire day in the shed with the door locked. Sunday was the same. That evening, I couldn't take it any more. Like a cat with a death wish, I went out to satisfy my curiosity.

"Erik?" I tapped on the door. "You in there?"

"Go away. I'm busy."

With great stealth, I tried the handle, but his Fortress of Solitude was secure. Damn. So much for bursting in on him and demanding an

explanation. I knocked on the door again. "How is it coming along? I mean, how is whatever you're doing in there coming along? You know, is it in overdrive?"

"What do you want?" He was just on the other side of the door.

"You feel like going out? See what's happening downtown?"

"Leave me alone."

"How about a coffee?"

I heard him sigh. "Look, I'm really busy, okay?"

"We're having a Mazola party later. Actually, we're using Crisco. You get all but a tablespoon back. Should be a lot of fun."

"That's nice." This boy just wasn't listening.

"Hal gave me permission to grow marijuana in the back yard. You want to help?"

"No, thanks."

So much for subtle tactics and devious manipulations. "Can I come in? Please? Pretty please? I won't touch anything, I promise."

"Why don't you go bother Sarah instead?"

"I tried that already. She threw one of her gigantic paperbacks at me. It almost broke my collarbone."

The inside latch went up and the door opened. "What the hell do you want?" he asked, which was an invitation to stop and chat if ever I heard one.

"Well, now." I squeezed by him and into the room. "I was just wondering what you're doing in here. All alone. It's not natural."

"Carpentry," he said.

I scanned the room. It was cluttered with wood, nails, shavings, saws, and sandpaper. "Actually, I figured that out all by myself. The wood was my first clue."

Erik went back to planing a board. I tried a different approach. "So, how did you find Even Tide?"

"It was easy. I followed Mary Bucke Street and, sure enough, there it was." He stopped planing and ran his hand over the wood. He reached for the sandpaper but didn't do anything. He just sat there, and then, looking over at me, he said, "It's just one big prison, isn't it? You get old, they put you back in prison. It doesn't make sense. And

boring? Man. They sit around all day looking out the window. Pass me the chisel—no, not that one. The other one."

I leaned over his work. "So, what're you making?"

"It's a long story. Pass me the mallet, will you?" He began tapping a slight groove along the edge of the board; a single curl of wood unravelled.

I leaned in closer. "You still haven't told me what you're making."

"If you keep blocking my light, I'll be making your coffin."

I stepped back. "Fair enough. I know when I'm not wanted."

"Birdhouses."

"Sorry?"

Erik put the board to one side. "I'm making birdhouses. That way, the inmates at Even Tide will have something to look at. I've finished most of them. They're under the tarp—and no, you can't look."

"Not a problem," I said. "I'll leave you to your work."

Late that night, when all were asleep, I crept out to the shed for a sneak preview. Unfortunately, Erik had locked the door. A note read: "Go back to bed, Will."

It wasn't until my week of cooking ended (much to the delight of the group) and I was back at Even Tide that I saw what Erik had done. He hadn't just built houses, he'd built an entire small town. There was a school and a barn and a lighthouse. There were tiny doors and windows and picket fences painted green and blue. There was a rotating windmill, turning on a breeze, and there was even a replica of Even Tide itself. Birds were everywhere, darting this way and that. Sparrows flitted about like an Einstein equation, neither energy nor matter but something in between. The residents of Even Tide—or inmates, as Erik insisted on calling them—were no longer looking into empty space, they were watching small daily dramas. Even the neighbourhood cat seemed interested.

"That young chap," said Bill, "the one who came in while you were away. He doesn't talk much, but he's good with his hands."

"You mean, he's not ignorant?" I said in disbelief.

Bill wouldn't go that far. "He *is* ignorant, but he does know how to build things."

"So Erik is kind of *semi*-ignorant?"

"No one," Bill reminded me, "likes a smart-ass."

The birdhouses turned out to be a mixed blessing. On the one hand, they cheered the place up considerably. But on the other, they added a new dimension to my work duties at Even Tide.

"You want me to do *what*?"

"Clean the birdhouses," said Mrs. Bergman. "Our janitor won't do it because it isn't in his job description. He checked the fine print."

"Rotten Irish bastard," I muttered. "Whatever happened to the Canadian work ethic?"

"It's alive and well and exemplified by Katimavik volunteers," said Mrs. Bergman. "You'll find a bucket and some rubber gloves in the closet."

I flashed her my teeth in a gesture that might easily have been mistaken for a smile. "You wouldn't have any sewer lines that need to be cleaned, would you?"

"Now that you mention it . . . "

22

IT WAS THE TENSEST meeting we ever had, and it was over the most trivial subject imaginable: how to spend our free weekend. In British Columbia, we had taken a group trip to Vancouver. François wanted to do something similar on this rotation.

"I talked with some offices in Ottawa. If we travel as a group we can see many things: the Parliament, the Senate. We can see how this country is run—"

"We already know how it's run," I said. "Badly."

"Always the stupid comment, eh? Everything is a joke with you, eh, Ferguson?"

"Fuck you, Frank."

"Calm down, calm down." It was Hal. "Listen. François, I know you put in a lot of work, and I know that a trip to Ottawa would be educational, but it is a *free* weekend."

No one else wanted to go to Ottawa, and without a group, François's field trip wasn't possible. "Why we are in Katimavik?" he asked. "I tell you why. To accomplish objectives. Not to just do whatever we want."

Hal interrupted. "Listen, François—"

"No, I don't want to listen to you. Isn't that your wife? I think she is calling you." Then, looking around at the rest of us, he said, "Some initiative. What a damn group. *Merde.*"

The meeting was over. Duncan said, "Anyone for popcorn?" and Hal put on his jacket.

"*Chef de groupe paresseux et incompétent,*" said François as he left.

"*Têteux, François!*" It was Lysiane, and she looked pissed-off.

Just one big dysfunctional family. I was sitting on the front steps when Erik came out. "So," he said. "What are your plans for the weekend? You going to see what's-her-face, that little one from the London group? The one with the tan."

Geneviève and I had been writing letters back and forth, and I had hitchhiked to London several times to see her. Erik had been carefully monitoring this, and he often asked me how the relationship was evolving. "When are you two going to knock bones?" he'd say in his caring, sensitive way.

The free weekend seemed like the perfect time. "This is it," said Erik. "Your big chance. Free weekend. Free love. You know what I'm saying?"

"I can't. They're on their survival trip this weekend. No rendezvous, unless I want to hike through forty miles of bush to find her."

"Bummer."

"Tell me about it. Anyhow, there's a town not far from here called Fergus. Apparently, I have a whole gaggle of cousins and uncles and aunts living there. Founded by a Ferguson, you see."

"Never heard of it. *Fergus?*" He turned it over in his head. "Goofy name for a town. Is that where you're going?"

"I don't think so. If I showed up in Fergus, they'd probably slap a skirt on me and feed me haggis till I puke. Transvestites obsessed with porridge: our great Scottish heritage."

"Why don't you come in to T.O., hang out with me for a while? You'll like Toronto. It's midnight-powered, man. It's wild. It's off the side and halfway down. It's—it's—"

"Overdrive?" I said.

"Exactly."

23

"I'M COMING HOME!" hollered Erik as the train pulled out of the London station. "Yes, I am! Praise Gawd, I'm on my way! *Hallaylooyah!* That's what they say in church, right? Hallaylooooooyah! I'm coming home!"

"Erik, it's a two-hour trip. Tell me you aren't going to yell the whole way."

He would have, honest to Gawd, if the conductor hadn't threatened bodily harm.

"You really think he would have thrown me off the caboose?" Erik whispered.

"I'm not sure," I said. "Why don't you start yelling again and find out?"

"No, I think I'll save it for when I arrive."

True to his word, Erik whooped it up when we got off at Union Station. He did a little victory dance and all but kissed the ground.

"He's out on a day pass," I said to passers-by.

We checked into a youth hostel on Church Street and then Erik dragged me off to see the sights of what he humbly referred to as "the greatest city on earth." We couldn't afford to go to the top, but we did get a close-up look at the CN Tower. (Erik had this crazy scheme about mating it with the Brooklyn tunnel.) We then wandered around lower Yonge, among the dregs of humanity. Erik seemed disturbingly at ease.

We made it back to the hostel just before curfew and spent the rest of the night drinking furtive, cheap wine (more cheap than furtive) in the hostel washroom. The wine tasted like grape vinegar, but none of that mattered. We were free. Katimavik couldn't reach us and the rules didn't apply to a pair of roving vagabonds like—

"Hey! I said 'Lights out!'" It was the Hostel Gestapo, walking through the dorm, rattling their nightsticks against the prison bars (I'm speaking figuratively, of course).

24

WE SLEPT IN the next morning and had to be roused from our beds by the youth hostel staff. No matter, we plodded out of the dorm feeling well rested and decadent. No work sites, no kitchen duties, no early-morning educational activities. Bliss, pure bliss.

"I want breakfast," said Erik, with a broad smile. "A real breakfast."

"Anything," I said. "Anything but"—and we said with one voice—"scrambled eggs!"

"You know what I want?" Erik smacked his lips. "I want pancakes!"

"What are you talking about? I made some last week."

"*Real* pancakes," he amended. "Pancakes you can eat."

So we gorged ourselves at Pierre's Palace o' Pancakes, or some such place, and then—having taken care of our hunger—we sought to satisfy mankind's second strongest urge.

"You'll love the Beaches," said Erik. "Women everywhere."

He was right. There were women everywhere—and men as well. Husband-type men. Boyfriend-type men.

"I don't understand the principle behind girl-watching," I said. "All it does is make you depressed and frustrated. It's like sitting in front of a dessert tray when you're on a fast. Self-torture, that's what it is. Self-torture. You might as well do penance by wearing a hair shirt and—"

"You know what your problem is?" Erik asked.

"My choice in friends?"

"Besides that. You lack confidence. Look at those two girls coming towards us, the ones in the bikinis. All we have to do is just stroll up to them and turn on the charm." He made it sound as simple as turning a faucet.

"And did you happen to notice the two cavemen who are walking beside those very same girls?"

"Charm, my friend. Charm always wins out in the end. Just ask my judge at family court."

"Erik," I said, getting desperate as the two girls and their monkey-men drew nearer. "Charm might go over well with judges and social

workers, but not in a fistfight. I have yet to see someone block a left hook with a clever anecdote. So do us both a favour and stop staring at the—"

Sure enough, one of the Neanderthals noticed. "What the fuck are you lookin' at?"

Erik whispered an aside. "Those guys are so pumped full of steroids, they're musclebound. Can't run worth shit. What d'you bet?"

"Not a cent, not a goddamn cent," I said frantically.

"Hey," shouted the Missing Link. "I'm talkin' to you. I said, 'What the fuck are you—'"

"I'll bet a dollar," said Erik, and he leaped up and yelled, "We're looking at your girlfriends. Didn't we see them up on stage last week at the Zanzibar?"

Cro-Magnon and his pal started towards us.

"Erik, are you mad? Those kind of guys have muscles in their poop!"

"I just want to see if they can run," he whispered. "Hey girls! Where did you find these bozos? At the zoo?" He began making monkey noises. This was not a good idea.

The two bozos, it turned out, knew how to run. They knew how to run very, very fast. Lucky for us, we too knew how to run—only faster. They chased us halfway across the Beaches, then up through a residential area and across a playground, where they eventually stopped and hurled insults and vows of vengeance at our retreating backs. By the time we managed to catch a passing streetcar, we were out of breath and doubled over in pain.

"You owe me a buck," Erik gasped.

All the way back to Yonge Street, I kept checking over my shoulder. I'm going to have nightmares about this, I thought.

The crowds downtown were as seedy and grubby as ever (what is it with this image we have of Toronto the Clean and Toronto the Good?), and as night seeped in, the lights came on in sallow yellows and desultory neon. We walked up and down Yonge for a while, then Erik turned to me and said, "Do you want to see the *real* Toronto?"

"Is this a trick question?"

"C'mon, I'll take you to my old neighbourhood. It's only a couple of blocks from here."

We left the tawdry head shops of lower Yonge and walked east on Dundas, into the crumbling edge of Cabbagetown. Erik used to live on George Street, a single block with a wide array of attractions. On this one block there was—I kept an inventory—a strip club named See-More's Calvacade of Co-eds (or some such thing), a police station, a men's hostel, a gay bathhouse, a juvenile detention centre, and, at the north end, Allan Gardens, where the junkies and runaways hid out.

"Never *ever* go to Allan Gardens at night," said Erik.

"Okay, but only if you insist."

Crowded in among the bathhouse, strip club, and detention centre were cramped rows of houses with mangy patches of front lawn and double locks on all the doors.

"Quite the neighbourhood," I said drily.

"And this is just one city block," he said. "Hard to believe, isn't it?"

"Why would you go anywhere else?" I said. "When everything you could possibly need is right here."

Erik stopped across the street from a darkened, nondescript brick building. Flickering lights and the low boom of bass were bleeding from a basement window. "This is where I was staying when I got out. The house belongs to a guy named Bag. They call him Bag, because, well—long story. Anyway, Bag and I go way back. He bought me a tie for my hearing. And hey, it worked, 'cause here I am." There was a long pause. "They're having a party," he said.

"Did you want to stop in? You know, say hi?"

"Bag has a friend named Louis. He's got a tattoo of Mickey Mouse giving the world the finger right across his back. Pretty cool. Anyway, Louis made one big sale, back about five years ago, and he's been sailing ever since. He's nuts, too. Completely. I remember one time he— Can you imagine introducing Constance to this crowd?" He laughed. "Now *that* would be worth seeing."

"Bag. Louis. They sound like very nice people."

"They are. Took good care of me. They even stashed the VCRs, which was a good thing because, well—it doesn't matter now."

Through the window, we could see shadows moving like ripples in the light. The music suddenly grew louder as someone went out the back door. It was getting colder and we'd been standing in the shadows for a long time.

"So," I said. "Did you want to go in?"

Erik didn't say anything. I waited. And then, quietly, he said, "No."

And we left.

25

OUR FREE WEEKEND—or "parole," as Erik referred to it—ended on a low note. We ran out of money and spent Sunday surviving on a loaf of Wonder bread and a jar of Cheez Whiz. Erik wanted to hawk our train tickets back to London and hitchhike home, but we couldn't find any takers. By the time we got to St. Thomas, we were positively *craving* granola.

It was now Monday, the nineteenth of June. Five days until the St-Jean Baptiste Day celebrations. The Katimavik group in Windsor had organized a mass rally on Peche Island, a small camping area in the river between Detroit and Canada, and we were invited. As was Geneviève's group.

Which meant, of course, that time slowed down and everything dragged on like a film played at half-speed. We had an evening of archery (memorable only because Sarah almost shot the instructor in the leg) and an evening on the environment (which was singularly *un*memorable, although it does seem to stick in my mind that the environment was a good thing and pollution was bad. Or maybe it was the other way around. Why is it that saving the planet is such a dull pursuit?) and some volunteer work at a blood clinic ("They aren't going to test us for anything, are they?" Erik had asked, a trifle paranoid). I couldn't concentrate. I was aching to see Geneviève again.

Saturday came crawling towards us like a wounded dog and eventually—*finally*—we were in the station wagon and on our way to Windsor, riding low across the tobacco fields of southern Ontario. The windows were open, and sleeping participants were piled up like bodies in a morgue. But I was wide awake and watching the landscape.

Green hills and small villages appeared and were gone, and then—into the weary city of Windsor. Across the river, Detroit and the American Dream lay, wreathed in smoke and ideology. It seemed somehow appropriate that Katimavik would take us to the very brink of the Canadian nation, to peer out over the edge of the abyss. It was like stopping a roller coaster right at the top.

Peche Island was as far as you could go and still be protected by socialized medicine, progressive conservatives, the RCMP, and Canadian beer. We were ferried out to the island across brown sluggish water, on board a put-put boat with a hacking cough.

"You ever been to Detroit?" asked Duncan, leaning across to Erik.

"Once," said Erik. "It was scary."

We circled the island to a wooded grove, where we could see dozens of Katima-victims already assembled, throwing Frisbees, waving fleur-de-lis flags, drinking beer. (Alcohol was allowed in Katimavik. Only the *abuse* of alcohol was prohibited.) We bumped up along the dock—and Geneviève was waiting for me.

She met me halfway down the pier. "They let *you* on the island?" she said with a laugh. "Big mistake."

"You survived your wilderness expedition. You didn't get eaten by a bear or anything."

"Me, I am not afraid of bears. And I am not afraid of you either." And she flipped me onto the grass. "Judo," she said. "We study it. How about you?"

I was lying there with my elbow and pride throbbing, looking up at this hurricane in human form. I said, weakly, "We studied massage."

"Massage?" she said. "With the clothes off—or English-style?"

"Both," I said. "Now help me up."

She pulled me onto my feet and brushed away some of the pine needles sticking to me. "Massage," she said. "That is more dangerous than judo, I think."

I agreed, but inside I wasn't sure.

Geneviève took me on a mini-tour of the island, past the main house where everyone would be sleeping and into a vast clearing where the bulk of the Katima-victims had gathered. There were more than a hundred young people from every dogpatch and railroad crossing in

Canada, but it was the Québécois who were in the spotlight. A large, billowing flag of Québec was strung up between trees and the cassette deck played an incessant loop of French music.

"For supper," said Geneviève, pointing to a fire pit. A lamb was being roasted, turning in sizzles over glowing coals. Mouthwatering aromas were dripping off it.

"Is this how you celebrate St-Jean Baptiste Day?" I asked. "You know, back in Petit-Rocher?"

"I am Acadian," she said, correcting me. "I am not Québécoise. That is an important difference. Of course, we share the same—how do you say—spirit. The same French spirit. But Acadians, we have our own holiday, August 15, and our own anthem and our own flag. This," she said, gesturing to the crowds and celebrations, "this is for Québec." And then, with a wry smile, "Of course, they get all the attention. But we Acadians, we were here first."

Geneviève and I walked along the shoreline of the island. We found a bone-dry tree trunk among the driftwood and sat down.

"The wind," she said, turning her face to it, eyes closed. "But no salt." She opened her eyes. "I miss that, the smell of salt."

"I know how you feel," I said. "I miss the smell of cow dung."

She laughed, and then said, "Do you know îles de la Madeleine? Small islands of sand. Shaped like a fish hook. Do you know it?"

"No."

But Geneviève didn't elaborate. She looked out across the sludge-brown river towards factory stacks and smoke plumes. Islands made of sand. Salt air and fish hooks in the sea.

I decided now was the time. I took a deep breath and said, "*Vous êtes resplendissante.*" I had memorized this from a phrase book.

"Thank you," said Geneviève, wisely choosing not to pursue the conversation *en français*. "I think of you often. I like the letters, also. But your emotions, they are too strong. Me, I am a girl from Petit-Rocher. And you? You are a boy—a very nice boy—from Manitoba."

"Alberta—"

"Wherever, it's not important. It is amazing that we meet, that we are friends. But we don't need so strong emotions." And she reached out for me. I flinched, expecting another judo flip, but all she did was

cup my face in her hands. She smiled and I quickly attempted to assess the situation. Clearly, she was sending me a Signal, one of those subtle women signals that are about as easy to decipher as Egyptian hieroglyphics. I put my arm around her and—hoping I had made the right interpretation—I came in for the kiss, dry lips and all.

"Hello there, Will!"

It was Duncan.

"Sorry to interrupt," he said as he clomped down the path towards us.

I ground my teeth. "Duncan, this had better be good. And it had better be important."

"Of course it's important," he said. "It's about food. They're starting to carve up the lamb and they sent me out to spread the gospel."

"Thank you very much," said Geneviève. "I appreciate that you find us."

"Yeah, Duncan. Thanks a million," I said, with a little less enthusiasm.

When we got back to the clearing, Erik was chasing Mac around with one of the lamb's semiglazed eyeballs. She used Geneviève and me as temporary cover before fleeing into the crowd.

"How you doin'?" asked Erik before dashing off, the jellied eye held out in front of him.

All around us, anarchy had erupted. Someone had rigged a ghetto blaster up to the main building's PA system. The lamb had been torn to tatters—greasy, succulent tatters—and the music was beating like the heart of a madman. Participants were ricocheting off each other in a game of kinetic pinball.

"We dance!" said Geneviève, and she dragged me into the melee.

A rend, a thunderclap, and an echo, and the rain began to fall, suddenly, in waves. Some ran for cover, others joined the crowd. We turned our faces to the sky, we sputtered and shouted and wiped it from our faces, and we danced. It was pagan and senseless and young.

"*Rain!*" someone cried, and a chant was picked up. "*Rain, rain, rain.*"

In reply, the tempo of the rain picked up. Faster. Quicker. For one synchronous moment the rain was in time with the music, and then—

with another audible crash—it went beyond it. It was coming down in gun volleys and washing across the dancers. The clearing turned to mud. T-shirts clung like suction and were torn off and discarded. We kicked our shoes aside and went barefoot.

And then the chill set in.

The cloudburst passed, the rain ended, and the crowd was left shivering in the aftermath. We pushed inside the main building: a mass of soggy, steaming, cold participants.

Geneviève went to dry off, and I found myself talking to a girl from Elbow, Saskatchewan. That's right, *Elbow*. When I asked her where that was, she replied, "Near Eyebrow." And where was Eyebrow? "Near Moose Jaw." How *do* they name these places.

Not long after, I met a boy from Red Lake, Ontario, and with one statement, I started a chain reaction. "Red Lake?" I said. "No kidding. I'm from Red *Deer*."

"You're from Red *Deer*?" someone else said. "I'm from White*horse*."

"Really?" someone else yelled out. "I used to live in Yellow*knife*."

"Hey! I'm from *Cut* Knife."

"Territories?"

"Saskatchewan."

At which point, the girl from Elbow showed up, and I left. By the time Geneviève came back, my head was spinning. "Let's go for a walk," I said.

"Another walk?" she said. "Don't you want to stay inside and talk to everyone, to find out where they are from?"

"I already have. Everyone here is from Canada. Let's go."

But Geneviève wouldn't hear of it, and she got caught up discussing hometowns with a group of Québécois. This was even more confusing, as it was all in French. As near as I could tell, they were all from someplace near someplace else. I soon got tired of the francophone version of Whereyafrom? and went in search of something warm to drink.

François was knee-deep in a heated debate over the future of the Parti Québécois (this was about the time that Pierre Trudeau had declared, "Separatism is dead") and Duncan was chatting with a

beautiful young girl from St. John's. Erik was surrounded by his usual instant bevy of admirers, and even Sarah had found someone: a scrawny young fellow named Izzy, from Someplace Small. I had met Izzy before because he was in Geneviève's group, but he hadn't made much of an impression. Still, he and Sarah seemed to get along well enough; she ignored his ferretlike features, and he ignored her green hair. Lysiane and Marie-Claude, meanwhile, had gotten quite tipsy on wine and were laughing like longshoremen. Lysiane passed me on the stairs.

"Allo, Will!" she exclaimed, as though she hadn't seen me in years. "Come! Come to drink *avec Marie-Claude et moi.*"

She was clumsy enough sober, but with a few drinks inside her she became one extended pratfall. It was the first time I had ever seen someone fall *up* a flight of stairs.

"So." She grabbed my arm and drew me in for a kiss. "You find a French girl after all. Geneviève is good, *non?* Not so sophisticate, but cute. She don't wear the make-up. A country girl." She pulled me in tighter and now her mouth was wet and partially open. "You like the French girl, eh?"

I was just managing to disentangle myself from her when Geneviève came along. "*Ça va, Lysiane?*"

Lysiane pushed herself away from me, and with a wave of her hand said, "I am drunk. Too drunk. *Salut.*" And she staggered away, tripping over her feet and sloshing the wine in her glass.

26

GENEVIÈVE'S FREE WEEKEND was scheduled for the fourth, fifth, and sixth of July. When we got back to St. Thomas, I checked our events calendar. The only thing planned was a general house cleanup (in preparation for our move to Québec), and I was sure I could squirm my way out of that. I had lots of relatives I could kill off—maybe an uncle or two down in the States or a cousin in Cape Breton. Anything to get some time away from Katimavik.

The nearest romantic destination I could think of was Stratford, so back to Stratford it was. Using the Katimavik account number, duly

noted on our last theatre outing, I called up and managed to con my way into two seats for one of the weekend performances of *Tartuffe*, a play written by Molière, who—according to Lysiane, anyway—was the French equivalent of Shakespeare. "Only better."

Unfortunately, getting out of the cleanup day was more difficult than I thought.

"Your Aunt Mabel?" said Hal. "Dead?"

"Down in Fergus," I mumbled. "Terrible accident. Blood everywhere. I really don't want to talk about it."

"I don't know which is worse," Hal said philosophically. "That you are lying, or that you are lying so poorly. You didn't put much effort into this. I'm insulted."

"Cousin Billy was in the car with Mabel," I said. "And so was Uncle Roy and Sister-in-law Bernice."

"The whole family? What is that—two aunts, an uncle, a cousin, and a partridge in a pear tree?"

"Something like that." I knew this wasn't working, but my dignity ruled out grovelling like a—oh, what the hell. I'd grovel for a weekend with Geneviève. "Please, Hal, please. I need those days off. I'll make it up to you, I swear."

"Well," he said, "seeing as how you're practically an orphan now."

So here's what happened: Hal said he'd let me go—begrudgingly— but only if I did a complete house inventory before I left *and* cut the lawn *and* straightened up the shed. We had a rusty push mower that bent the grass more than cut it, and cleaning the shed took me well into the night. Which meant I was running through the house at one in the morning haphazardly counting pots and pans. Somehow, I made it. I handed Hal my Highly Detailed and Mostly Fictitious Inventory the next morning and, arms still aching from the ordeal of the grass, I caught a train to Stratford.

Geneviève had arrived in Stratford a few hours earlier, and she met me at the station. "Hello, traveller!" she said, with a trusting smile. "Where are we staying?"

Damn. "Yes, well, lodgings—yes." Joe Traveller. "I didn't think to call ahead. But there has to be a hostel or something."

There *was* a hostel. It was closed. We found it behind a KFC. It was a

large, yellowing building, and the woman who answered the door said in the sweetest possible way what amounted to "Bugger off."

"What are we supposed to do now?" I said huffily.

The woman was dressed in a purple peasant's dress with dangling jewellery. She swept her hair, grey and long, back behind her ears and said, "I wish I could help you. I truly do. But they closed the hostel down just last week."

"Well, that's just *great*," I said. "That's just marvellous. Wonderful! What, are we expected to sleep in the gutters? Or has Stratford closed those down as well? Perhaps we'll just break into someone's barn and bed down with the pigs. Maybe we'll just—" and so on. Alas, sarcasm and self-righteous indignation rarely win people over.

Geneviève stepped up to the plate. "Is there any other hostel or maybe a budget hotel? You see, we are paid only one dollar a day and we need to—"

"A dollar a day? Those are slave wages, honey."

"We work for the government," I said. "Katimavik. It's a covert operation. Very dangerous."

"Really?" She sounded dubious. "What do you do?"

"If I told you, I'd have to kill you."

"We are youth volunteers," Geneviève said. "We came to Stratford to see the theatre, but now we have no place to stay. So, if it is not possible to stay here as guests of the hostel, may we stay as guests of yourself instead?" She gave the lady a smile that could have disarmed the Warsaw Pact.

The woman thought about this for a moment and then said, "My name's Elizabeth. Come in."

We stepped inside. The building was as warm and worn as a grandfather's sweater. "You can stay here as long as you like," she said. "But on two conditions: you can't steal anything, and you have to supply interesting conversation." She shooed a cat off a kitchen chair. "Sit, sit. I'll put the kettle on for tea."

We drank our Red Rose from mismatched china that had chips on the rim and handles half missing. Elizabeth was endlessly fascinated by our travels. "It reminds me of my own wanderings," she said. "One day, the urge to travel took over. I had to get out of Stratford. So I

hitched a ride to Winnipeg to see a friend. When I left, all I had was nineteen cents in my pocket and half a pack of cigarettes. When I got back, I had a buck fifty and a full pack. So, I came out ahead. If you start out low enough, you usually do."

"Quite the trip," I said. "How old were you?"

"Oh," said Elizabeth. "That was just last April."

I blinked. "Last April?"

Suddenly, Katimavik didn't seem like such a risk-taking adventure. That's the problem with travelling. No matter how far you go and no matter how daring you become, you will always meet people along the way who have gone farther, done more. If you have just ridden a mountain bike across the badlands, sure enough you will meet someone who went across the Sahara blindfolded—on a pogo stick. (Years later, I hitchhiked the length of Japan and met an American going the other way *walking*. You just can't win.)

That afternoon, Geneviève and I had a late lunch of cheese and cheap wine beside the river. For dessert we shared an apple. It was—and I say this with the hindsight of more than a dozen years and hundreds of repasts in exotic locales around the world—simply the best meal I have ever eaten. I would give anything to be back there, eating cheese and drinking cheap wine on a dollar a day by the Avon.

The Avon cuts a languid swath of green through the heart of Stratford, and Geneviève and I walked along the shore past small islands and footbridges. Weeping willows were hanging low into the water. Swans were floating by. Houses lined the far side.

"This is what I've been looking for," I said. "This is where I want to live. In an upstairs apartment with a hardwood floor and a view of the river. I want to live in a city like this, with small cafés and summer theatre. In the evening, I will sip coffee and read old books. And afterwards, I will meet eccentric friends and have heated arguments about nothing." I stopped and looked around me. "This is where I want to live."

"In a town?" she said.

I nodded. "How about you? Don't tell me. Paris? Rome? No. Montréal. Am I right?"

"No, no," she said, annoyed at my lack of perception. "I am not Lysiane. Is that how you see me, at cocktail parties, acting like the snob?"

She didn't say anything for some time.

"The air in Montréal stinks," she said finally. "Do you know that? It does." And then: "You remember I said about îles de la Madeleine? Small islands of sand. You remember? I told you and you didn't understand how important it is, not at all." There was another long pause as we walked along the water. And then: "My family went to the Madeleines when I was a little girl. I remember it, running into the wind. You could taste the air. It was salty. Someday, I will buy a small house beside the ocean, and at night, I will hear waves. And when no one is there, I will take off my clothes and run on the beach. I will swim in the full moon and I will raise horses and I will eat lobster every night."

And then, without warning, and as if to prove a point, she leaped out across the water, caught a low-hanging branch, and swung herself back to shore, turning in midair as she landed. She spun around to look at me, and her hair was blowing across her face and she was laughing. She waved at me to follow and she said half in jest, half in taunt: "Your turn!"

"I'll fall."

"Your turn!"

"But I'll fall in," I said, looking down at the water. "And I only have one pair of jeans, and if I get them wet they'll never be dry in time for the play, and I'll end up—" My voice trailed off.

"You are afraid of water?" she asked. "Jump!"

"I can't," I said. "I'll fall. I know I will."

I never did make the leap. Instead, I walked beside her feeling sheepish all the way to the theatre. And every time we passed a puddle or a drinking fountain, she cried, "Look out! Water! Be careful."

I had no witty riposte then, and to this day I torture myself trying to think up some kind of snappy retort. Suggestions can be mailed to me care of the publisher.

27

TARTUFFE IS ABOUT A conniving priest who takes over a family. Although cast as a villain, Tartuffe is really the hero of the piece: he is the mover, the shaker, the instigator. It takes the deus ex machina of a benevolent prince to suddenly reverse Tartuffe's schemes—as arbitrary and unbelievable a dénouement as ever I have seen. Brian Bedford played the priest, with his stained tunic and lecherous grin.

When we left the theatre, the streetlights were on and cars were moving slowly through the rain, headlights watery and blue. With jackets up over our heads, we ran back to Elizabeth's, and by the time we reached the front door, we were soaked. It seemed as if every time I saw Geneviève I ended up chilled and wet and racked with shivers. Elizabeth was out so we let ourselves into our room, where I peeled off my shirt and was towelling down my hair when—*boom*—just like that, Geneviève pulled her tank top up over her head and off. She wasn't wearing a bra. I stood there stupidly, not knowing what to say.

She wrung out her tank top in the sink and pulled on a dry cotton work shirt, but the damage was done. My brain had seized up like a water pump in dry heat.

"You, um, look good in plaid," I said.

She searched through her backpack and brought out a bottle of wine and a corkscrew. "I have my own massage for you," she said. "Acadian-style. Leave your shirt off."

And then, well, hell, she pushed me back and wet her lips with wine and traced patterns across my chest, all of which—given my limited experience of back-seat gropings and hurried humps outside school gymnasiums—was a revelation. I didn't know you were even *allowed* to do things like that. I thought it was only in the movies.

It made a deep impression on me, that night in Stratford, and the memory is as vivid today as it ever was. And now, if you'll excuse me, I have to go and run my head under cold water for a few minutes until I calm down. Suffice to say, I have become a *big* Molière fan. And I think the city of Stratford should be given a commendation of some sort, maybe a plaque or, at the very least, its own national holiday.

28

SUNDAY NIGHT. The midnight run back to St. Thomas was empty save for myself, the bus driver, and a mother holding a sleeping child. The child's head was nodding with the hum of the motor. I walked from the depot on Talbot down towards Maple Street.

Hal was waiting for me. In his hand he held my Highly Detailed and Mostly Fictitious Inventory, and on his face he wore his Highly Annoyed Expression.

"So," he said. "Did you have a good time in Stratford?"

I didn't realize this was meant to be *(a)* ironic and *(b)* rhetorical. "It was fantastic," I said. "Absolutely fantastic. We met this *incredible* woman and we saw this *hilarious* play and we ate at this *wonderful* restaurant"—Joe Adjective—"and afterwards we went for a long walk along this beautiful river—"

"I am so happy for you," said Hal, but he wasn't smiling. "Now, about your so-called inventory." He held it up to within an inch of my nose. "I was wondering why the chesterfield wasn't on the list."

I feigned a look of great concern. "Sorry, Hal. I must have overlooked it. Anyway, the play we saw—in Stratford? by Molière?—anyway, the thing about it is—"

"You overlooked the chesterfield?" asked Hal. (Again, in retrospect I would guess this was meant to be taken rhetorically.) "You overlooked the chesterfield. I can see how that would be easy to miss. Just like the vacuum cleaner, the lawn mower, three shovels, two chairs, our garden hose, the rake, the clock in the hallway, the spaghetti strainer, *all* of the silverware . . . I went over your entire inventory. You 'overlooked' an awful lot."

"Gee, if I knew you were going to check everything anyway," I said, "I would have let *you* do the inventory in the first place. You're a much more thorough person than I am."

"Listen to me," said Hal, sounding like a character in one of his westerns. "And listen good, because I'm only gonna say this once—"

But the phone rang just then and Hal had to stomp off and answer it. The conversation he had was pretty dull on our end. "What? Where? When? *Now?*"

Hal put the receiver down and stood there, stunned, as though he'd been hit on the head with one of my missing shovels. "Baby," he said.

"Baby?"

"The wife," he said. "Baby."

"Shouldn't you, ah, be somewhere right now?"

He nodded, but he didn't move.

"Think, Hal. *Where should you be?*"

"Hospital."

Sarah came down the stairs. "What's going on? Was that for me? Was it Izzy?"

"Hal's having a baby," I said.

Two seconds later, pandemonium erupted. Everyone came stampeding into the living room and half-pushed, half-pulled Hal into the driveway.

"Baby," he said to us one last time before getting into the car. We cheered him on from the front porch.

"Son of a gun," said Duncan. "I never knew that old station wagon could hit a hundred."

The delivery of l'il Tex had become such an anticipated event that we were now too excited to go to bed. We stayed up in the living room, slowly succumbing to sleep one by one like characters in an Agatha Christie novel. Mac and I were the last. We fell asleep on the chesterfield (our noninventoried chesterfield) as dawn crept in.

"What are you doing up?" asked Hal. He looked tired but calm.

"Are you—"

"Yes, I am now a father."

Duncan pumped his hand. "Congratulations!" he said. "How's the little guy doing?"

"Girl," said Hal. "It was a beautiful little girl."

"A girl?" There was a long pause. "What did you name her?"

"Tina," he said, a tad defensively. "We'll call her Tina for short."

"So her full name is—what? Christina?"

"Not exactly." He hemmed and hawed for a moment. "It's *Dustina*. Tina for short."

There was a two-beat pause and then the laughing began. "Dustina? You named her Dustina? What's her middle name? Texetta?"

"No, it's Dalice."

"Dallas!" shrieked Sarah. "You named your *daughter* Dallas?"

"Not Dallas," Hal protested. "Dalice." (There was absolutely no difference in pronunciation.)

"Dustina Dalice Vanbreesenbrock." I shook my head in sympathy. "The poor girl already has two strikes against her. But tell me, Hal, what are you going to do with all those footballs and Tonka trucks you bought?"

"Why, nothing," said Hal, genuinely puzzled. "They're for Tina. Why would I have to do anything with them?"

"*Oui!*" said Mac. "Why he have to change that? What is the problem?"

Sarah and Lysiane wanted to know the same thing.

"Oh, nothing," I said. "Nothing at all." My western Canadian mores were being put to the test now.

Mac was not appeased by my nonanswers and pursued the question vehemently. "You have the problem for the girl to play football? Or hockey?"

I mumbled something about "dolls and such" but said little else for fear of being lynched.

29

THREE DAYS LATER, we left for Québec.

Hal called one last meeting (yes, still just a "meeting"; he never did catch on to the lingo). On a large sheet of paper, he drew a circle and divided it into four quarters, then labelled them: *Forming, Storming, Norming,* and *Performing.*

"I got this from the manual," he said, almost apologetically, as though he felt bad for not having developed his own theory of intergroup dynamics. "These are the four stages a group goes though. *Forming* happens at the beginning, when everybody is uncertain and no one is being themselves. Often, infatuations or strong dislikes take shape—and this leads to the next stage, *Storming.* This is when the dominant personalities emerge. There are conflicts and power struggles. In some groups, the storming phase is very brief. Other groups

never move beyond it; they keep looping back to old conflicts and unresolved tensions. With luck, no irreversible damage is done and the group moves on. *Norming* is the settling-down phase, when the group's character—and every group has its own distinct character—is set. Participants develop their own roles and niches. Everything falls into place and the group finally begins to *Perform*." He adjusted his cap and asked if we had any questions.

"So where are we in the Great Circle of Life?" I asked.

Hal volleyed the question back to us. "Where do you think you are?"

"Storming," said François from the back of the room.

Lysiane disagreed. "Norming," she said. "We are finding our place."

Erik butted in. "No way, man. We're performing. This group is finally starting to rock. It's, like, off the ceiling and in the hole."

"It is?" said Hal.

"Definitely," said Erik and we all nodded, even though none of us had any idea what he was talking about.

"I think Erik is right," said Hal. "When you arrived, you were still storming. But over the last few months things have begun to work. This group almost runs itself now, which has made my job a whole lot easier—"

François snorted from the back of the room.

"—and I hope everything goes well in Québec. Now, before you leave this room, I want a kiss from all the girls and a handshake from all the boys."

We groaned and lined up. Hal gave us each a small farewell present. As might be expected, the gifts were all Jumbo-related—T-shirts, key chains, and address books with that familiar Elephant-That-St.-Thomas-Killed proudly stamped across the front. "I want a kiss too," said Erik to Hal. "A big wet one, right on the lips." François was the last one to run the gauntlet, and I wasn't sure if he would go through with it. He hesitated, then held out his hand.

We had a surprise for Hal, too. Lysiane presented him with a hand-painted card and a gift-wrapped box. "We give you this present," she

said, "because all the time you wear the goofy hat. So, like Will says, 'If you can't kill him, join him.'"

"That's *beat*," I said. "If you can't *beat* 'em, join 'em."

"Whatever." She brushed me aside with a Gallic wave of her hand. Inside the box was a bright yellow farmer's cap with the word KATIMA-DADDY printed across the front.

Hal was so touched by the gesture that none of us had the heart to tell him we had used the rest of our International Awareness budget to pay for it. We figured, why not make bureaucracy work for us? Let the Katimavik head office sort it out.

You know what they say: If you can't kill 'em . . .

30

ONCE AGAIN, WE were on the move. Loaded down like a desert caravan, we invaded the London train station and hoisted our bags on board. Our farewells were hurried and harried.

As the train pulled out of the station, we could see Hal standing by the side of the tracks, waving to us. He looked small and relieved and sad. Lysiane pressed her face to the window and watched Hal slip away into the distance. We could see him waving his hat high above his head, back and forth, back and forth—until he was gone.

"Why did he have to do that?" said Lysiane. She was laughing and crying at the same time. "Why did he have to do that?" And now she was only crying.

I never saw Hal again. He faded into memory, like a figure lost in steam, standing beside the train tracks, waving his hat, saying good-bye.

On June 29, 1985, the Jumbo the Elephant Memorial Statue was unveiled amid a five-day gala celebration known, appropriately enough, as Jumbo Days. It was to be the high point of the town's recent history. Since that summer, St. Thomas has gone into a long, slow decline.

In 1988, after more than one hundred years of providing instruction to young ladies "to make their lives useful and happy and their

tastes elevated and refined," Alma College closed its doors. The text-
books and desks were left just as they were, as though everyone
simply walked away one day and never came back. The High Victo-
rian Gothic towers stand deserted. The walls have been vandalized,
windows have been broken, and the girls of Alma no longer flutter
down the avenues and side streets of St. Thomas.

The college, once such an imposing structure, sits like a decaying
castle in the heart of town. It is one of the saddest sights in all of
southern Ontario.

In 1998, Alma College and all its contents were put up for public
auction.

Part Three
ST-CANUT
QUÉBEC

1

THEY SHOULD HAVE a sign outside of Mirabel: "Welcome to White Elephant, Québec: A Testament to the Megalomania and Corrupt Extravaganza of la Belle Province." The town of Mirabel, we soon discovered, is a work of fiction. It doesn't exist. It was created, by bureaucratic fiat, to act as the site of the now infamous Mirabel International Airport.

The airport was a Québécois scheme funded by federal money, and boy, doesn't it show. It is the Biggest Airport in the Whole Wide World—not the busiest, the *biggest*. Built at a cost of over $500 million, it opened in 1975 to a puzzled public. No one quite knew what to make of Mirabel. After all, there was not nearly enough air traffic to justify such extravagance, and anyway, Montréal already had a more conveniently located airport at Dorval.

Mirabel was a circus of corruption and irresponsibility that went on to become a laughingstock within the airline industry. When we went through, the terminal was operating at less than 15 per cent capacity: a vast, cavernous structure, almost cathedral-like in its stillness. Today, it has been scaled down even further, handling cargo shipments and little else: the world's most technologically advanced ghost airport.

This absurd Ode to Excess would be hilarious if it weren't for the

fact that the government expropriated vast tracts of farmland to build it, disrupting more than three thousand families. A new entity, vaguely defined as "Greater Mirabel," was created in the midst of this Stalinist experiment. No fewer than fourteen different communities were merged into an arbitrary union. (The original hamlet of Mirabel, ironically, was covered in asphalt and survey lines and has completely disappeared.) Mirabel exists only on maps and in government dossiers; we went to St-Canut, a small, sleepy town in the agricultural belt north of Montréal.

St-Canut billed itself as a budget getaway for tourists, with all that that implied: hamburger stands, holiday trailer parks, man-made ponds. The town's identity as a low-end tourist mecca was a recent incarnation. St-Canut had a long habitant history and was strongly— *completely*—francophone. The first thing we saw when we drove in was the steeple of the Catholic church rising above the treetops.

The town itself was a long, twisted rope. There was only one main street, rue de Latreille, with side-street subdivisions branching off on either side. The Katimavik house, a bland white bungalow, was at the far end in a small pocket of suburbia. Our group leader was waiting for us when we arrived. She had soft drinks and snacks and smiles galore. Her name was Bernadette Thibeau. Bernadette was from Ottawa, healthy and cherub-faced, with cheeks that were always pink and eyes that were wide and blue. Joyce had been dedicated but sardonic. Hal had been laid-back. And Bernadette? It didn't take us long to discover her key trait. We did so during our inaugural meeting, when the subject of committees came up.

"Don't forget the Beer Committee," said Erik.

"The Beer Committee?"

Erik was only too glad to explain. "We had one in B.C. and again in Ontario. We buy the necessary ingredients and then we make beer. It comes out of the, ah, Nutrition and Well-Being budget."

François muttered to himself but held his peace.

"Oh," said Bernadette. "In that case, who wants to be on this committee—this Beer Committee?"

Erik's hand shot up. "I volunteer."

And from that first brief but telling exchange, we learned

everything we needed to know about Bernadette. She was gullible. Malleable. Easy to fool. In short, the ideal group leader.

With the critical issue of beer production taken care of, Bernadette went on to outline our St-Canut work site. There was only one: the planning and construction of an outdoor playground/obstacle course. (Geneviève's group had rotated to Laval and they were doing much the same type of work.) The town of St-Canut had agreed to supply the tools, the materials, a rough blueprint, and a work supervisor; we would supply the grunt work.

"And so," said Bernadette, "because everyone will be working at the same site, I think we will assign two people at a time to the cooking and cleaning duties. This will make the housework easier—but it will also mean your name comes up twice as often on the schedule." (I'll pause here to let you work out the logic behind this.)

We drew up a cooking schedule, divvied up the bedrooms, posted our usual list of House Rules (i.e., no smoking inside, no loud music after 11:00 P.M., no naked pagan voodoo dances after 1:00 A.M., and so on). Then came the really controversial issue.

"We have two bathrooms," said Bernadette. "A larger one with a full bath upstairs and a smaller one in the basement with just a shower. Now, the group that was here before you decided to—"

But by this point she had a riot on her hands. Objects were thrown, curses hurled, punches threatened, reputations besmirched, and family lines disparaged. Bernadette watched in horror, like a well-intentioned minnow trying to calm a shark-infested feeding frenzy. The battle lines, as always, came down to gender. The female contingent was determined to get the luxury bathroom, but the male brotherhood was just as adamant that they be so rewarded, pointing out—at maximum volume—that they had suffered the most in Kelowna. (Which, of course, was not at all true.)

"But we had to take the attic in St. Thomas!" shouted Sarah.

"Screw you!" I explained in a calm, rational manner.

"Hold it," cried Bernadette almost plaintively. "Why don't we toss a coin?"

"No," I said. "I will not have a matter of principle settled by pure chance. Besides which, the girls always win. It's not fair."

Erik and Duncan agreed, but our protests were in vain. A coin was tossed. The girls won.

"Nya-nya-nya-nya-NYA-nya!" they said, taunting us.

"Oh, yeah?" I shouted back. "Well, *we* had a waterbed in Kelowna. And electricity. And a toilet that flushed properly."

"Did not!"

"Did too!" I dug out some photographs from my backpack and passed them to our female adversaries.

"It's true," said François, cool as all get out. "Face it, ladies. We out-manoeuvre you in British Columbia."

"We had showers too," said Duncan. "Nice hot showers, as long as we wanted, any time of day."

"And a waterbed," I said. "Don't forget the waterbed."

"Nya-nya-nya-nya-NYA-nya," chanted the boys in unison.

Bernadette let out a long sigh—more of a groan, really—and said, "I have a feeling this is going to be a very long rotation."

2

DUNCAN, ERIK, AND I went for a long stroll down rue de Latreille. St-Canut had that lazy, languid, vaguely bored energy of summer camp: people standing by doorsteps chatting aimlessly, kids kicking up dust, and the long, low gold of evening. We passed the Catholic church, with its steeple and headstones and statue of Christ pinned to the cross like a butterfly. Paint was peeling off his chest. The blood of his wounds had faded in the rain and sun to a soft, pastel pink. The telephone wires were humming.

We found a small canteen specializing in fried foods and oily paper plates and, amassing all the coin we had, decided we could just afford a cup of coffee each. We sat in a corner booth and looked in bafflement at menus that might as well have been written in French, for all the good they did us.† The other customers eyed us with that glassy, small-town stare I know so well.

† That's a joke, you see. Because they *were* written in French.

The trouble began almost immediately.

"*Qu'est-ce que je peux t'apporter?*" the waitress asked.

We smiled stupidly at her, not unlike the Three Stooges. (Where was François when we needed him?)

"Coffee all round," said Erik, figuring this would be one item found on any menu.

"*Je m'excuse, mais je ne parle pas l'anglais.*"

"Let me handle this," I said, and I held up three fingers. "*Trois!*" I shouted. "*Trois, s'il-vous-plait.* Coffee! You know, hot black stuff." I made a drinking motion with my hand.

The waitress, an older, world-weary type, said nothing.

Erik looked at me. "That's terrific," he said. "Don't know what we would have done without you."

"Hold on," I said. "It's not called coffee. It's *café. Café!*" I shouted. "Bring us some *café.*" Several customers had turned around to watch at this point.

"*Café?*" said the waitress.

"*Oui, oui, oui,*" I said. "*Café, s'il-vous-plait. Trois cafés.*"

When she filled our cups we all said "*merci beaucoup*" very loudly, proud we were able to communicate with our fellow Canadians in their mother tongue. Unfortunately, the waitress didn't go away and leave us to our triumph.

"*Quelque chose d'autre?*"

We stared at her. Duncan said "*merci*" again, but that wasn't the right answer. Erik addressed the other customers. "Anyone here speak English? We need some help."

Other than a few grumblings of "*maudit anglais,*" no one responded.

"*Quelque chose d'autre?*" the waitress repeated.

"*Oui,*" I said, trying to bluff my way out of it. "*Oui, oui, oui.*"

She sighed. "*Ben, quoi?*"

"*Oui!*" I said, more frantically this time.

"*Oui, mais quoi?*"

At which point I leaned in and said to her, in a conspiratorial whisper, "*Moi, je nay parle Français,*" as though she hadn't yet figured that out.

She looked me dead in the eye and said something which no doubt translated as "You scum-sucking piece of loose stool, I shall spit surreptitiously in your next cup of coffee," and she left.

Erik looked around the place. "This is weird, man. All the signs are in French. The menus. Everything. No one here speaks English."

"It's like we're in a whole other country," whispered Duncan.

"You're right," I said. "It's spooky." This must have been how Mac and Lysiane felt in Kelowna.

"You don't have to whisper," said Erik, suddenly loud. "No one knows what we're saying."

A heavy-set, rough-looking man came in and sat down across from us. He was wearing a leather jacket with the sleeves torn off and a denim shirt underneath.

"This is great," said Erik. "We can talk about people and we don't have to worry. We can say anything. Like, check out the big fat pig who just sat down."

I laughed. "Looks like he hasn't had a bath in weeks."

"Weeks?" said Duncan. "More like a year."

We began making oinking noises, at which point the large man turned and said, "You guys—you t'ink you are funny or somet'ing?"

Duncan, Erik, and I performed a move known as the Three-Coward Simultaneous Sphincter Clench. "No, sir," I said, my voice suddenly high. "We don't think we're funny at all, sir."

We left the restaurant quickly, thankful we had gotten out alive and praying to all the saints in Heaven that we weren't going to be followed out by Bilingual Pig-Boy and beaten to a pulp. The three of us strolled away at a very high speed—so high, in fact, that it probably isn't accurate to describe it as a stroll. It was more of a barely constrained sprint. We slowed down only after we had cleared town and were out in open farmland. *Bienvenue au Québec!*

Having escaped mortal danger, we relaxed, and our pace slowed down. We walked across freshly tilled soil laid out like a quilt, and the deep wet smell of earth brought back memories of my childhood, drifting by like—

"What the hell is that smell?" said Erik. "It reeks."

"It's called manure, city boy. And that over there is a barn. And those funny-looking things are called cows."

Erik gave me a curdled look. "Well, it smells like shit to me," he said.

"It *is* shit," I said. "That's the whole point. And this—this is what we simple country folk call a fence."

"What does the sign say?" said Erik.

"Who knows, who cares?" I climbed up and over.

"It says 'Attention,'" said Duncan. "*Attention au chien.*"

Erik and Duncan followed me over. The three of us had barely started walking when we discovered what *attention au chien* meant.

"What is that?" said Erik. "Over there."

We stopped to look.

"Looks kind of like a wolf," said Duncan.

I chuckled to myself. "Don't be silly. That's not a wolf, that's a GER-MAN SHEPHERD!!" (That last bit was shouted over my shoulder as I ran back to the fence, abandoning my comrades to the fray.)

Duncan was the last one over, mainly because Erik used him as a human bridge, and the dog came snapping up one or two heartbeats behind them. *Bienvenue au Québec!*

It took me a long time to catch my breath. In between gasps, I said, "This town is trying to kill us."

Duncan and Erik agreed.

We walked back in to St-Canut and, shaken by both the snarling locals and the snarling dogs, decided to cower in our house awhile. Rather than go past the restaurant again, we took a scenic, cowardly route, across the river and up by a small dam. The scene revealed itself like a hidden idyll. The water pooled and spilled out, tumbling over boulders in a wild froth, and the air was cold and moist. Spindrift was billowing up like dandelion plumes.

We looked down from the vertiginous edge, down at the elation of water below, and Erik said, "This must be where they go at night to knock bones." Nature always brought out the poet in him.

"It might also be where they push anglos off the edge," I said.

Either way, it must have been a popular spot.

3

EVERYTHING HAD BEEN scaled down. With each rotation, from B.C. to Ontario to Québec, we were cut back and trimmed down. We went from a large barn to a three-storey brick house to a cheap little bungalow. At the same time, we went from a full-size van to a station wagon to—well, to foot power. Our work site was near the church, down Rue de Latreille about three kilometres from our house. We walked it every day.

The Katimavik group before us had cleared the underbrush and broken trail, and had even marked out the course itself, in the trees up behind the town's tennis courts. The rest was up to us. The plans included a tree house, a rope walk, a wooden tunnel, a swaying bridge, two Tarzan swings, and a path of rubber tires laid out for the kids to run through. The *piste herboriste*, as it was known, would be a cross between a nature hike and a Marine camp.

For our first assignment, we were organized into various crews. Duncan and Erik were in charge of rock clearance, and they went at it like characters from *Lord of the Flies*, laughing and sweating and wrenching boulders from the earth and rolling them down the hill to the rock pile. Duncan's work habits had improved considerably, I noted. *They* were having fun. I, meanwhile, was put in charge of the tire run, which meant lugging huge balding tires into the woods and then pounding them into the ground with great mediaeval spikes. As I lugged the tires up, the lovely children of St-Canut swarmed around me, getting in the way and pestering me with questions in rapid-fire French.

I was slick with sweat by the time the last of the tires was in place. Now I needed to hammer them into the ground, but when I looked for the sledge hammer, it was gone. I smiled at the rabble of schoolchildren. "Any of you brats know what happened to the hammer?"

"*Nous ne parlons pas l'anglais,*" they bleated.

Using a rock, I managed to pound two spikes in before a little girl took pity on me and shyly pointed to a nearby bush. I went to investigate and, lo, there was the sledge hammer. "*Merci,*" I growled as I returned.

Now the spikes were gone.

By the time lunch came around, I was grinding my teeth and dreaming up vast biblical acts of vengeance to be rained down upon the children of St-Canut. "What's the matter?" said Marie-Claude. "Are you tire-d?"

She laughed herself silly, not a big step, granted, and I replied in perfect deadpan: "Very witty, Mac."

"It is a joke. *Tire-d*. Do you understand? My first joke in English. My very first joke."

"And it may be your last."

Sadly, Mac's pun was the high point of my day. Not long after, our work supervisor appeared. His name was Étienne. He was a short, stocky man, as solid as a tree trunk. He examined my tire run and shook his head and frowned as only the French can. He said something I didn't understand and the crowds of children burst into laughter.

"Marie-Claude!" I shouted. "*Viens ici!* I need some help."

"Why?" she asked. "Are you tire-d again?"

Étienne launched into a long, complex explanation. He pointed at the tires, he paced them out, he shook his head *oh non, non*, he rolled his eyes, he shook his head some more, he flailed his arms, he made measurements of the angle of the next vernal equinox and divided it by the hypotenuse of the square root of—who the fuck knows what he was talking about. After twenty minutes of this, Mac turned to me, thought carefully for a moment, and said, "Étienne says, 'Don't worry, it's good enough.'"

You ever get the feeling that something has been lost in the translation?

Following the Great Tire Fiasco, my next task was the Adventure Excitement Rope Walk. This was basically two ropes—one for the hands and one for the feet—strung out like clotheslines from tree to tree. The ropes had to have just enough slack to make it a challenge. No sooner had I wrestled the last knot into place and hammered down the last guiding rod than a dozen kids were scrambling along the ropes, bouncing each other off and laughing and squealing like hyperactive piglets.

I stepped back to admire my handiwork. The Rope Walk. *My* Rope Walk.

From behind me, I heard Erik say, "It's no good." I turned to watch him roll a rock free from the earth. "The rope thing you put up," he said. "It's no good."

It was sad, really. He was so obviously jealous. I looked at him. "What are you talking about?"

"It's no good."

"It's fine," I said. "The kids love it."

Erik walked over to me, wiping his forehead with the back of his work gloves. "It's no good," he said.

"*Will you quit saying that?*"

"Those two trees in the middle," he said. "They're dead."

I craned my neck to look at the ashen, barren branches at the top. "They're just late to sprout, that's all." But I didn't sound convincing, even to myself. "I mean, what's the worst thing that could happen?"

"Will," said Erik. "Trust me. Those two trees are dead."

Just then, we heard a low cracking sound—kind of like a bone breaking slowly in two—and one of the aforementioned "late bloomers" toppled over from the collective weight of the children. It crashed to the forest floor, snapping the rope and flipping several kids into the air.

"But I could be wrong," Erik conceded.

"Tell me something," I said with a sigh. "Were any of those dear little children squashed underneath that tree?"

"Nope. The kids are fine."

"Pity."

By week's end, I was relieved to be taken off the work site and put on cooking and cleaning detail. Erik came on with me, and we replaced François and Marie-Claude. The rest of the group was not as excited about this change as Erik and I were. Individually, the two of us had been known for serving up *(a)* spaghetti and *(b)* spaghetti. Nor were we known for being conscientious housekeepers. I had this theory about how certain bacteria were actually beneficial to humans (I had read that in a science journal or seen it on *The War of the Worlds* or something) and that by cleaning, say, the toilet bowl, we might very

well be killing valuable microscopic allies. Erik in turn questioned the value of washing dishes. "Why bother?" he'd ask, reasonably enough. "They'll just get dirty again."

And yet, paradoxically, no one was upset at seeing François and Marie-Claude's week of cooking come to an end. While they were in charge of housework, the place was spotless—why, you could practically eat off the plates—but François, alas, had a streak of gourmet in him. Unfortunately, he lacked the necessary training to ever quite pull it off. He once spent half his grocery budget buying escargots and spinach for the evening meal. I'm sorry, but I don't eat insects. Mac served large salads and homemade stews, but François kept experimenting with newer and stranger dishes. He once served us asparagus and hollandaise sauce, but something had gone horrible awry, giving the entire mess the viscosity and flavour of phlegm.

For dessert on their last day of cooking, François had made—well, a mess is what he had made. It was supposed to be a large puff pastry, but it had somehow deflated and now sat, under our scrutiny, like a soggy condom made of dough and covered with raisins. It looked like the type of thing a billy goat would drop out of its ass. An *ill* billy goat.

"Excuse me, everyone," said Bernadette. "I have to catch up on some Katimavik paperwork."

Duncan's excuse was even lamer. He said: "I'm not hungry."

No one was touching his dessert, and François went into a slow boil. You could tell when he was pissed-off: splotches of red would appear in his cheeks, and his eyes—his sniper's eyes—would narrow to razor width. "So," he said. "I do this for nothing, eh?"

There was an awkward silence, the type where you pray for a meteor strike or a grease fire or anything to change the topic.

"Um, I'll have a piece," said Sarah. She served herself a huge helping. "It looks yummy," she said. But then she took a bite. You could see her mouth fighting with her face. She forced herself to chew and swallow rather than spit it back onto the plate. She choked down one more mouthful and then sat for a while, toying with her food, before saying, "Um, I'm not really hungry now. But it was good. It really was. I'm just not, you know, hungry right now." Her voice faded into giggles and she gave François a smile that was meant to win him over.

It didn't.

"So why did you take so damn much, eh?" His voice was surprisingly angry—nasty, even—and his face was filled with sneers. "I ask you a question. Why you take so much? You are big enough already. You don't need so much dessert. If you are not sure, you take a little. If you want some more, you take some more. You understand?"

"François!" It was Lysiane. "Enough."

Sarah giggled again, but her eyes were filling with tears.

"Hey, Frank," I said, leaning towards him. "Why don't you write that down and put it up as a House Rule. 'How to eat a piece-of-shit dessert by François, King of Pastries.' I've seen cow flops that were more appetizing. Don't blame Sarah if you—"

"Am I talking to you?" he asked. "No. So shut up. I am trying to do new things, even when I'm cooking. For the challenge. And you— *bah*—everything is a joke to you."

"Fuck you, I do my bit."

"Will, why are you here?" he asked. "Why did you join Katimavik? Just for a joke?"

I roared back the only answer I knew: "I joined to get out of chemistry class!"

"*Quelqu'un peut me dire ce qui se passe?*" It was Bernadette.

François ignored her and kept his target-lock on me. "You know why I join Katimavik?" he asked, his eyes burning with anger. "You know why? I joined Katimavik *to find myself.* That's why I joined."

I stopped, not sure how to respond. "François," I said. "I don't even know what that means."

"Neither do I! If I knew what that means, I wouldn't have to look, would I?" It was a statement that was at once utterly irrational and completely logical.

"Look, look," said Sarah, desperately shoving pastry into her mouth. "It's good. I'm eating it."

"This isn't about dessert," I said, and I left, half-expecting François to follow me outside.

I heard the door open behind me and I spun around. It was Erik.

"Well, well," he said. "If it isn't the Great White Hope. What's wrong with you? You want to duke it out with Frankie?"

"François is an asshole," I said.

"And what, you've decided to become the Masked Avenger? You want to rid the world of assholes?"

"I can take care of myself."

Erik laughed out loud. "Are you kidding? Frankie would have killed you. You're not a fighter. Trust me."

I was about to object, but I remembered Erik's observation about the dead trees.

"You know," said Erik, "I used to think *you* were an asshole. Back in Kelowna, back when we first met." He grinned at me. "I still do. You were always bellyaching and bitching and complaining. You know something? If François was lazier and more of a sneak—he'd be you, Will."

I stopped. "Listen, Erik. If this is your idea of cheering someone up—"

"I'm not trying to cheer you up," he said. "Personally, I think Frank should have punched you in the mouth. You were both acting like idiots."

It was after dark by the time Erik decided I had cooled down enough to return to the house. By then, everyone was in bed. Everyone except Sarah, who was waiting in the living room.

"I just wanted to say thanks. You know, for sticking up for me."

"Don't thank me," I said, and I went downstairs.

François and I shared the same bunk bed. He had the bottom mattress and I had the top. I was going to climb into bed—maybe accidentally step on Francois's stomach on the way up—but something Erik had said was niggling away. *If he was sneakier and lazier—he'd be you.*

"François? Are you awake?"

No answer.

"Listen," I said. "I apologize. I acted like a jerk."

There was a pause. "*C'est correct.*"

I waited. Nothing. "Well?" I said.

"Well what?"

"Aren't you going to apologize to me now and say, 'I'm sorry, I acted like a jerk too'?"

I heard him laugh. "Sure. Whatever. *Bonne nuit.*"

I wasn't really certain if that counted as an apology, but I decided to accept it anyway. "Thanks," I said. "*Bonne nuit!*"

Now, I would like to say that François and I began to chum around in a gruff but endearing manner, and that we learned to overcome our differences and respect each other, and that we became better people for it, but none of these things happened. At best we had a truce—an armed truce. But you may imagine such uplifting coming-of-age moments if you wish.

Unfortunately, life is never quite as simple or as comforting as all that.

4

ERIK AND I LAUNCHED our week of cooking with everyone's favourite breakfast: scrambled eggs. "Not again," came the collective moan.

"Ah, but this time we made it interesting," I said. "We left some of the shells in. It's like a treasure hunt."

The group were almost finished their crunchy eggs when Bernadette asked, "*Où est Duncan?*"

I went downstairs to find him. He was still asleep, a big bear in blissful hibernation. Like a true friend, I kicked him awake. "Duncan! Rise and shine, goddamn it!"

"Howzat?" he mumbled, his eyes still resolutely shut.

"The house is on fire. Run for your life."

"Tha's nice." He rolled over and hugged his pillow.

"Duncan, you're making a habit of this. You've been late for work every day."

"Jus' another five minutes, 'kay?"

"Duncan, if you don't get up right now, I shall be forced to go to the washroom, fill up a glass with cold water, and pour it into your ear."

"Tha's nice."

Two minutes later, Duncan was sitting up, wide awake and shaking water out of his ear. "What happened?" he asked.

"Leaky roof. Come on, breakfast is ready."

Not only did Duncan sleep in, he slept loud. His resonant, house-shaking snores grew so thunderous that François, Erik, and I threw him out of the boys' bedroom and made him sleep in the basement storage closet instead. This suited Duncan just fine, because he could now sleep undisturbed while the rest of us were getting up for work in the morning.

One night, however, while the rest of the house slumbered, Erik and I developed a cunning scheme to cure Duncan of his chronic tardiness. Like many a great idea, our behaviour-modification plan came about under the influence of alcohol. Or at least, what was supposed to be alcohol.

Erik had wanted to sample some of the homemade beer we were brewing, and he talked me into staying up past Bernadette's bedtime and pilfering a few bottles from the pantry.

"This is awful," I said. "It tastes like yeast."

"Swallow fast and you won't notice."

We started drinking, but the beer hadn't fermented long enough and the alcohol content was practically nil. After three hours, all we felt was bloated.

"You know what we should do?" said Erik. "We should wake up Duncan."

I looked at the clock. It was three in the morning. "You want to wake up Duncan in the middle of the night to drink nonalcoholic yeast? What are you, some kind of sadist?"

"Not for the beer," said Erik. "Let's just wake him up, tell him it's time to go to work. We'll close the curtains so he can't see it's dark out. We'll hide everyone's work boots so he thinks he's late. I'll even make him breakfast."

"Erik, you *are* a sadist."

So we closed the curtains and hid the boots and made the breakfast and turned the clocks ahead. We even snuck in and changed the time on Duncan's wristwatch. Erik set the table with dirty dishes to give the impression that the group had just eaten (fortunately, we still had lots of dirty dishes on hand), then I went downstairs and, as was our tender ritual, I kicked Duncan awake.

"I'm up, I'm up. Geez, quit kicking." He rolled over and went back

to sleep. Several more jabs and another earful of water and Duncan staggered to his feet. "What time is it? I feel awful. Feels like I had hardly any sleep at all." He stumbled into the bathroom to brush his teeth and, groggily, he got dressed. "I can't stop yawning," he said.

"You should do something about your eyes," I said. "They've got great big rings under them."

He staggered upstairs and Erik threw a plate of scrambled eggs in front of him. "No time for coffee. Eat your eggs and go. You're late. Étienne called and he's pissed-off."

Duncan shovelled in a few mouthfuls and then, in one extended stretch and yawn, put on his work boots, grabbed his hard hat and gloves, and staggered to the front door. We held it open for him.

"What the hell?" he said, stopping halfway. "It's black as tar out."

"Total eclipse," I said. "Freak occurrence. Pay no heed."

"Get going," said Erik, as he tried to push Duncan out the door. "You're late enough as it is."

Duncan stood there on the threshold, looking at the darkness, and then—like a long slow putt—it sank in. "Total eclipse, my ass!" He turned and charged towards us like a stampeding rhino. We tried to close the door and lock him out (that was the original payoff for the joke), but Duncan forced his way in and we fled down the hall and into the girls' bathroom, where we skidded inside and slammed the door shut. Erik just managed to lock it before Duncan threw himself against the door.

"I never heard tell of such fools!" He pounded on the door, almost—but not quite—succeeding in knocking it off its hinges. He did, however, succeed in waking up Bernadette and the girls.

"What's happen?" yelled Mac.

"Duncan," I pleaded from the other side of the door. "You don't want to wake people up in the middle of the night. That's really inconsiderate."

Fortunately for Erik and me, Duncan was more sleepy than angry, and he eventually stomped off to bed. Erik and I stayed inside the bathroom for another half-hour or so, just to be safe, before creeping back downstairs.

A few hours later, I was jolted awake by a piercing sensation in my feet. I screamed and sat up. Duncan was at the foot of my bunk, casually tossing ice cubes into my sleeping bag.

"Rise and shine," he said.

Erik and I resisted the urge to retaliate against the retaliation, and thus, a possible escalation was avoided. It was a draw: Duncan went back to sleeping in, and Erik and I refrained from further practical jokes. Heck, we even managed to whip up our prize-winning Macaroni-and-Cheese Extravaganza for dinner that night. It was well received.

"Not bad," said Lysiane, who had clearly taken a page from Hal's book. "But not really good, either."

"Well, it's better than nothing," said Bernadette.

"Thank you, thank you," I said. "Please, no applause."

Somehow, they managed to honour my request, and we were spared the embarrassment of a rousing ovation. "And for dessert . . . ," I said.

"Not Jell-O," they groaned. "Not again."

"*Au contraire*," I said. "Yesterday it was *strawberry* Jell-O. Today it's *raspberry* Jell-O." But the nuance was lost on them, philistines that they were.

Erik and I were clearing the table, a dreary job indeed—eight people leave a lot of dirty dishes—when Erik leaned over and said, sotto voce, "It's driving me crazy. Absolutely crazy."

"What is?" The last time he was this agitated it was because of an Alma College debutante with severe gastrointestinal problems.

"Montréal," said Erik. "It's driving me crazy."

"Montréal is driving you crazy?" (Talking with Erik always entailed imaginative leaps of logic.)

"It's like a high rewire on the inside track, you know?"

The boy really needed subtitles. I began filling the sink with sudsy water. "Erik. Buddy. Pal. I realize that you speak neither official language, but would you mind not—"

"It's so *close*," he said. "It's like, just over there." He pointed out the kitchen window, as though he expected to see Mont-Royal rise up above the bungalows at any minute. "The bad city is two hours away,

max. And we're stuck here in no man's land. It's not right. It isn't."
He took a deep breath and exhaled slowly, almost overcome with
mourning.

"Erik," I said. "You know the rules. We can't leave our host com-
munity unless it's on Katimavik business or on our free weekend.
True, Bernadette gives us a lot of leeway, but it's still—"

"I have a plan," said Erik, and an evil grin surfaced.

Bernadette, it turned out, was going into Montréal that coming Fri-
day. She was taking the bus in all the way, just to drop off a bulky
package filled with Katimavik manuals to a Montréal-based group.
She wasn't especially enthusiastic about this, and rightly so, because
she then had to turn around and immediately return.

"I'll convince her to let us go instead," said Erik. "We'll take the bus
in, drop off the manuals, and then catch the next bus back."

"What's the point? That'll give us, what, two hours in Montréal?"

Erik looked at me sadly. "Have I taught you nothing?" he said. "We
will go into Montréal. And we will *miss the last bus home*. We'll get
stranded."

"First of all," I cleared my throat, "I doubt if you can talk
Bernadette into letting us go—"

"But I can," said Erik. "That's easy. In fact, she'll be grateful."

"And secondly," I said, "if we phone Bernadette and tell her we
missed the last bus back, she'll have us drawn and quartered."

Erik shook his head in exasperation. He looked very disappointed
in me. "Will," he said. "You know nothing about people."

I was starting to get annoyed. "I know plenty about people.
Plenty!"

"No. You don't. Listen to me, if we call Bernadette all scared and
alone, a couple of young boys lost in the big, bad city, she will *not* be
angry. She will be worried. Worried sick, but not angry. Hey, she
should never have sent us in there in the first place. What if Head
Office heard about this? Bernadette will probably even pay us back
the money we spend."

"A Katimavik-sponsored trip to Montréal?"

"Exactly. Now go scrape together as much cash as you can get. Bor-
row it from Mac and Lysiane if you have to, but get it."

5

I NEVER SHOULD have doubted.

We left after supper, arriving in Montréal at dusk, and checked into a hostel in the McGill ghetto. It was my first time in the city and everything fascinated me: the narrow streets, the staircases that twisted and turned like contortionists to keep inside the property lines, the second-storey walkups, the seedy sex shops, the snooty cafés. And yet, myths to the contrary, it was a singularly *un*attractive city.

This is the great unacknowledged truth in the Canadian psyche: Montréal is an ugly, dirty, grubby place. But it doesn't matter, because it has attitude, and attitude will take you places looks never will. It's like a pug-ugly man in a silk-cut suit, or a plain-faced woman with all the right make-up. The city of Montréal is an architectural jumble with no discernible skyline and more dirt than a London tabloid—but it doesn't matter. Why? Because Montréal is chic and hip and cool. And why is Montréal chic and hip and cool? Because Montréal *says* it is, that's why. Is there any city in North America as self-congratulatory and self-aggrandizing as Montréal? I think not. The emperor has no clothes, his body is flabby and covered with warts, but who cares? He is held aloft by the collective Canadian delusion that somehow Montréal is the Paris of the North, when in fact—visually, at least—it is more a Belgrade of the North than anything.

"What a great city!" said Erik as we pushed our way through the crowds, watching jaywalkers gang up on drivers and force their way across against the light, listening to panhandlers asking for spare change in two languages, passing video arcades and moody sidewalk boutiques, breathing in that intoxicating Montréal aroma of car exhaust, urine, expensive perfume, and fresh bagels. "What a great place."

I had to agree. "It's not what I expected," I said. "But it does have character. I can't think of any place quite like this place."

"Character?" said Erik. "I'm talking about the women. Do you notice? They don't look down. They don't even look straight ahead. They look *up*, above everybody."

"Yup," I said. "Snobbery. A real turn-on."

"The women in Montréal," he said. "They have something, you know? They've got—they've got . . . " He searched for the right word.

"*Savoir-faire?*" I said.

"No, no. That's not it. *Style!* That's the word I'm looking for: style. They play the sideroom, you know?"

"And fashion," I said. I had never seen such a mélange of fads. "What do you figure that woman over there is wearing? It looks sort of like a gunny sack—with sequins."

"It *is* a gunny sack with sequins," said Erik. "This is Montréal. You can wear anything!"

As night fell, we took the Métro to the edge of Montréal's much-ballyhooed Old City and walked in. I was suitably underwhelmed. Across the water, the rusted skeletal remains of Expo 67 reflected wet and oily across the surface of the St. Lawrence. Tourists and late-night strollers milled about, laughing and chatting and congratulating themselves on being in Montréal. A fire-eater was breathing flames into the air. Applause and spare change rippled through the crowd.

Erik was intrigued. "Check out the loot this guy is taking in. People are putting in bills. You know something? I bet I could do that. I bet it isn't hard at all. You just have to be quick and—"

"Let's just go, okay?" Erik had that familiar gleam in his eye, and I didn't feel like spending the night in the burn unit of a hospital.

We moved farther along, where a mime was juggling invisible bowling balls (or at least, I *think* they were bowling balls). A group of flip-scarfed, glitter-skin girls walked past, fluttering smiles at us.

"Talk to them," said Erik. "Say something. You speak French."

"I do?"

"Tell 'em we're gypsies. Tell 'em we just blew into town. Tell 'em"—his face lit up with inspiration—"tell 'em we're fire-eaters."

I smiled at them. "*Bonjour,*" I said.

One girl swept back her hair and smiled coyly at us. "*Comment vas-tu ce soir?*"

"Um, *je suis bon,*" I said.

"*Ah, oui?*" They broke up. "*Anglais,*" they said to themselves, as though it confirmed some pet theory of theirs.

Erik was getting worried. "Why are they laughing? Tell them to

stop laughing. Tell them we're sailors on shore leave. Tell them we're from Australia or something. Tell them we're Americans."

The girls had a huddle and then one asked,"*Les garçons, voulez-vous venir à la rue Crescent avec nous?*"

I smiled blankly at them. There was an awkward silence, and eventually they smiled and shrugged and walked away.

"So what did they say?" Erik wanted to know.

"Beats me," I said. "Small talk, I guess."

We found a pay phone nearby, and as a horse and carriage clattered over cobblestones, we shouted into the receiver to Bernadette. Just as Erik had predicted, she was distraught. "Do you have enough money to survive?" she asked.

"Barely," said Erik.

"Save your receipts," she said, and so we did. Erik had the next waitress give us a blank slip and we penned in a ten-dollar profit for ourselves. We found a late-night liquor store and stocked up on beer and cheap wine. Our plan was to sit by the wharf and drink ourselves into the proper aesthetic mood for a Montréal midnight prowl, but that quickly changed when Erik asked me, offhand, "Do you like tequila?"

We were standing in the checkout line of the liquor store. In retrospect, what I *should* have said was "No, ghastly stuff. Let's stick with Cuvée des Patriotes and Molson lager." But unfortunately, what I said was "I don't know. I've never tried it."

"You've never tried tequila?"

And that was it. We returned our previous choices to the shelves and left the Société des Alcools du Québec with a bottle of the cheapest rotgut tequila we could find. (It had, I believe, been wrung out of the socks of Mexican alcoholics who had passed out in barroom puddles. We're talking cheap. And awful. Lighter fluid would have been easier on our stomachs.)

"We'll pick up some lemons and salt," said Erik. "And when we get back to the hostel, I'll introduce you to an old Hjellerman tradition."

"We better hide the bottle," I said. "They'll never let us into the hostel with it."

"This is Montréal," said Erik. "No one cares."

But Montréal, we soon discovered, did care. The lady at the front desk threw a fit when she saw us sauntering in with our arsenal of tequila and accessories. If we left it behind the desk maybe—*maybe*—she would allow us in. We declined.

"No problem," said Erik in a whispered aside. "I have a plan."

Outside the McGill hostel (which has since closed down, I'm happy to inform you), Erik searched through his pockets until he came up with the scrap of paper he had written the Katimavik address on. The manuals were still in the hostel, but there was no reason why Erik and I couldn't drop in to say hi.

"And how are we going to convince the group leader to let us drink tequila in their—"

"We don't ask, that's how. There has to be a yard or a basement or something. We wait till the group leader's asleep and then we kick back the shooters. C'mon, let's go." And off we went, in avid pursuit of sin.

It took us several hours to find the Montréal Katimavik house. It was in the East End, in a tattered neighbourhood inhabited primarily by angry, shouting men and women who stayed shut behind doors. The street lamps were broken and the cars were rusted, and everywhere were subtle reminders of working-class poverty. A perfect Katimavik location. Our feet were sore and aching by the time we reached the house.

No one was home.

"Shit," said Erik simply.

I started walking back. "Well, maybe we'll get to the hostel before dawn," I said, my voice full of rue.

What I forgot, of course, was that I was with Erik "B 'n' E" Hjellerman, a man undeterred by such trifles as the Canadian Criminal Code.

"I'm going around back," he said. "Wait for me here."

"Don't even think about it. Erik? Erik?" But he had already vaulted over the chain-link fence and slipped into the shadows. A few minutes later a light came on inside. Erik opened the front door and said, "Come on in."

I was shaking all over. "I don't like this, Erik, I don't like it one bit."

"Cut me some slack," he said. "I climbed the balcony and popped the lock on the patio doors. Piece of cake."

"And if we get caught?"

"We tell them we got stranded. Came here. The front door was open. They'll understand." He began twisting the cap off the bottle. "Let's do this in the kitchen."

"Damn," said Erik when he spotted lemons in their fridge. "We wasted forty-nine cents. They've got salt, too." He cut two lemons into wedges and lined up several shot glasses. "You see?" he said. "They have shot glasses. That's practically an invitation."

I couldn't stop shaking. "Let's do it and get out of here."

"So," he said. "How many shots are you good for?"

"I don't know. Seven?"

"That's my boy!!" He sloshed tequila into a glass and explained the lemon-and-salt ritual. "It's great," he said. "This is the only drink that has its own built-in drunk test. When you can't remember the order of salt, tequila, and lemon, you are officially pissed."

By now I was almost hyperventilating from fear. "Ten minutes," I said. "We'll do the shots and be out of here within ten minutes."

It was very easy to say that when I was sober. But after the fifth shot I couldn't focus on the clock. After the sixth, I couldn't tell time. And after the eighth we no longer knew where we were. We stopped only when both lemons had been sucked absolutely dry and the salt was burning our lips.

"So, whad'ya think about tequila?" asked Erik.

I crawled out from under the table. "Is really good," I said. "Mexican culture. Gotta love those Mexicans."

"Hey, Will. Come over here. Look a'that." He was staring out the front window. I staggered over.

"Tha's a Katimavik van," I said.

"Great!" said Erik. "Come an' join the party! Hey, maybe they got girls."

The van opened up and we watched a group of parts climb out and head up the front walk. Erik and I were waving stupidly from the window. Fortunately, they hadn't noticed us.

We heard the group leader's voice as they came up the porch stairs.

"Hey, who left the lights on?"

"Abuse of alcohol," I said and laughed. "Rule Number Two. Maybe Four. Don't remember. We're in big trouble now."

We could hear the key in the lock when Erik grabbed my arm and began running. "Escape!" he cried. "Escape!"

We leaped from the back balcony, crash-landing in the shrubs below and waking up the guard dog next door. We crawled through the branches, tripping and slipping, and we flung ourselves over the back fence and ran down the alley.

We ran until our wind gave out and we stood, bent over and panting, having roused the entire neighbourhood. A patrol car happened by, and Erik yanked me into the shadows. "Whadda disaster," he said, his breath still ragged.

"They almost caught us."

Erik shook his head. "Not that. The tequila. I left it behind. We still had some left."

We staggered back along the street until we reached downtown and then, following a process of elimination, we walked up and down one McGill street after another. It was an English-speaking area, so we were able to ask for directions—not that they did us any good in the state we were in. At one point we stopped the same man twice, having circled the block without realizing it.

When we finally did find the hostel, we had missed the curfew, but no one was at the desk and we managed to sneak back in. We collapsed across our beds.

"This is a decadent city," I moaned. "Decadent and evil."

"It sure is," said Erik, across from me. "Don't you jus' love it?"

6

WHEN I WOKE, someone was repeatedly pounding a brick between my eyes. A vice was being tightened around my temples. Sometime during the night my skull had shrunk several sizes and my brain ached.

"Erik," I moaned. "Come quick. Think I'm gonna die."

"Get up, man. We have to deliver those manuals."

I opened one blood-bleary eye and saw Erik zipping up his bags and looking chirpy.

"Can't move," I said. "Head's gonna explode."

Erik slung my arm around his shoulder and half-carried me out of the building like a soldier in one of those Vietnam War movies. For breakfast I had two aspirin and several pots of coffee. Erik kept forcing me to drink it, so now I was queasy, bloated, *and* jittery. A wonderful combination. Back on the streets, someone had cranked up the volume, and the morning traffic was a tintinnabulation from Hell.

"Gonna die," I prophesied, again and again.

I had only mildly recovered by the time we reached the Katimavik house. We handed the manuals over to the group leader, but he insisted we "come in and meet the group." They had started Katimavik only five days before, and already they'd had some excitement.

"Someone broke in last night!"

"We found a bottle of tequila and some lemons. And the patio door was jimmied open."

"And they vandalized our hedge out back," someone added.

I tried my best to look surprised. "You don't say."

"What, uh, happened to the tequila?" asked Erik.

"Our group leader poured it down the sink." They nodded gravely. Erik almost started to cry.

They offered us coffee and scrambled eggs. I declined, but Erik dug in. As we left they asked for words of advice from a pair of veteran Katimavik-ers.

Erik shrugged. I mumbled, "I don't know. Have fun."

"Gee, thanks!" they said. "We will!"

This was one cheery group. I would have liked to see them after six months.

The bus ride back to St-Canut was stomach-churning. I sat beside an open window with my head hanging out and my tongue flopping like a cocker spaniel's.

"Just minor brain damage," Erik explained to the other passengers. "He'll be fine."

It didn't matter. No one spoke English. *"Maudit anglais,"* they said. *"Maudit anglais."*

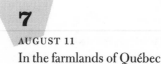

7

In the farmlands of Québec

Dear Everybody:

J'écris cette première partie en français parce que je veux que tu penses que je parle français. Mais, vraiment, c'est un québécois qui l'a écrit pour moi et tu n'en sauras rien car tu ne lis pas le français.

How's that? Pretty darn slick, eh? As you can see, here in St-Canut I have become a cosmopolitan-type French-speaking bon vivant.

We are deep into manual labour now. (Katimavik operates under the faulty premise that there is something ennobling and uplifting about manual labour.) The town has asked us to build a playground/obstacle course. So far, the casualties have been few. This in spite of our best efforts. I am now in charge of building a wooden tunnel for kids to crawl through—which will, I am sure, look awfully sharp on my résumé.

Étienne, our work supervisor, is eloquent and unilingual. He is also very irritating in his demands that we do everything reasonably well. I curse him in English, he swears at me in French, and after work we go for a beer at the local *brasserie*. Maybe bilingualism isn't such a good idea after all. Maybe this country would get along better if none of us understood what anyone else was saying.

Aside from work, we are now preparing for our obligatory wilderness excursion. François is overseeing it, and—being François—he has packed the four days with as many activities as possible. First, we will take a canoe trip deep into the timberland region around Mont Tremblant. Then we will go rock climbing. And then, if we should make it through that, we will begin an outdoor survival course, which should finish us off nicely. Deep in the woods, where even the bears don't speak English, we will be armed only with matches, a compass, a hatchet, and our indomitable will. The preparations for this are very long and serious, and I won't get into them here. But just let me say that if you are ever stricken with the overpowering urge to eat bark and forage for berries, give me a call.

To make matters worse, my partner in all this will be Lysiane, a theatrical, hopelessly urban person. She is also hopelessly clumsy. I'm not sure which I fear more, a French separatist bear or Lysiane with an axe in her hands. The *excursion en forêt* (as we say in Québec) is scheduled to begin in just a few days, so this may very well be the last letter you ever receive from me.

Your soon-to-be-departed sibling/offspring/embarrassment to the family,

Will

8

I KNEW I WAS in trouble the moment Lysiane stepped into the canoe. She didn't sit down.

"Lysiane." I smiled. "Please sit down."

Nothing. She was turning this way and that, and the canoe was rolling from side to side.

"Lysiane," I said, still smiling. "You aren't supposed to stand up in a canoe."

"*Oui,*" she acknowledged. "But I look the best place to sit down. The canoe, she is full of sleeping bag and backpack."

"Lysiane." My smile was now taking on a hysterical quality. "If you don't sit down right now, I'm going to start screaming."

"Okay, okay. Relax." She shoved a pack to one side and sat down on my lunch. The canoe yawed heavily but somehow managed to stay afloat.

"Now what?" said Lysiane happily.

"Now, we paddle," I said with a sigh.

We pushed off from the pier and moved out in convoy. Bernadette waved to us from shore. Coward, I thought. A real group leader would have followed her parts to their deaths. Joyce would have led the way, would have blazed a trail and made a portage. Bernadette acted as if she couldn't wait to get rid of us.

Ahead of Lysiane and me—cutting the water on a sharp blade— was the lead canoe, with François and our guide, René, chopping the

water like seasoned voyageurs. As Lysiane and I floundered about try-
ing to catch the main current, Duncan and Erik went thundering by.
They were all splash and pull and no co-ordination, but it did the
trick. When Sarah and Mini-Mac passed us, I became truly worried.

"We don't go so fast," complained Lysiane.

And then, as she spoke, we caught it: the river's central flow. We
found a comfortable rhythm and the hours slipped by. The motion
became hypnotic. (Motion is one of life's greatest narcotics.) The
canoe brigade stretched out in a long line, and there were times when
Lysiane and I were alone, the canoes ahead of us just around the next
bend, evident only in the ripples they left behind. It was like tracking
ghosts.

The river ran through canyons of trees, and the air was as clean and
crisp as a celery stalk snapped suddenly in two.

Canada is somewhere still.

This phrase emerged and repeated itself, like a canoeist's mantra.
I'm not sure where it came from, but it accompanied me down the
river, keeping pace. *Canada is somewhere still.* The ambiguity of the
word "still" lingered, and I turned it over and let it fall. But even then,
I knew that a forest is not a country, and a river is not an idea. In the
margins of my journal, I later scribbled a message to myself: *Canada
is not a landscape.*

The river widened like a fan. It grew slower, shallower, and we
scraped over sandbars and through reeds where musty scents hung.
Lysiane and I turned a slow arc and the others came into view. They
were setting up camp in a grassy clearing, their canoes lined up in for-
mation along the shore.

Lysiane was pink with sweat and her strokes were slower and thin-
ner now, but she seemed pleased with herself. "It is tough," she
laughed. "Not what I expect. Not what I am used to."

It wasn't until we'd dragged our canoe out of the water that the
soreness hit my arms. My shoulders began to throb and my palms
were blistered and cracked. I was ready for some campfire coffee and
lunch.

"How you say—I squish your food," said Lysiane as she handed

me the bag. I looked inside. My sandwiches were flattened, my cookies were mushed, and my banana was oozing from both ends. "You want to swap?" I said.

"It's not so bad," she said, peeling her own healthy, fully erect banana. "Quit complaining. You always complain."

9

THE SKY TURNED a deep rich blue. We had spent the day spelunking (i.e., crawling around in muddy caves), and we were now sitting around a campfire recuperating and feeling all rustic and outdoorsy. "It's great," said Lysiane, marvelling at the mud and twigs on her clothes and in her hair. "It is rare, you know, for me to be messy. *C'est fun.*"

"This is cool," said Erik. "I mean, I haven't been camping since, well—since *never.*"

"I ever tell you guys about the Junior Forest Rangers?" said Duncan. "I made Third Rank Woodchuck."

"It remind me my father," said Mac, her face glowing campfire orange. "We do like this. Cutting the wood, put up the tent. My father, he always have high hopes. But always, it rain. He yell and kick the tree." She laughed at the memory. "My mother said, 'Your father, he is the rainmaker.' Now, *poof*, they are divorce, but I don't think it is for the rain they did that."

I fed dry branches into the fire and drank my coffee. "I remember a camping trip back in Alberta. A friend of mine named Dave talked me into spending a night in Blood Gorge. Big mistake."

"Blood Gorge?" said Duncan. "Why'd they call it that?"

I threw another branch into the fire, sending a flurry of sparks skyward. "It's an old Indian legend. Many years ago, when the buffalo didn't come, a chief sacrificed his only son to the Great Spirit. The chief, Onomatopoeia, slit the boy's throat with a ragged obsidian knife—at least I think it was obsidian, could have been igneous proxlite, hard to say, really. Either way, the blood flowed and flowed from the boy's throat. It wouldn't stop. It filled the valley and drowned the

entire village. Turns out the buffalo were just late. They showed up a couple of days afterwards. Shame about that. Anyway, to this day the earth in Blood Gorge is a dark, blood-stained red."

Duncan swallowed. I loved a gullible audience, and my group was more gullible than most.

"It's just a legend," I said reassuringly. "Mind you, scientists from NASA flew in to Blood Gorge and studied the soil, and they have yet to figure out *why* it's coloured the way it is. There's no geological reason for it, and they've run hundreds of tests. Who knows?" I shrugged. "Maybe the legend is true after all."

Mac huddled nearer the fire.

"But that's not why I was afraid to spend the night in Blood Gorge. No. You see—" I dropped my voice. "Anyone who has ever dared spend the night in that demon-haunted glade, well ... " I shook my head sadly.

"What?" Mac wanted to know. "What?"

"Twelve," I said grimly. "Twelve in the last ten years."

"Twelve *what?*" Mac persisted, her eyes wide.

"Murders," I said. "Twelve unsolved murders. The Mounties can't figure it out. Twelve campers found in Blood Gorge, their heads nearly severed from their bodies. The weird thing is, their throats were cut in a ragged fashion. Almost as if"—and here I paused for full dramatic effect—"almost as if they had been executed with, I don't know, an obsidian knife or something."

"That chief, he had an obsidian knife," said Duncan.

I frowned thoughtfully. "That's right. He did."

Lysiane laughed. Erik was shaking his head and trying not to roll his eyes.

"It was on a night very much like this," I said. "We were sitting beside a fire very much like we are now. Dave was asleep. I was nodding off—by the way, did you guys notice that slight vermilion tinge to the sand? Down by the shore? It looks a lot like the red soil of Blood Gorge. But that's beside the point. Now, where was I?"

"You were by the fire," said Sarah.

"Dave was asleep."

"Ah, yes. I remember it well. A night very much like this. I was almost asleep when—*wait!* I heard a voice. It was faint, but distinct. At first I thought it was just the wind. It sounded like *ooonooomaaaa-toopeiaaaah.*"

"That's—that's the name of the chief," said Duncan.

"I'm afraid you're right. I wish it wasn't true. But it is. It was the voice of the wind, calling out the name of Chief Onomatopoeia. I was terrified, and yet—I wasn't. I got up. Slowly, I walked into the forest. Following that sound—following that voice."

François snorted. I looked over at him, expecting a sour look, but he was actually enjoying this.

"I couldn't find it," I said. "I couldn't find the voice. It was everywhere—and nowhere."

"*Sacrebleu,*" whispered Mac. "What happen?"

"I became obsessed. A rage filled me. I ran through the forest, blindly trying to find that voice—that awful, evil voice. And then, I saw it." I stopped. Reaching over, I refilled my cup of coffee.

"What?" Mac and Sarah demanded. "What?"

"Sorry?"

"What did you see?"

"A silhouette," I said. "The shape of a man, high on a hill. At first I thought it might be a park warden—or maybe a Third Rank Wood-chuck—but as the figure turned to face me, I saw burning sparks where the eyes should have been. There was war paint on his face and feathers in his hair."

"Who was it?" asked Sarah, densely.

"It was that chief," said Duncan. "It had to be the chief."

"I was terrified," I said. "I ran back to our camp and packed my bag. Dave was still asleep, but I couldn't abandon him, not in Blood Gorge, not with Chief Onomatopoeia on the loose. Dave was curled up in his sleeping bag and I shook him, but he wouldn't wake up. I shook him some more, and then I rolled him over—but only his body turned. His head stayed where it was, with only a small piece of skin holding it onto his neck."

Sarah almost fainted.

"Someone," I said, "or some*thing* had slit Dave's throat from ear to ear. His blood spilled from his sleeping bag and down across the red sand and into Blood Gorge. Victim number thirteen."

There was a long, loud silence.

Sarah giggled nervously. Duncan exhaled. "That was a good story," he said. "You had us going for a while."

"Oh, but it really did happen," I said calmly. "On a night very much like this."

Later that night, when everyone was fast asleep, I slid out of my sleeping bag and crept across to the girls' tent. Huddling outside, I began to softly moan, "*Onomatopoeia. Oonoomaatoopeiaaaah.*"

When nothing happened, I tip-toed closer and moaned again. When this got no reaction, I opened the tent flap and looked inside. No one was moving, so I reached right in and ran my hand, clawlike, through Mac's hair. "*Oonoomaatoopeiaaaah,*" I whispered.

Strange, I thought, she isn't moving. I shook her gently. Nothing. I poked her in the ribs. Nothing. This was starting to get creepy. Slowly, I rolled her over. Her head rolled back grotesquely.

"*Boo!*" she said.

I shrieked and fell backwards, tripping over a log and crashing into the bush. Mac laughed with unrestrained triumph and the other girls stuck their heads out from the flap.

"After seven months," said Mac, "I know your voice, Wheel. Even when you try to be the ghost."

By now, all the girls were laughing.

"Boy, Will. She sure scared you," said Sarah, underlining the obvious.

10

RENÉ HAD MENTIONED "a few short portages." They turned out to be Death Marches across towering mountains and tangled woods. We staggered along, laden down with canoes and supplies. By my calculations, we walked more on Day Two than we actually canoed. Whenever we did have to portage, I let Lysiane take the front. She was like a human minesweeper, stubbing her toes on

every root and rock along the way, giving me advance warning of every approaching obstacle.

By the time we reached our destination, our arms and shoulders, and now our legs, were throbbing with renewed pain.

"Ready to climb a mountain?" asked René.

The cliffs that rose above us were steep and riddled with fissured crags. High above, a few pine trees clung to the summit, wind-blown and sparse. Just the type of landscape you want to conquer after a gruelling portage.

René went up a side path to get to the top, where he pounded in a piton and threaded through a safety cord. He then rappelled to the base. He made it look easy. Death-defying, head-spinning, and dangerous—but *easy*. He explained that one person would stand anchor at the bottom while another climbed. As the climber made his ascent, the person anchoring him was responsible for keeping just the right amount of slack in the cord—in case the climber slipped off.

"You climb unaided," said René. "The cord is only a precaution. Don't rely on it."

He then showed us several grips and reviewed the Principle of Opposing Action (i.e., by pulling out with your arms and pushing in with your feet at the same time, you can propel yourself upwards). He dusted our palms and feet with chalk and said, "You first."

"Me?" I said. "Why me?"

"Why not?" (I hate it when people answer a question with a question.)

"François," said René. "I want you to be Phil's anchor."

"That's Will," I said. "*Will*. At least get it right in the obituaries."

"Why do I have to be his anchor?" said François.

"You're the same height and weight. You'll balance each other perfectly. Let's go."

"François," I said as I strapped on my helmet. "My life is in your hands. You realize that?"

"Yes," he said. "I know."

I enjoyed climbing trees as a kid, and I was hoping it would all come back, like riding a bicycle. The first section was deceptively simple: a series of outcrops formed a rough staircase that was easy to

climb. I scrambled over several boulders and then dragged myself up to a toehold ledge. From there, it got more difficult. I had to search for handholds. Fortunately, previous climbers had left chalk-dust tattoos along the way. "Let's hope they were *good* climbers," I said, and I launched myself upwards, running on a mixture of two parts adrenalin and one part momentum.

Unfortunately, I took a wrong turn along the way. I could faintly hear René yelling up at me, but I couldn't bring myself to look down. I followed a ridge of rock upwards at an odd angle—and found myself stranded. The ridge disappeared into sheer rock face. Above me was a hollow and an overhang of rock. If I could somehow scale the *inside* of this hollow and then pull myself up . . . I lunged up, and for one virile moment I hung, suspended by my hands.

And then I fell.

Well, I didn't really fall. That's too dignified a word. I slid, backwards, down the rock face. The cord caught me in the balls and stretched, making a groaning noise that I mistook for the sound of a piton being wrenched out of rock, and I panicked. Kicking and flailing, I clawed at the cliff, but it was no use. It was pit-and-pendulum time. I hung in space and—like a fool—I looked down. Everyone was very small.

"Don't kick!" yelled René. "François has you."

I felt the cord slowly pulling me up, inch by inch. *Don't slip, François. Don't you fucking slip.*

He didn't. Not for a moment. I was hauled up, back to the cliff face. I grabbed onto it and, once he was sure I was secure, François let out the slack.

When I reached the top, I could see the curve of earth, the endless forests, the silver trail of river, a distant huddle of mountains. It was so windy I could barely hear my heart beating.

Going down was easier on the nerves, because it involved taking *off* the safety belt and walking, following a hiking path through the woods. By the time I reached the base, François was hooked up and ready to go.

He handed the cord to me and said, "Don't let go."

François's ascent went smoothly. He never stumbled, he never

hesitated, he never fell. It was almost fluid, and it was all I could do to keep up with him, pulling the cord in fast enough to maintain the correct amount of slack. He even insisted on coming right back down the rock face, leaving the side path for people "without nerve."

By evening we had all made the climb. Lysiane had to be helped halfway by René, who bounded up without safety cord and took her step by step to the top. Duncan almost fell. Erik was foolhardy. Mac went up with confidence and aplomb, and Sarah was jittery. But we all made it, and when René asked if anyone wanted to go again, I volunteered. This time I didn't use the side path to return but came back down the cliff face. The cord stayed slack the entire way.

I smiled at François when I got to the bottom. "Not bad, eh?"

He returned my smile unopened. "It is a good thing you did not slip this time. My arms, they are very tired. I don't think I could have rescued you like I did before."

For an instant, the image of myself toppling to my death flashed in my mind, but it quickly departed.

11

WE CAMPED NOT FAR from the cliffs, beside a mountain stream on a wooded slope dotted with other campfires and distant guitars. After supper, I wandered back to the mountain. The moon was a stark, phosphorous white. It followed me like a spotlight.

"You come to see if it's still here? The mountain?" It was François. I hadn't seen him as I approached. He was leaning against the stone.

"What are you doing here?" I asked, startled.

"I came here to be alone. To get away from everybody."

"So what are you saying? You want me to leave?"

He lifted his canteen to his mouth and drank. "I really don't care."

"Well," I said. "I'm staying."

"I don't own the forest. Do what you want."

I put my hand out against the stone and looked up. Stars were scattered across the sky. Even from here, I felt dizzy.

"That was a hell of a climb," I said.

He nodded and held out his canteen. "Wine. You want some?"

I filled my mouth and swallowed. "You realize this is against the rules. On our outdoor excursion, I mean."

"It's a stupid rule," he said. "After a meal, I drink wine. It's a family tradition."

"With every meal?"

"Since I was a child."

"So what are you? A family of boozers?"

"No," he said with a sigh. "It's French. It's culture. You wouldn't understand."

"Drinking wine every day is culture?"

"Yes."

"How about beer? I drink beer pretty much every day. Is drinking beer culture?"

"No."

I mulled this over for a bit. "I suppose it's just as well that beer isn't cultural. Otherwise, Erik would be considered a highly cultivated aristocrat."

François tilted back his canteen. "Italian," he said. "My father, he prefers medium French red, but I like a nice, dry Italian." He passed the canteen back to me. "How about you?"

"I like white wine. German."

"Of course."

"What's that supposed to mean?"

"Nothing. Drink the wine, there's more back in the tent."

So I finished it off and we sat in the murmuring silence. The wind was searching the underbrush, sweeping sounds from the trees, and we heard someone approaching. A figure appeared on the path.

"Is that one of us?" I asked François.

"Sure. It's Duncan."

"Can't be. It's too thin."

"Hello there!" said Duncan as he came into the clearing. "Came to look at the mountain, did you? That was something else, wasn't it?"

"You've lost weight," I said.

"Who? Me?"

It was true. He was still a solid-looking boy, but he wasn't really fat

any more. He had been shedding pounds almost imperceptibly, adding muscle, growing fit.

"No one will recognize you when you get back," I said.

He smiled. "Oh, they'll be surprised in Parsons Pond, that's for sure."

"Who knows?" said François. "Maybe they will make you the mayor."

"Now, wouldn't that be something," said Duncan, clearly entertaining the idea. "Wouldn't that be something?"

"So," I said. "You ready for the big survival training tomorrow?"

"Sure. It's just like Junior Forest Rangers. I ever tell you guys about—"

"Yeah, yeah, all the time," said François wearily. "The chipmunk thing."

"*Woodchuck,*" said Duncan. "Third Rank."

"Anyway," said François. "It's not real, our survival training. It's a joke. One day. That isn't the real survival. Katimavik used to be real. It used to have real training, several days in the woods. My brother went on Katimavik and it was very tough. He is in the Armed Forces now. Katimavik used to be much more of a challenge."

"So what happened?" I asked. "Why'd they stop it?"

"One of the participants, he died."

12

THE NEXT MORNING, René gave us the coordinates for the camp and sent us off in pairs, into the woods. We had a list of items to look for and a list of things we were expected to accomplish.

Duncan and François went north, Sarah and Mac went south, Erik and René went east, and Lysiane and I went west. Using our compass, we followed a straight line, clambering over boulders and through thickets until we were several kilometres from camp. We sought out a water supply, following the land contours and the thickness of ferns (though in fairness, water wasn't hard to find; there were streams everywhere).

Lysiane tossed her scarf across her shoulder like a Parisian philosopher and said, "Here. Here we must build our shelter."

She was standing in a bog.

"Wouldn't you rather be nearer some trees? So we can build a lean-to?"

"Fine," she said. "Over there. We must build our shelter over there."

It didn't take long to fit together a crossbeam and side supports. We laced them down with twisted false nettle and then used spruce boughs to form a roof—of sorts.

We collected firewood, and Lysiane stripped a square of green bark from a black ash tree and made a crude water jug/billy can. It was held together in the shape of an ice-cream cone by spruce gum and rubbed dirt (to stop the gum from sticking to our hands). René had let us bring our notes on edible plants. Lysiane and I searched through the underbrush, using her list as a guide. Berry-gathering took most of the morning, but we managed to amass a fair stock. We made a fire and boiled water for tea. Lysiane threw in our supply of wild cherry and chokecherry twigs, and we let it steep. It was very bitter and barely drinkable, but it kept us going.

We were sitting in front of our small fire when Lysiane said, "You remember in Kelowna?" and I thought, *Oh boy, here we go.*

I stirred the fire and pretended I hadn't heard.

"You remember Kelowna?" She laughed as though it were years ago. "You were so much in love with me. *Très romantique.*"

"I was never in love with you," I said.

But this just made her laugh louder. "Sure you were. Oh, come here, my little Lysiane, let me kiss you, *smack, smack, smack.*" She was imitating me making a kissy face. "Remember that, Will?"

"Leave me alone," I said, but she continued, eyes scrunched, lips puckered, smooching the air.

"You look at Geneviève like that?" she asked suddenly. "Is that how you do? Oh, my little Geneviève, let me kiss you, let me touch you, *smack, smack, smack.*" She laughed again.

I sulked until she apologized, but even then she couldn't stop laughing. "I am just tease you," she said, but there was a distinct edge to it. She'd been waiting a long time to say this.

13

WE RECONVENED AT our campsite that evening, everyone with their own small adventure to tell. Mac and Sarah had seen a deer. Erik had mistakenly picked stinging nettles. François had built and dismantled a rabbit snare. Duncan had collected pine cones (which Erik later fired at our heads in unsuspecting moments).

We made bannock and stew for supper and sat in our atavistic circle around the campfire, faces flickering orange. When the mosquitoes appeared, we threw green leaves on the fire and were bathed in smoke. The wood crackled and popped, sending showers of sparks upwards.

"You know," I said. "Seeing those sparks reminds me of an old Indian legend."

There was a loud groan. "We don't want to hear about the monster," said Lysiane.

"Yes," said Mac firmly, in full agreement. "No more scary stories, Wheel. No more blood." Sarah concurred.

"It isn't a gruesome story," I said. "It's a genuine Indian legend, told to me by an old woman with one eye and a trailer full of amulets. You'll like it. Very New Age and sensitive."

They were hesitant, but eventually they relented. "All right, tell us the legend."

"Well," I said, immediately warming to my task. "There was once this blood-sucking demon from Hell that—"

"*Je t'avertis!*" said Lysiane sharply. She looked as if she were ready to punch me.

"No, no," I protested. "It's all part of the legend. It seems that this demon—a vampire, we would call it today—had possessed the body of an old hermit woman who lived on the edge of the village. Young men began to die mysteriously, sucked clean of their blood, their faces frozen in terror. And everyone knew who was responsible."

"Who?" said Sarah.

"The, uh, the *vampire*," I said.

She nodded slowly.

"Ahem. Anyway, one night the people in the village caught the old

woman and built a huge bonfire. When the flames were burning high, they tossed her in—just like that."

"Just like that?" said Duncan.

There could be no other way. "Just like that," I said. "And as she roasted, her skin bubbling and peeling away, her flesh blistering and her eyeballs melting—"

"Enough!" said Lysiane. "No more detail. Just finish the story."

"*Legend*," I amended. "It's a legend, not a story. So, where was I?"

"The blistering flesh," said Sarah.

"The melting eyebrows," said Duncan.

"Oh, yes. As the vampire witch-woman from Hell burned to her death, she looked out and said—her lips hadn't fallen off yet—she said, '*You cannot kill me! Every spark that flies up from this fire—and all fires after—will turn into mosquitoes. They will come back down. And I will still get your blood!*'"

I looked around for a reaction. "Pretty cool, eh? All those sparks, flying up, turning into mosquitoes."

"That's it?" said Sarah. "No one dies?"

"Well, the vampire dies," I said.

"Hmm. I kinda prefer the story about Blood Gorge and that chief, the one with the knife."

"Me too," said Duncan. "It reminds me of Junior Forest Rangers. One time, we were camping up in Gros Morne—"

Lysiane moved over, closer to me. The fire was crumbling into embers. "It was good today," she said in a half-whisper. "We survived."

"The forest?"

"Everything." She watched a flight of sparks fly up and into darkness. "More mosquitoes," she said with a laugh.

"I ever tell you about the Demon Bear? It's a wild fanged beast that crawls out of the underworld at night, breathing fire and—"

Lysiane drove her fist into my solar plexus, knocking the wind out of me and successfully dampening my desire to spin more tales.

"Enough," she said softly.

Everyone's a critic.

14

ÉTIENNE WAS NOT HAPPY.

He was standing, arms crossed, lips pursed, expression pensive, as he considered my handiwork. We were barely back from the woods— the smell of smoke still clung to my jacket and skin—and already I was in trouble. I had completed a wooden crawl-through tunnel just before we left, and now, on our return, I was faced with a deeply disappointed boss.

Étienne frowned. He shook his head. He explained at great length, with elaborate gestures and sweeping generalizations, where I had gone astray. This went on for quite some time and ended with him saying, sadly but firmly, "*Ceci est tout à l'envers. Il faut que tu le changes.*" It was a statement I had become quite used to hearing.

Marie-Claude was passing by and I called her over. She spoke with Étienne in serious, minute detail. They frowned some more, they mulled the situation over, they discussed the phases of the moon and the shift of the tides and the significance of ancient Babylonian architecture, and then—at long last—Mac turned to me and said, "It's not good."

"I know it's not good," I said. "But *why* is it not good?"

More discussion. They mused and pondered and frowned some more, they took barometric readings and plotted the rotation of the earth, and then Mac turned to me and said: "Bees."

"Bees?"

She wasn't sure. "Maybe hornets."

"What about them—*wait!* Don't ask Étienne. Just tell me."

"Well," said Mac with a sympathetic sigh. "The bee and hornet make the nest inside the tunnel. Many kids—how you say—bite? The parents complain. Very angry."

"A hornet's nest?" I stepped back. "*Guêpes?*"

"*Oui,*" said Étienne. "*Guêpes.*"

I turned to Mac. "Tell him that's part of the obstacle. It's part of the challenge. Makes the kids tough."

Mac relayed the information, but Étienne did not approve, and

they spent the rest of the day fumigating the tunnel. I have a lethal allergy to bee stings—I have to carry an Epipen injection kit—so I stayed far away, a fact that did not endear me to the rest of the group. "Way to go," said Erik as he returned, coughing, at the end of the day.

15

"I NEED A VOLUNTEER," said Bernadette. "So I chose you."

"I see."

We were sitting in her dimly lit office/bedroom, surrounded by stacks of paperwork—the bane of Katimavik group leaders. Why I had been summoned remained a mystery, but it was clear that whatever my mission was, it involved secrecy and danger. A midnight skulk across enemy lines, perhaps, illuminated only by the occasional flash of artillery fire. In situations like this, the patriotic response could only be: *Ready, aye. Ready.*

"And what exactly have I been volunteered for?" I asked, my upper lip stiff and jaw square.

"Ile Perrot," she said.

"I see. Ile Perrot." I didn't know what—or who—Ile Perrot was, but that didn't stop me from looking gravely concerned.

"Ile Perrot. The Katimavik board of directors will be meeting there next week. It's just outside of Montréal. Sixty-five groups have been asked to send representatives. I want *you* to represent *us*."

What could I say? It was my duty. "All expenses paid?" I asked.

"All expenses paid. Plus an extra travel allowance."

I smiled in a brave-front, self-sacrificing sort of way. "So where do I sign?"

After we had filled out the forms and arranged the tickets and allocated the proper funds, a thought struck me. "Why didn't you ask François or Lysiane or Marie-Claude? They're bilingual."

"I did ask them," said Bernadette. "They declined."

"I see." Cowards. "Did they give a reason?"

"They didn't want to miss the raft trip."

I paused. "The raft trip? You mean that white-water expedition we have coming up? Don't tell me this conference is scheduled for the same weekend."

Bernadette nodded.

And so it was, as the rest of the group prepared to careen down rapids on inflatable rafts, I caught a bus to Ile Perrot. The rest of the group was going on an adventure. I was going to a meeting. Or rather, a Participant-Director Intercommunication Workshop and Dialogue. (The further up you went in Katimavik, the longer the titles.)

The headquarters at Ile Perrot were in a wooded camp complete with barracks, cabins, lunch halls, and assembly grounds. Katimavik. The Heart of the Beast. Apocalypse Nice. I had worked my way into the very epicentre of the organization—me and several dozen others. Participant representatives poured out of buses and vans all day. We were assigned rooms, meetings, topics. We lined up again and again. Bodies pushed and flowed on human tides. It was, in short, well-organized chaos (which kind of sums up Katimavik itself).

I ended up in a dorm-style room with two extremely enthusiastic first-rotation parts.

"I'm Bob! My group is in Kenora, Ontario, and we're working in forestry."

"And I'm Joe!" chimed the second. "My group is in Tignish, P.E.I., and we're helping to build a cross-island bicycle path."

I blinked. "You realize," I said, "that you are only required to give your name, rank, and serial number."

Joe laughed and Bob slapped his knee repeatedly. "That's a good one all right!" declared one of them. (I couldn't remember who was who.)

"It sure was!" said the other. "I bet we are going to have a swell time rooming together."

Wonderful. I was trapped in the woods with the Care Bears.

Bob 'n' Joe were all abuzz about the upcoming address from Senator Jacques Hébert (aka Kurtz). In his youth, Hébert had travelled across China—in the middle of a civil war, no less—with another young gadabout named Pierre Elliott Trudeau. Pierre went into

politics; Jacques went into publishing. Later, as an author and activist, Jacques helped launch Canada World Youth, an international exchange program, and still later, Katimavik.

Joe 'n' Bob, meanwhile, had grown tired of agreeing with each other and had skipped off for a "nifty" game of volleyball. I stayed in the room and prepared my notes for the next day's meeting. In St-Canut, Bernadette had held an Open Dialogue on Participant Suggestions (i.e., a meeting, i.e., a bitch session) and I had jotted down scads of complaints and recommendations. They ranged from Sarah's ire over the "no junk food" guidelines to François's demand for preselection interviews. Katimavik participants were chosen based solely on the demographics taken from the application forms. This was how Yves of the Midnight Screams had managed to get in. It was too much of a lottery, François complained.

By the time I had everything in order, the supper gong was echoing through the camp—the only effective way to bring sixty-five participants together at once—and as we stood in line for our tofu burgers and alfalfa-sprout salads, I ran into a young man from Corner Brook, Newfoundland. He was tall and square-shouldered and built like a Greek statue on steroids. "I know you," he said, his eyes direct and unblinking.

"You do?"

"Sure," he said. "We met at your International Day, back in Ontario. I'm in Geneviève's group."

"You are?"

"Sure," he said. "Me and Gen get along great."

"No kidding," I said, my chest deflating. I could feel my ego shrinking back on itself like a testicle in cold water. Geneviève had this guy in her group? How could I possibly compete? I resolved at that moment to begin doing sit-ups, just as soon as I finished dessert.

"So," I said in a casual, offhand sort of way. "You got a girlfriend or anything?"

"Naw." He gave me a grin: pure white teeth. "I play the field," he said, and nudged me in the ribs, bruising several and causing my ego to disappear completely in a tiny poof of air.

What bothered me even more than being outsized by the Corner Brook Giant was the nagging feeling that something was askew. Geneviève knew I was coming to Ile Perrot; I had mentioned it in my last letter. If her group was also sending a representative, why hadn't she tried to wheedle her way in as well? Why hadn't she made an effort to meet up with me? They were the type of questions that can slowly gnaw the marrow right out of your bones, and it was only later, in the dying days of the program, that I found out why she hadn't come. In the meantime, for dining companions I had a choice of Joe, Bob, or Testosterone Boy.

I ate alone.

16

THE MEN AND WOMEN responsible for Katimavik arrived the next day. Joe-and-Bob could barely contain their glee. "The entire board of directors! And Senator Hébert himself."

If Joe-and-Bob had expected a fleet of limousines to pull up, accompanied by bodyguards and television cameras, they were sadly disappointed. The directors just sort of wandered in. Most were wearing jeans and Katimavik T-shirts, and aside from the thinning hair, grey strands, and soft paunches, none of them looked especially old or distinguished. Jacques Hébert was not seven feet tall. Nor did he leap up on a crate and whip us into a frenzy with his dazzling rhetoric. He was a short, balding, gregarious man, amiable and impossibly good-natured. I thought to myself, *I don't remember ever being as young as Jacques Hébert is now.*

The schedule was hectic. There were rumours of a massive expansion of the program, and the Katimavik board of directors wanted to be ready. A raw sense of excitement ran through the meetings, and I found myself swept up in it. We were on the brink of something— something *big*. There were omens and portents on every side, and all of them were good:

• Great Britain, New York City, India, and Australia had modelled youth volunteer corps directly on Katimavik.

• The Business Council on National Issues was urging the government to expand the program. Katimavik, said the council, had reached the "social conscience" of Canada.

• Beyond ideals, the program was also remarkably cost-effective. A study by Econosult, an independent firm, reported that every dollar the government spent on Katimavik generated $2.43 in the Canadian economy. And two-thirds of the money spent went directly into the communities involved.

It got even better. Katimavik had just been awarded a medal by the United Nations Environmental Program, and the next parliamentary session would open in the International Year of Youth. Surely this boded well for the future. But what none of us knew at Ile Perrot—what none of us could possibly have known—was that Katimavik was on the brink not of expansion, but rather cancellation.

It was easy to believe in Canada back then, back at Ile Perrot. It was the eighties. There was money to burn and the separatists were in retreat. It was during that great lull between the 1980 referendum and the death of the Meech Lake Accord in 1990. It was a time when Canada—as an idea, as a system—seemed as if it just might work.

Katimavik was going to save Canada. It was ridiculous, sure. But it was also courageous in a Don Quixote sort of way. It was silly and brave and inspiring. It was very, very *young*.

Rarely has the gap between the Ideal and the Real been so vast. Having stuffed my head full of wild schemes and contagious ideals, I returned to St-Canut all fired up, only to be confronted by the specific misfits who made up Group 216.

Nothing had changed. The white-water raft trip was followed by yet another general yard cleanup day. Mac was being cheery. Lysiane was being melancholy. François was striding about the yard in a strident manner doing all sorts of strideful things. Duncan had vanished from the face of the earth, and Sarah was doing whatever Sarah was doing. Probably something annoying.

I felt like a kite returning to the ground after the wind has passed. We were Canada in miniature: loud, chaotic, well-intentioned. We weren't going to save the nation, or anything else. We were, I realize

now, a generation without a mission. That was the bad news. And that was also the good.

As night descended, the streets of St-Canut filled with revellers and raucous celebrations. Young men roared up and down the main drag, honking horns and yelling triumphantly. Fleur-de-lis flags and rich blue banners fluttered from windows. Brian Mulroney had just been elected. The Tories had swept Québec and rolled across the nation. They had won the largest majority in Canadian parliamentary history, and the very air was alive with energy and promise.

18

IT WAS THAT time again. Time for Direct Community Interaction and Awareness of Local Lifestyles (i.e., billeting). Families were hard to come by in St-Canut; we were the third Katimavik group to come through, and the citizens were less enthusiastic, if not downright jaded, about the whole thing. In several cases we had to double up: Duncan and Sarah went to a young family who operated a bakery in nearby St-Jérôme; Lysiane and François went with a family in St-Columban (the father worked for Mirabel Airport, and his college-age daughter had been around the world and spoke several languages). Erik was sent alone to a dairy farmer in the fields south of the airport. With all the jets landing and taking off and scaring the livestock, it was said the cows produced curdled milk and cottage cheese. Marie-Claude and I were billeted with Pierre and Aline LeGros, an elderly couple who ran the local corner store. We knew the LeGros well; their store was just across the street from us.

Pierre was a short, spherical man who liked to laugh, his eyes disappearing into laugh lines when he did. His silver hair refused to hold a part, and his droopy grey moustache was getting so shaggy that Madame LeGros compared kissing him to kissing a sheepdog. Mind you, a *cute* sheepdog, she was quick to add.

Aline was irrepressible. Her hair, a suspicious red, was swept up and held in place by a lacquer of hairspray and high spirits. She spoke twice as much English as her husband, but this wasn't a great

achievement, because Pierre's entire *vocabulaire anglais* consisted of "maybe yes, maybe no, maybe rain, maybe snow," a phrase that he used to comment on everything from national politics to professional hockey. Aline, on the other hand, loved to chatter away to herself in a disarming blend of English and French as she bustled about the store, forever making two trips when only one was needed.

During their years together, Aline and Pierre had added twelve little LeGros to the world, most of whom had grown up and moved to other towns where they were procreating with the same vigour. Only their youngest son, twenty-six-year-old Gaspar, remained at home. Gaspar suffered from slight retardation as well as a harelip that some surgeon had done a slap-patch job of repairing. Pierre and Aline had spent years giving Gaspar encouragement and guidance, mostly in vain, for their son never did learn to read or write above a grade-school level. Nor did he ever fully overcome his speech impediment. His harelip and plugged-nose slur made him difficult to understand, as well as a constant source of entertainment and mockery for the town kids.

As a shy boy of twelve, however, Gaspar had discovered the cash register at his parents' store. It was a love affair from the start. Although he couldn't write a simple sentence, Gaspar could add and divide and juggle complex sums. He worked the cash register like some people work a pinball machine. He was even capable of outsmarting customers. I remember one tourist who came in, a sharp-witted man from Montréal, who tried to bully Gaspar into giving him a discount. Ears of corn were on special, six for a dollar, but the man only wanted to buy four—and he wanted a deal. He was adamant. "Okay, okay," Gaspar said finally. "I'll give you four for seventy-five cents," and the man swaggered away, convinced he had come out on top.

The store itself was *extraordinaire*, a low, sprawling building with adjoining rooms and side nooks and angles that didn't quite add up. On a *good* day, it looked as if a tornado had recently passed through. Different types of clutter exist in this world: a professor's paper-strewn desk is Clutter with a Purpose, the front yard of a family who is moving is Clutter for a Reason, but the LeGros store was Clutter for the Sake of Clutter. Clutter for the sheer joy of it.

Some illustrations are in order. Madame LeGros had once, very

briefly, decided to open a bottle depot. She had never gotten around to returning the bottles for a refund, though, and over the course of time the stack of empty beer cases had come to serve as an overflow newsstand/coffee counter/gossip nest. Customers stood around catching up on their reading: last week's newspapers, dusty back issues of nudie magazines, and month-old editions of crime tabloids—something of a Québec tradition, with their hemorrhaging colour photos and lurid red headlines. It was a family sort of place.

The rest of the store was just as dishevelled, with numerous dead ends and shelves that ran at cross-purposes. I once found a fountain pen and a supply of India ink tucked in behind a cache of Kewpie dolls, gathering dust. (There were corners of the store where the dust was as thick as dryer lint.) The LeGros did not subscribe to the practice of taking inventory and updating prices. In this spirit of *laissez faire*, they disregarded government "best before" dates on perishable items ("Those are just suggested guidelines," insisted Aline), preferring instead the venerable ethics of Buyer Beware. For all that— because of all that—their store was a local institution. It had been there for years, and it was regarded with a certain affectionate exasperation by the townspeople.

Half the challenge of shopping at LeGros' was finding what you wanted—and remembering why you came in the first place. The store had that effect on you. It was distracting, to say the least. As near as I could tell, the shelves had been stocked and arranged according to whim. Fishing lures were piled up next to Christmas ornaments, canned hams were stacked beside pantyhose, fabric softener and laundry detergent were at opposite ends of the store, peanut butter and jam were separated by several aisles, and even the salt and pepper were not in the same area.

One weekend, when Madame LeGros went to visit relatives in Montréal, I decided to surprise her by reorganizing the entire store, front to back, top to bottom. It was a monumental task. I laboured for two days, sweating and straining and moving shelves and stock around—I even lined the refrigerators up in a systematic way.

"*C'est bien,*" said Marie-Claude as the last shelf was restocked and the floor swept and mopped.

"*C'est fini,*" I wheezed.

The LeGros store was now a neatly structured, highly efficient base of operations. Aisles were open at both ends, products were arranged by category, the dead ends and clutter were gone. It was—

"*Terrible!*" exclaimed Aline the minute she set foot inside the store. "Why for you did this my shop?" (When Madame got excited her English syntax tended to suffer.) "Oh, so good my God! It's terrible! Terrible! *Oh, mon Dieu!*" She fanned her neck and threatened to faint dead away.

"You don't like it?" I said, brilliantly assessing the situation.

Pierre was a great help. "Maybe yes, maybe no," he said. "Maybe rain, maybe snow."

"Oh, oh, oh, you sweet boy." Aline smiled and pinched my cheek. "I'm sure you work very hard, very much. It is the sweet gesture, *non?* But—but . . . " Her fingernails began to dig deeper into my cheek. "But now everybody can come in and see what they want very quickly."

"I know," I said. "Isn't it great?"

"*Mon Dieu!*" she wailed. "Now they buy only what they need! They don't have to search. They don't have to look the other merchandise. The customers, they will not like. We will lose the business. Oh, oh, why you do that for when I cannot stop?" She threw her hands heavenward and left the store.

I looked around at my clean, anal aisles and tidy displays. It had never occurred to me that the LeGros made such a good living from their corner store *because* of its clutter, not in spite of it. Marie-Claude came to my rescue. "Don't worry," she said. "*C'est correct.* You cleaned up the store, so I will *remess* it. Is that a verb in English?"

"It is now."

After the LeGros store had been remessed, Aline's mood improved considerably. Mac had done a good job. It would take several years before things finally acquired the proper patina of dust and neglect, but at least it was a start. Gaspar ran the cash register. Aline flitted about, cajoling customers into buying Dr. Ryan's Acu-Pressure Insoles (or whatever item she had decided to unload that week). Pierre, meanwhile, sat by the door smoking his pipe and smiling at the world.

Appearances to the contrary, Pierre was a vital part of the store's operation; many people dropped by just to chat with him or share a joke. Once Pierre had lured them to the store, Aline would reel 'em in, using her best honey-dripped voice to persuade them to purchase a lifetime supply of collapsible drinking cups.

Mac and I, meanwhile, had our own system when it came to restocking the shelves. I would put all the boxes and cans up on the shelves, and then Mac would come right behind me and turn them all around so the French side was showing. It was a habit I could never break.

19

THE LEGROS STORE was the town's Khyber Pass; everybody came through at some point. Sarah and Duncan roared in one day to buy emergency icing sugar for the bakery. They left two hours later, the proud owners of a See-Thru Cheese Grater and a handy set of Stove-Top Cover-Ups ("to hide unsightly stove-top mess"). Lysiane came by frequently to play cards with Pierre, and she usually left with some indispensable gadget as well. François also dropped by, with his billeting father. The only participant who hadn't shown up was Erik.

I was starting to fear he was either dead or had become a hermit when he suddenly appeared at the store, sunburned and smiling wearily.

"Erik! How the hell are you?"

"Tired. Very tired. I have straw in my hair and cow shit on my boots. I feel like an Albertan."

"You should be so lucky." I tossed him a bottle of cream soda, on the house. "You know," I said, "I half expected to see you come crawling in here within a couple of days, whimpering for a ticket back to Toronto."

He guzzled the cream soda and let out an impressive baritone belch. "It's worse than I thought. But it's better, too. Let me tell you something, farmers are fuckin' nuts. We get up when it's still night, we work until breakfast, go back to work till noon. We're asleep by nine."

"You don't mind?"

"It's not that bad," he said. "Once you get into the rhythm of it. The only thing is, I feel guilty milking the cows. I mean, we always stop after foreplay."

I opened a second bottle of cream soda for him. "Erik the Sunburned, wooing the cattle of St-Scholastique. There's a ballad in there somewhere."

He chugged back more pop and wiped his mouth. "I'll tell you another thing. When this ends, I don't ever want to see another cow as long as I live. Unless it's hamburger. *Cows are so stupid!* Before I went to the farm, I always thought cows were kind of sly or shrewd or something."

"Cows? Sly?"

"Well, now I know. From now on, I will never feel bad about eating steak. Matter of fact, I'll probably enjoy knowing a cow died for my meal." He grabbed me by the shirt and pulled me in. "I'm talking stupid. Not dumb, not shy. *Stupid!* They never move when you want them to, they crap everywhere, they lick the inside of their noses, they just stare at you when you try to—"

"I know, I know," I said, taking his hand away. "They're bred to be stupid, like television anchormen or professional hockey players. It's all in the genes."

Erik finished the second bottle, let out another Lord Almighty burp, and got up to leave. "Have to go. Their son is waiting for me, and he's a real pain in the ass. He calls me names in French, I can tell."

I walked Erik down the road. The farmer's son was glaring at us from the driver's side of a pickup. He was a sour kid. It looked as if he had been weaned on a pickle, as though he gargled with lemon juice— just for the fun of it.

"Check it out," said Erik, his voice dropping slightly. "The other day, I was picking up bales from the field, and he kept the tractor moving just fast enough that I had to run to get the bales on. It's like he's always testing me, you know? And he hates Katimavik. He thinks it's just a plot to make the French and English get along better."

The son was getting impatient. *"Hey-eh! Dèpeche-toi, tête carrée!"* he yelled.

"What does that mean, *tête carrée*? He calls me that all the time."

"It means square-head," I said. "It's what they call us. It's an insult."

"Fuckin' frog," said Erik under his breath.

Yes, Katimavik! Bringing the two solitudes together, bridging gaps and healing rifts.

"Still," said Erik. "I like his parents. They're good people. And I like the horses. They have horses. We went riding down by the river the other day. My ass is still sore."

The son was now leaning on the horn.

Erik sighed. "You know, when the judge gave me a choice between jail or Katimavik, I wonder if I made the right decision."

20

"SCRAMBLED EGGS?" we whined in unison as Sarah dished out our morning meal. It was our first breakfast together after billeting, and already our mood was foul.

"We only have a week and a half left," I said bitterly. "Can't you come up with something different?"

"Why should I? You never did."

"That's beside the point." (Which is what I always say when I have no decent comebacks.)

The menu never did change. Right to the goddamn end we were eating goddamn scrambled eggs and goddamn spaghetti with goddamn Jell-O for goddamn dessert. Though I suppose, in a way, it was fitting. For as soon as the group disbanded, we would be free to eat whatever we wanted.

We were mentally preparing ourselves for all aspects of life in the Real World. Duncan would be able to sleep in without seven people yelling at him, Erik would no longer be hindered by the Code of Conduct, Lysiane would be able to work on something more creative than manual labour. And I—well, I would be able to do whatever it was I wanted to do. The thousand-dollar honorarium was as much a burden as it was a reward. Are you going home? Are you gonna travel? Will you put it in the bank? In a trust fund? Will you use it to buy a

second-hand car? Or a rail pass? Or a huge big chunk of hash? (That last question being Erik's.)

My family was wondering much the same thing. (Except the part about the hash.) But when asked, I would smile enigmatically and say, "Maybe yes, maybe no. Maybe rain, maybe snow. I don't know."

21

OUR FINAL DAY of work.

The obstacle course was finished, and we walked the entire path one last time, from start to finish. It was, we all agreed, a tremendous achievement, one that would stand for generations, one that would outlast the pyramids themselves, one that would—and here we were really reaching for hyperbole—be even grander than Mirabel Airport. We were in a self-congratulatory mood. We raked the last of the sand, we double-checked all the knots and boards, and I went through painting large red circles on selected boulders (to mark each station). François nodded with satisfaction. Erik and Mac decided to try each obstacle firsthand, and I leaned back and watched the procession. It was only after I stood up that I realized I had been leaning against a marked boulder. The paint was still wet. I had a stain on my jacket, a stain that would never come out even with repeated, abusive washings. A large red birthmark of a stain. It dried into the colour of blood.

That night, back at the bungalow, we sat around buoyed by the Unbearable Lightness of Leaving. Erik said, "We should do something, you know? We should go out with a bang."

"Why don't we invite some other Katimavik groups over?" I said, a reunion with Geneviève dancing in my head. "Like we did in St. Thomas. We could have another International Day. Part Two, the Sequel."

"That's a stupid idea," said François.

"You have anything better?" I asked.

"No," he said. "But having another International Day is a stupid idea."

"How about a beer festival?" said Erik. "We could have chug-a-lug contests and wet T-shirts and—"

We groaned.

"Hear me out," he said. "It would be on-the-rope and radical."

"How about a theatre festival?" asked Lysiane. "I could write the *scénario*, we could have music and costumes, and we could perform it in the community centre."

But this elicited even more groans of protest. "Sing and dance? Forget it."

It was in the midst of this increasingly belligerent bickering that Sarah said, "I have an idea."

The room went quiet. Sarah giggled nervously. "I was thinking, um, you know how we have, like, an obstacle course and everything. Right? So why don't we use it? We could invite different groups over. We could have a Katimavik Olympics."

No one said anything. Sarah's voice grew quieter. "It was just an idea."

"I love it."

"It's perfect!"

Even François conceded this. "It's a good idea, Sarah. Very good. Better than some stupid International Day."

"And we could have beer," said Erik, still trying valiantly to advance his own agenda against a wall of indifference. "And one of the events could be a chug-a-lug contest."

So it was that we decided to end our time together by being the hosts of the first ever Katima-lympics. Sarah wanted to be a team leader, so it fell to Erik and me to organize the event. (We were the Active Leisure Committee: I was Chief Omnipotent Ruler and Erik was my Vice-Supreme First Lieutenant.)

Our first decision, by unanimous consent, was to hold an international potluck supper with the cuisines *assigned*. ("Your group is Chinese. Your group is Mexican. Your group is vegetarian.") Naturally, we reserved Italy for ourselves.

In the middle of all this, the Montréal Katimavik group (of tequila shooter fame) showed up on our doorstep. It was late in the afternoon and they looked exhausted. Disillusioned. And generally embittered with the universe. Gone were the bubbly enthusiasm and innocent expectations, gone was the keen sense of team spirit: the Montréal

group looked like an army patrol returning from the wrong side of an ambush. Several collapsed onto our living-room couch and fell asleep with the suddenness of people hit by stray sniper fire. They were snoring within minutes. Several others started raiding our fridge.

Their group leader followed them in like a forlorn shepherd. "We just finished our four-day wilderness training," he said. "Is it all right if we clean up, use the washroom, maybe have some tea?"

"How did it go?" I asked one of the semiconscious parts.

"How did it go?" he said. "*How did it go?*" This was not a question I should have asked. It unleashed a litany of reported hardships and complaints from the group. "The canoes capsized. It rained. Our guide got lost. Our compass couldn't make up its mind. Our paddles are somewhere in Lac Bellevue. We had to portage over a mountain as big as—as big as—" But they couldn't come up with a metaphor big enough. "Well, it was *really* big."

"But the worst thing," said one of the girls, "the very worst thing, was the food."

On this there was consensus. They turned on cue and glared at a little guy sitting alone in the corner.

"Alfred organized the meals," they hissed, and it looked as though they were going to lynch poor Alfred right then and there.

"Beans!" one of them cried. "Beans! Nothing but beans for four days. Alfred had the bright idea to bake enough deep-brown beans to feed the entire Eastern Townships."

Alfred slunk further back in the corner, his eyes flicking frantically about the room for the quickest way out. He spotted the window, and you could tell he was prepared to leap through it when the time came.

"Which brings us to this," said the group leader. He handed Bernadette a heavy tin bucket. "We aren't suppose to waste food or resources in Katimavik. But my group doesn't want to see baked beans for a very long time. Enjoy them in good health. And maybe leave the windows open tonight—to air out the house."

Bernadette accepted their generous contribution—more flatulence, just what our group needed!—and she in turn invited them to our upcoming Olympics, though in all honesty I wasn't sure if they would have recovered by then. Especially when it came to running through

the forest, scaling walls, or swinging across ravines.

Sarah took the bucket of beans and said, "Neat. Now I don't have to cook supper. Not today or tomorrow or the day after."

Marvellous. Bloody marvellous.

Erik went over to Alfred, who was still cringing in the corner. "Don't feel bad," said Erik. "You guys are new at this. What you should have made is bean soup. Or, even better, bean popsicles."

"Popsicles?" said Alfie. "I didn't know you could make popsicles out of beans."

"Sure," said Erik. "Isn't that right?"

"It sure is," I said. "Next time you're on cooking detail, serve up a big plate of bean popsicles for dessert. Your group will love you for it."

"They will?"

Pow! Pow-pow-pow-pow! Pow!!

A series of explosions echoed through our house. Erik dropped to the floor, a reflex undoubtedly acquired through years of crime.

"What is that?" yelled Sarah, as she too ducked for cover.

The bedlam continued. Everyone was shouting, and François got up and went to investigate. He returned a moment later. "It's the pantry," he said. And then: "The beer."

"*Noooooo!*" said Erik. "Not the beer!" He leaped up and ran from the room.

Erik yanked the pantry door open and wailed in despair. I found him standing in the corridor as the entire Beer Committee's work detonated, one bottle at a time. He was beyond condolence, but I tried my best. I patted him on the back and said, "I think they're ready now."

The Montréal group was very thoughtful. They helped us mop up the beer and broken glass, and they opened both doors to create a cross draft. Our house smelled like a brewery. Some of the beer had even seeped through the floorboards and dripped into the basement. I doubted whether Katimavik would be getting back its damage deposit.

Erik was devastated by the untimely demise of the beer. I think a little piece of his heart had died with each shattered bottle.

"What will we drink?" was his lament. "What will we drink?"

"Not to worry," I said. "Soon we'll all be a thousand dollars richer. We can buy our own drinks. The only real loss is the time and the effort and the loving care you put into brewing that beer. All those hours, all that work."

This did not comfort Erik as much as I had hoped, and he slumped to the floor in defeat. Still, life went on. Erik didn't jump off the roof or drown himself in the bathtub. He put on a brave face. He fought back the tears. He continued with the preparations for the Katima-lympics. But there were times, often late at night, when I saw his expression change and his eyes well up and I knew he was remembering "the beer that got away," and I stepped back to let the sorrow pass.

22

WE INVITED A DOZEN groups to the Katima-lympics. Rather than pit group against group, we decided to mix it up. We would draw names from a hat and place participants from different groups on each team. Erik and I appointed ourselves judges, and the others—François, Marie-Claude, Lysiane, Sarah, and Duncan—were made team leaders. Points would be awarded for *(a)* most shameless attempt at flattering the judges, *(b)* worst team song, *(c)* best time in the obstacle course, and *(d)* strongest showing at the grand-finale tug-of-war. (Erik wanted to include a kissing contest, but Bernadette gave him an acerbic look. "Come on," he pleaded. "I'm not talking tongues or anything." But to no avail.)

The Obstacle Course Relay was to be the main event. Participants would each traverse a single obstacle, passing a small Canadian flag like a baton as they ran. The race would begin with the Tarzan rope swing, then progress over the rope walk, through the tunnel, across the tire run, and so on to the finish line, where the last person had to eat an entire banana and yell, "*Katimavik, le défi!*" clearly enough for Erik and me to understand.

"What we need," Erik said to me, "is some kind of cool opening ceremony, like they had in L.A."

"We could have a torch run," I said. "There's an old hockey stick in the basement. We could soak one end in rags and light it."

"And an Olympic flame," he said. "We could use the bucket the beans came in. Fill it up with briquettes."

Lysiane volunteered to paint a Katima-lympic flag, to be raised at the start of the Games and solemnly lowered at the end. This was getting better all the time.

"We could have a balloon release as well," said Erik. "Only instead of thousands of balloons, we'll just release *one* balloon."

I liked it. It was stylish. Understated. "We could release doves as well," I said. "One dove. There are all kinds of pigeons in this town. If you can catch a duck, you should be able to catch a pigeon."

"No problem," said Erik. "But do you know what we really need? A police escort."

Erik convinced Mac to call the local police detachment and request a patrol car to lead the torch run through St-Canut. Very little crime happens in this sleepy area of Québec, and the constables agreed at once. A police escort. An Olympic flame. Balloons. Bananas. It had everything you could possibly want in public entertainment.

Étienne came by the house the day before the big event. I was at the sink doing dishes when he walked in.

"*Bonjour, comment va tout le monde?*" He dropped a tangle of thick rope on the kitchen floor. "*Voici la corde.*"

It looked frayed and rotted. "You sure this is strong enough for a tug-of-war?"

"*Quoi? Tu ne te souviens pas de moi? Je suis celui qui ne parle pas la langue des têtes carrées.*" He flicked his cigarette ashes into my rinse water.

"*Solide,*" I said. "*Est-ce que la corde sera assé solide?*"

"*Oui, oui.*" He crushed out his butt in one of my freshly cleaned saucers. "*Solide. Adieu.*" And he left.

It was meaningful interactions like these that made Katimavik such a unifying force in Canada.

23

OUR CONTRACT WITH Katimavik ended on October ninth. The Katima-lympics were scheduled for the tenth.

The end came rushing up suddenly. What had started in a barn in British Columbia came to a close in a bank queue in St-Canut, Québec. Our cheques arrived, and Bernadette gave them to us without ceremony. It was profoundly anticlimactic. We were all a thousand dollars richer and we walked to the bank together, signed deposit slips, bought travellers' cheques. When everything was taken care of, we filed back outside.

Then the cheering began.

No more rules. No more curfews. No more work sites. No more meetings. No more. No more. No more. "We are free citizens!" shouted Erik. "Free!"

Free to do what?

After nine months of regimented, scheduled, preplanned days, our sudden lack of constraints was—in itself—constraining. We now had almost limitless options; we could go where we wanted, do what we wanted. It was intimidating. I imagine that leaving Katimavik was a bit like leaving the army or a prison: an odd blend of exhilaration and apprehension. We didn't quite know what to do with ourselves.

In theory, we still had another ten hours as members of Katimavik (our contract ended at midnight), but with the money in our accounts there was little anyone could do to stop us from just walking away. However, we had more than a hundred people arriving the following day, and the Katima-lympics gave us a chance to go out in style, with a bang not a whimper.

That night, we drank expensive wine and sat out on the back patio.

"Well, I know what *I'm* doing," said Erik. "I'm on a bus back to T.O. I have a court appearance next Monday, and after that I'll—" He stopped, uncertain. He had never thought beyond his court date. "After that—" He turned to me. "You coming through Toronto?"

"I don't think so."

He laughed. "You will. Everybody comes through Toronto at some

point. Look me up when you get in. It'll be a blast. No more rules. Money in our pockets. Off the corner and halfway home."

"Well," I said. "If you ever come through Alberta—you know, if you're running from a posse or something—look me up."

Duncan was going home to Parsons Pond. Sarah was going to Nova Scotia to meet up with Izzy. François was heading back to law school the following semester.

"Law school," I said. "Sounds serious."

"It is." There was an awkward pause. "Listen, Will. If you are ever in Montréal and you need a place to stay—"

"Come on, François. You don't mean that."

He laughed. "You're right."

"Take care of yourself," I said.

"*Toi aussi.*"

Sarah was into the wine and had gone all tipsy on us. She staggered about, maudlin and ripe with giggles. "Willy!" she cried as she flopped down beside me. "How ya doin', cowboy?" Her mouth was full of potato chip mulch. "I'm gonna miss you. Really. Even though, you know, we didn't always get along so well. I mean, we did fight a lot. 'Specially in B.C."

"And Ontario," I added. "And Québec."

"But still, I'd like to think of us as, you know, *friends.*"

"We *are* friends."

She was taken aback by this. "Thanks," she said. "Thanks so much." She gave me a shoulder-crushing hug and a gummy wet kiss on the cheek.

Duncan was handing out his address to everyone, "in case you're ever passing through Parsons Pond."

"What is the deal with your name?" I asked. "*Gallant.* Duncan Gallant. It sounds French."

"It is," he said. "It's completely French."

"But you're from Newfoundland. I thought everyone was Irish or English."

"Not where I'm from," he said. "It's English now, but way back when, the whole eastern side of the island was French. They called it

the French Shore. It was the French what discovered it and set up camp. All the bays and towns right up to L'Anse aux Meadows—it was all French."

"L'Anse aux Meadows," I said. "That's where the Vikings landed." Erik was trying to tell a joke to Lysiane. "Don't you get it?" he asked with more than a little exasperation. "The lady's toes were curling because she still had her pantyhose on."

"*Je m'excuse*," said Lysiane. "I don't understand."

He was about to try again when he heard us discussing the Vikings of northern Newfoundland. "Hey!" he said. "I'm part Viking. The name Hjellerman is Swiss or Swedish or something."

"You sure it isn't Norwegian?" I asked.

"No," he said. "Swiss. Definitely Swiss."

"Erik," I said. "I don't think a lot of Vikings sailed out of Switzerland."

"Well, then, Swedish. Definitely Swedish."

Duncan turned to François. "Your name is English, right?"

François balked at this. "It's Québécois, *pure laine*."

"But your last name is Johnston."

His voice tightened. "I am Québécois," he said. "Johnston is an old Québécois name. And on my mother's side, we go back all the way to Champlain. I have ancestors who fought on the Plains d'Abraham. I am *pure laine*. It is Lysiane who has an English name."

This got an immediate response from Lysiane. "*Je suis Québécoise aussi*," she said. Her last name was Phaneuf. It didn't sound very English. "But it was," she said. "Originally. In 1700, a man from New England, his name is Farnsworth, he was catch by the French. They take him to Montréal. After time, he had a wife, many children. But no one can pronounce his name. So they change it, from Farnsworth to Phaneuf. It is unique, this name. And today, there are many Phaneuf in Québec."

"So it isn't really French *or* English," I said.

"It is Canadian," she said. "Anyway, at least I am not the witch like Marie-Claude."

Mac laughed. "Stop it," she said. "I am not the witch."

François explained. "Marie-Claude's name is very famous.

Lavallee. There was, how do you say, *un sorcier* named Jean-Pierre Lavallee. He lived on Ile d'Orléans, not far from Québec City. When the British ships appeared he goes like this"—François made a conjuring gesture—"and heavy rain and lightning and the fog came down. Many ships sank. Many people died."

"*C'est vrai*," said Marie-Claude with a laugh that was part embarrassment and part pride. "I am a Lavallee. My ancestor, he kill many Englishman. Maybe it's why today my family are all sovereignists."

"You're a separatist?" I asked, agog.

"*Oui*, all my family."

"But you're so—you're so *nice*," I said. "Your dad—he works for Elections Canada. With the government."

"That's right."

"The federal government. He works for the federal government."

"So?"

"So *he works for the federal government*."

She saw no contradiction in any of this. Neither did anyone else in the group. As long as I live, I'll never understand Canadians.

"What about you?" said Erik, turning his attention to me. "What's your story?"

"We're from Cape Breton," I said. "My great-grandfather came over to work in the mines. I belong to the only Scottish family who failed to make a fortune in the New World."

It's true. Canadian history is full of Scotsmen who came and built railways and banks and made fortunes and became prime minister and went around being dour and counting their money—unless they were incorrigible drunks; then they drank gin as they counted their money. It's been said that the Scots made English Canada what it is today. But whenever textbooks expound on the "Successful Scots," there should be an asterisk and a footnote reading: "Except for the Fergusons out of Whycocomagh, Cape Breton, who were a right balls-up when it came to making a fortune."

You've heard of the Fergusons of the powerful corporation Massey-Ferguson? I am not one of those Fergusons. You've heard of Graeme Ferguson, who invented IMAX? A completely different Ferguson. John Ferguson, the legendary hockey player and coach? No relation. Don

Ferguson, comedian and Royal Canadian Air Farce alumnus? Nope. No connection. Howard Ferguson, former premier of Ontario? Maynard Ferguson, jazz trumpeter and composer of the *Rocky* theme song? Emily Ferguson Murphy, aka "Janey Canuck," popular author, first female magistrate in the British Empire, and leader of the movement that forced the law to recognize women as "persons"? Or Marilyn Ferguson, New Age mystic and author of the best-selling *Aquarian Conspiracy*? No relation. I come from a completely different line of Fergusons. True, all Fergusons are related if you trace it far enough—the family dates back more than a thousand years—which is why we can all claim a connection, however tenuous, with the ex–Duchess of York.

We, however, are the Cape Breton Fergusons. When we first migrated to Canada, we were very, very, very poor. But through hard work and clever investment, successive generations have managed to work their way up, and we are now merely very, very poor.

"My family's Russian," Sarah volunteered. "Really, it's true." No one had denied it. "My last name's Driedger, but it used to be, um, I forget. It was a long time ago. Anyway, we had to come to Canada because everyone was against us in Russia. Because of our religion."

"Jewish?" I asked.

"Doukhobor. My grandparents went to Grand Forks and then later, my grandfather left the church and they moved to Vancouver."

"Aren't the Doukhobors the ones who used to take off all their clothes and burn their houses to the ground?"

"Not all of them," she said. "And they were protesting stuff."

"Like what, the high cost of clothing and housing?"

"No," she said. "War. Taxes. Religion. You know, *stuff*."

"You ever take off all your clothes?" asked Erik.

"No," she said in a fit of giggles. "But there's this nude beach in Vancouver, near where I live. Really, it's true."

Now, *that* caught our attention, and we were off and running, the topic of nude beaches holding us far more rapt than did genealogy. The First Rule of Conversation is this: naked people frolicking on a beach trump Cape Breton coal miners every time.

Still, that evening stands out in my memory—not just because it

was our last time together, but because of all the doorways and questions it opened up. Why is it that just when you start to know someone, it's time to say good-bye? Vikings. Sorcerers. Prisoners. Protestors. Virtually every Canadian—every damn one of us—is here because of adventure, either personal or ancestral. We are the children of adventure, all of us.

It was an epiphany that has stayed with me ever since.

24

GENEVIÈVE WAS ON her way. She had called that morning and my hormones and heart had been throbbing ever since. (At that age it is often difficult to tell the two apart.)

Three Katimavik vans pulled up at the same time, emptying participants onto our lawn. Bodies and backpacks were jumbled together in confusion. Geneviève moved through the crowd and met me halfway across the lawn. We kissed like a couple in an Armistice Day photo.

"What?" I asked. "No judo flips?"

"Not today," she said.

The other Katima-victims poured in: the St-Jérôme gang, the Joliette mob, the Mont Tremblant terrors, and eventually the hapless Montréal house, who were only now recuperating. After dropping off their supplies, the participants gathered outside the St-Canut community centre.

François, Mac, Erik, and I would be running the torch through St-Canut to the start of the obstacle course, where throngs of cheering participants eagerly awaited our arrival. The tension was so thick you could shovel it. Back at the house, Lysiane painted our faces with fleurs-de-lis and Olympic insignias and we took our positions, paced out along rue de Latreille. At precisely a couple of minutes after twenty to ten, François lit the flame and jogged out of the yard. Leading the way was a police cruiser, lights flashing and siren screaming.

It was—and I say this with deep humility—a mind-boggling cavalcade of excitement the likes of which St-Canut had never seen before. Puzzled homeowners came out at the sound of the police siren and watched, quizzically, as we passed. François handed the flame to me, I

passed off to Mac, and Mac passed off to Erik. Erik ran it in, trailing smoke and smouldering flames—possibly the only time in his life when he would be pursuing a police vehicle and not the other way around.

The awestricken huddled masses, speechless in their wonderment, gathered around the bandstand (two picnic tables pushed together). The other runners had followed Erik in, and we gathered now in the spirit of national unity and deep—

"Get on with it!" someone shouted. (You have to watch yourself with awestruck crowds. They can turn on you in an instant.)

Erik handed me the torch, I held it high, and then—dramatically—I plunged the flame into the bucket. "*Que les jeux commencent!*" I announced. "Let the games begin."

Nothing. No reaction. "*Psssst*, Will." It was Erik.

"What is it?" I said from the side of my mouth.

It was the bucket. Nothing was burning. Not even a whiff of smoke. Not even a puff. Not even a puff of a wisp.

Laughter. A few anonymous witticisms were shouted. The situation was growing critical; I was losing the respect of the crowd. "That was just for practice!" I shouted.

The gasoline, I realized, had settled in the bottom. Using the burning end of the torch, I dug around in the bucket, stirring it up until—BOOM! The gasoline erupted in a fireball, throwing briquettes into the air and finally sparking a response from the now unruly crowd. "Do it again!" they yelled. "More fire! More fire!"

We released our balloon, which had withered considerably since morning. It dragged impotently across the ground and into the audience. Someone stomped on it and we heard a sad pop. (Erik had failed in his attempt at catching a bird, the pigeons of St-Canut proving more agile than the ducks of St. Thomas, so there was no "release of the dove," alas.)

Lysiane then hoisted our Katima-lympic flag, which unfurled on the wind and sent the crowd into paroxysms of excitement. "It's upside-down!" they shouted. We pulled the flag back in and turned it over, and thus ended the opening ceremony.

We began the long process of separating the participants into teams and explaining—*again*—the rules. Geneviève ended up on Sarah's

squad and I was astonished, if not a little dismayed, at how well the two of them got along. Their team was the first to run the relay, and Geneviève started it off with a daredevil swing across the ravine. She sprinted up the embankment and passed the flag to a tall, gangly kid who lurched his way across the rope walk. And on it went, from tire run to wall climb to log balance; each team ran the course, and their times were duly recorded with stopwatches. It took several hours to complete, amid much hilarity and injury. At the end of it, Erik and I discovered that our separate time sheets didn't agree, so we took the average, divided it by pi, and then took a rough guess.

We were about to begin the tug-of-war when Stefan, the group leader from Joliette, approached me and said, "What? The group leaders, they don't get to compete?"

"But there's only ten of you," I protested. "And we have sixteen obstacles to run."

"*Pas grave,*" said Stefan. "The group leaders, we are invincible! Six of us will do *two* obstacles each."

"You're on," I said. "But give me half an hour to prepare the course."

What this meant was altering obstacles. The rope walk was loosened a bit to give it extra bounce and sway; every second tire was removed, lengthening the stride required to two metres a step; the rope climb was liberally coated with cooking oil; and the tunnel was plugged with burrs and sprinkled with gravel. (You ever tried to crawl across gravel? It hurts the knees something fierce.) The *coup de grace*? Waiting for them at the end was a seriously overripe banana liberally laced with tabasco sauce. When the last of the group leaders came limping across the finish line, I shook my head in disgust. "Worst time yet," I said.

"You're a dead man," said Stefan with a gasp.

The tug-of-war championship never happened. The rope snapped like dry grass in the first round, sending the opposing teams sprawling backwards into the dust. François knotted the rope together for a second try, but again it broke. And again. After which we cancelled the event. Damn Étienne and his *corde solide*.

It was late in the evening when the final results were announced. Sarah was bouncing around like a fart in a mitten; she had heard

rumours of a victory, and they were true. "I've never won anything before!" she said.

To the hearty cries of "Recount!" and "Fraud!" Sarah's gang came forward to receive the highly coveted, handcrafted Katima-lympic medals (beer caps glued to purple ribbon). We brought out the Olympic Fire Bucket and Erik poured a jug of water over the Olympic Briquettes. (He had wanted to pee on them as a grand finale, but the idea was nixed in the interests of Olympic dignity.) A white cloud of smoke rolled up and the Games were brought to a close. There wasn't a dry eye in the house. To the tender shouts of "When's supper?" and "Bring on the food!" we slowly lowered the Katima-lympic flag.

Erik stepped forward and held his hands out for silence. "As you all know," he said, "after today our group no longer exists." (extended applause) "I know that you are heartbroken to hear this." (much laughter) "I know that you will miss us." (cries of "Dream on!" and "Good riddance!") "But before we go, we wanted to make a small gift to the Montréal group. They are new at this, and we thought we'd pass something on to them."

The Montréal group shuffled up, unsure of what to expect. With a flourish, Erik unwrapped a batch of baked-bean popsicles. They looked like long, frozen dog turds, and we forced them on the Montréal group. "*Mangez! Mangez!*" chanted the crowd, and they did. Most of them looked ready to gag, but not Alfred. He gobbled his bean popsicle right up.

"Hey, these aren't bad," he said.

The rest of his group eyed him with evil intent. It was clear that Alfred's days were numbered.

"Eat up," said Erik. "There's plenty more where those came from."

25

IT WAS A POOR NIGHT for stargazing.

Music was pulsating from inside the community centre gym and flocks of participants milled about under the tennis court lights, laughing in the darkness, playing interminable rounds of Whereyafrom? and D'yaknow? The Katima-lympics were over, the

potluck supper had been a rousing success, and everyone was lit from within by that odd elation that comes with the end of an event.

Geneviève and I walked along the obstacle course until we found a clearing. "*La dernière soirée,*" I said in a deep, serious voice—a voice ripe with implications.

Geneviève missed the gravity of this. "*La dernière soirée.*" But when she said it, it didn't sound sad at all.

"Think about what we can do," I said. "Between the two of us, we'll be rich." (I was nineteen. I thought a thousand dollars was a lot of money.)

"*La dernière soirée,*" said Geneviève, and she slid closer.

We were in the middle of a hot and heavy session when I said, "This is only the beginning."

She pulled back. "What do you mean?"

"I went to the library," I said. "I found pictures of the îles de la Madeleine. You were right. Those islands are wonderful. The fishing coves, the sand dunes, the sea. That's where I want to live. In a small house, overlooking the ocean. A sky full of stars every night. The sound of the wind. Fishermen for friends, music in the—"

"Stop." She was looking at me with a mix of bafflement and anger. "That is my island," she said.

"We'll swim naked in the sea," I said. "We'll teach the seagulls to laugh. We can raise horses and drink wine."

I waited for a smile. And I'm waiting still. Instead, a chasm opened up in the earth, a red-hot poker was shoved up my ass, the stars fell, and a voice said: *Here is a moment you will be replaying again and again for the rest of your life. Here is a moment that will inform everything you do from now on, no matter how small.*

Geneviève said, "When I go to îles de la Madeleine, I go alone." She turned to the sky. "Tonight is the last night of many things," she said.

Her face was in profile, and I wished—in that moment, just this once—that she didn't look so beautiful. I couldn't think of anything nasty or cutting to say. I couldn't think of anything memorable. I just sat there, looking at her looking at the sky.

It was a poor night for stargazing. I walked Geneviève back to where the crowds were and she laughed and bounded off, into the

music, and she was soon lost amid the dancers. I stood there, dumbly, as the melee swirled by.

Outside, Lysiane was sitting on the steps drinking wine straight from the bottle. She looked slightly drunk, but when I sat down beside her—fell down, really—she gave me a sympathetic nod.

"So, where is your little Acadian girl?"

She passed me the bottle, and I took a long, desperate drink. "*C'est fini,*" I said.

She shrugged. "You play the game, sometimes it happens."

My chest felt light. My legs felt numb, as though Novocain were slowly seeping into my veins.

"Where do you go from here?" said Lysiane. "You go home?"

"I suppose." Back to Alberta. And then? It was as though I had entered a cul-de-sac, as though I had spent the last nine months turning a slow, pointless circle—avoiding everything, resolving nothing. "I don't want to go home. I want to go—somewhere. Somewhere else."

"I have a small apartment in Lévis," she said. "It is across the water from Québec City. You can see the Château Frontenac from my bedroom. If you need a place to hide, you can hide there."

I passed the bottle back to her. "I don't know what I want."

"Who does?" she said.

26

THE HOUSE WAS STILL ASLEEP.

I woke in the early dawn, slung my backpack onto my shoulders, and stepped outside into the ordinary chill of October. The streets were soft with fog and the morning sun lay swollen and orange across the green fields of St-Canut. I walked through the deserted streets, feeling empty, awake, alive, confused.

The bus would not arrive for another hour. I checked and rechecked the schedule, making sure the connecting buses were properly aligned.

Inside the depot, a tired-looking clerk sold me a ticket. I tagged my backpack and went outside to watch the fog lift.

It never did.

Afterword

IN 1986, THE RECENTLY elected Tory government made its presence known. Canada's youth budget was gutted, unemployment among young people skyrocketed, and Katimavik was given the axe. Brian Mulroney called the program "a noble idea whose time has passed."

With Katimavik gone and the nation's youth budget in ruins, Senator Jacques Hébert launched a three-week hunger strike in the foyer of the Upper House. It was one of the most remarkable protests in Canadian political history, and it sparked a storm of controversy across the country. Even then, it would take nine years and a change of government before Katimavik was back on the national scene.

I returned to St-Canut in 1997, more than a dozen years after my tour of duty with Katimavik. I was in Montréal on a book tour for *Why I Hate Canadians*, and I had spent the day shuttling from interview to interview. My wife was pregnant. The rent was due. The first sales figures weren't in yet, and my future hung in the balance. I was waiting to find out if I had just launched my career—or destroyed it. There were six more cities to go, and I was already bone weary.

St-Canut has grown. The church steeple is still the highest building in town, but subdivisions have been added, spilling out into the

fields. I went to the LeGros store only to find new owners running it. The shelves of the store are now tidy and well organized. Pierre LeGros had died several years before. Aline LeGros no longer has bright red hair, and no one says, "Maybe yes, maybe no. Maybe rain, maybe snow."

The obstacle course is gone. If you go to St-Canut today and walk up the hill behind the tennis courts, all you will find is a rough trail, a few loops of rope mouldering around trees, a plank nailed to a trunk. And—if you know where to look and if you don't mind searching for it—you will find a rock with a large red spot painted on it that once marked the end of the course.

I stood there for some time, looking at that red birthmark. The next day, I flew on tour to Ottawa and the following day to Toronto. I was travelling on a tight schedule. By the time I reached Vancouver, the sales reps were wearing smiles and my future was set, however tentatively.

A follow-up Gallup poll has demonstrated that former Katimavik participants are twice as likely to be gainfully employed as other members of their age group. Polls have also shown that ex-participants are more keenly aware of themselves as "Canadian" than almost any other segment of society. That I believe.

Katimavik was resurrected in 1995. The structure remains much the same, but the operation is smaller, and the scope of the program has been pared down. I understand that participants have been given a hefty raise: they now earn the princely sum of *three* dollars a day.

It seems so long ago.

The last time I heard from anyone in my Katimavik group I was on my way to Japan. I was packing and repacking my bags, trying to second-guess what I would need in Asia, when the phone rang. And suddenly, the years tumbled back and there I was, a Katima-victim again, lost in Canada.

"How did you get my number?"

Erik laughs. "I have my ways."

The past is not that far away. Sometimes, all it takes is a voice over the phone. "Remember?" says Erik. "Remember."

There are times I suspect—or rather, I fear—that there are only two states of being: nineteen and *not* nineteen.

"You'll never guess where I am," says Erik, laughing like Pan.

"Alcatraz?"

"Not even close." The static crackles along the line, an arc cutting across the distance. "I'm back in Kelowna. I've got a room downtown, across from the museum."

"Why?"

He laughs, his best damn Hjellerman Viking laugh. "I'm helping a guy sell drugs."

Of course.

"I'm working at a pharmacy. I'm an assistant trainee. Can you imagine? I'm also taking a night course in carpentry and I'm helping this crazy German guy put an addition on his house. He said he knew you."

"He still hasn't finished that damn house?" It's my turn to laugh.

"Tell me," says Erik. "Did you ever hear from her again? The little one, the one with the tan?"

"Once. I heard from her once."

Later that night, when I cannot sleep, I turn on my bedside lamp and reread the postcard. It is a picture of the ocean with blue skies and seabirds and a lighthouse in the distance.

My friend,

On days like this, I think of you. It was raining and sunny at the same time.

I think of you. Are you happy? Have you found what you were looking for? Very much, I hope that you have.

Sincerely,
Geneviève

P.S. The seabirds are singing. You can hear them on the wind, where I am.

WILL FERGUSON's first book, *Why I Hate Canadians*, was a surprise best-seller that made both the *Globe and Mail* and *Toronto Star* best-seller lists, climbing as high as #3 nationally. Ferguson has appeared as a contributing editor on CBC Radio One's *This Morning* and is also the author of *The Hitchhiker's Guide to Japan* and an upcoming travel memoir entitled *Hokkaido Highway Blues*. Born and raised in northern Alberta, he now lives in the Maritimes. He has been described by his detractors as "Pierre Berton with attitude."